Photographers:
A Sourcebook for Historical Research

Stereo half, c. 1870. "A Photo Gallery in the Mountains. Emigrants from Walla Walla around it," manuscript in pen on the reverse. The photographer is identified as H. Brince who, according to Peter Palmquist, worked around Susanville, California.

Photographers:
A Sourcebook for Historical Research

RICHARD RUDISILL

PETER E. PALMQUIST

DAVID HAYNES

STEVEN F. JOSEPH

RON POLITO

LINDA A. RIES

1991
CARL MAUTZ PUBLISHING
BROWNSVILLE, CALIFORNIA

FIRST EDITION
©1991 CARL MAUTZ
ALL RIGHTS RESERVED

COMPOSED IN ITC BERKELEY OLD STYLE
PRINTED AND BOUND BY McNAUGHTON & GUNN,
SALINE, MICHIGAN
IN THE UNITED STATES OF AMERICA
DESIGNED BY RICHARD MOORE

ISBN 0-96219-402-6

CARL MAUTZ PUBLISHING
POST OFFICE BOX 9
BROWNSVILLE, CALIFORNIA 95919

Contents

Introduction

Photographers: A Sourcebook for Historical Research is two books in one. First, six essays focus on the theory and techniques of regional research, the why and how of delving into the lives of long-dead photographers. This section is followed by Richard Rudisill's *Directories of Photographers: An Annotated World Bibliography*, which summarizes directory work already in print or underway, giving researchers an invaluable base from which to explore.

The study of photographers *by region*—usually by district, state, or country—is a relatively new phenomena, but one that has yielded significant results across the entire history of photography. The process has been likened to the piecing-together of a giant jigsaw puzzle. Whereas it is nigh impossible for a single researcher to find and record all of the world's past photographers, the job can be broken up into smaller bites, with each researcher contributing data from their region. The end result of this cooperative effort, like a completed jigsaw puzzle, provides a much fuller picture with an understanding far beyond the sum of its parts.

Who is doing this type of work? Most regional research has and is being conducted by individuals. Some are associated with or supported by institutions, while others work quietly on their own. The work is tedious and time consuming, requiring great patience and perseverance. Yet there are also rewards of discovery and a sense of belonging to a small association of men and women who share a passion for the subject.

For twenty years I have studied the photographers of California. I have interacted with many researchers. Recently, I compared my California list with Graham Garrett in Canada. There were significant "matches" between my Gold Rush-era photographers and those on Garrett's list of photographers active in eastern Canada.

I have made many friends among those involved in the process of regional research. For years I have corresponded with researchers whom I have yet to meet. Bruce Hooper, for example, researches Arizona photographers. He first wrote me in 1986, and we have exchanged dozens of letters each year since, all containing useful tidbits of information. (Bruce even after all these years, still addresses me as "Dear Sir," while I call him "Dear Bruce.") These relationships are as unique as the individuals involved, some of which are very visible in the field and others are perhaps best described as "reclusive." A few, like Richard Rudisill (*The Photographers of New Mexico*) have already worked in the field for decades, and yet "Dick" would be among the first to assist the "newest and greenest" candidate with even a passing interest in researching photographers. Although I described the field as "relatively new" we have already lost some of the finest members of our fraternity, pioneers such as the late Bill Darrah.

The six essays of the first part of this book are more than a mere primer on "how to conduct research about photographers." Rather, the writers are sharing their personal experiences in the field. Collectively, we hope that this information will prove useful, and we would be very pleased if the reader was encouraged to undertake similar research in order to provide a few more pieces of the "Photographers of the World" jigsaw puzzle.

Peter E. Palmquist
Arcata, California
August, 1991

PART I

The Experience of Regional Directory Research

Oil Dealers.
(Wholesale.)

National Oil Works and Mill Supply Co., 46 Franklin, James N. Quin, mgr.
Protection Oil Co., 15 Main, C. W. Robinson, propr.
Waters Pierce Oil Co., ns Wash'n bt 3d, 4th, J. Eckel agt.

(RETAIL.)

Texas Lamp and Oil Co., 75 Main, Robert Griffin, mgr.

Oil, Oil Cake and Meal Mfr's.

Howard Oil Co., office 101 Congress, works Chaney Junction. See advt.
Southern Cotton Oil Co., ss Wash'n line So. Pac. Ry.

Omnibus and Baggage Transfer.

Baldwin J. C., propr Houston City transfer line, office 64 Main.

Opera House.

Pillot's Opera House, 54 Franklin, H Greenwall & Son, lessees; Ed. Bergman, business mgr.

Opticians.
(See also Jewelers.)

Conradi S., 67 Main. See advt.

Oysters, Fish and Game.

Artusy Eugene & Bro., 76 Travis, and stall 24 City Market. See advt.
Lang Charles, 30 Travis.
Lang John H., 30-32 Travis. See advt.
Mohr John B., 94 Travis and stalls 20-22 City Market.
Miller Joseph H., 44 Liberty road.
Williams George, 8 W. Preston

Oyster Saloons.
(See also Restaurants.)

Dawson Joseph, 115 Main.
Lang John H., 30-32 Travis. See advt.
Mathuly John, 305 Congress.

Painters.
(House, Sign and Ornamental.)

Baker Wm. H., junction Liberty ave, Eagle.
Lane & Dunn, 108 Main. See advt.
Pereira & Kilcullen, 106 Prairie. See advt.

Pereira & Randolph, 278-280 Preston cor Fannin.
Rottenstein F. S., 48 Fannin.

Paint Manuf'rs.

Pereira & Randolph, 278-280 Preston cor Fannin.

Paints, Oils, Painters' Supplies.

Bute James, 31-33 Main. See advt.
Pereira & Randolph, 278-280 Preston cor Fannin.

Paper Hangers.
(See also Painters.)

Baker Wm. H., junc. Liberty ave, Eagle.

Patterns.

Bentley A. Mrs., 81 Main. See advt.
Labuzan S. E. Mrs., 113 Main.

Pawn Brokers.

Charles Bente, 276 Preston.
Dunn Frank, 90 Congress. See back cover line.
Sweeney & Coombs, 66 Main.

Photographers.

Anderson Samuel, 85 Main.
Deane C. C., 306 Preston.
Roesberg G. F., 135 Congress.
Wright C. J., 82-84 Main cor Prairie.

Physicians and Surgeons.

Abrahams J. L., ne cor Main, Prairie.
Adair J. B., 112 Main.
Archer W. A., 32 Young's ave.
Arnold J. M., 27 Liberty ave.
Baker A. C., 77 San Felipe.
Beach L. L., 225 Washington.
Blake James H (Homeopathic), 86 Main.
Bonneau Edwin A., 41 Hardy.
Boyles J. M., house surgeon Houston Infirmary, nw cor 10th, Washington.
Boyles T. J., 64 Main.
Bryan L. A., 172 Rusk.
Burroughs & Autrey, 86 Main.
Castleton E. L. E., over 53 Main.
Coleman W. L., 281 Washington.
Cowling James, 257 Preston.
Daniel J. W., 90 Prairie.
Ellis & Chamberlin, specialists, sw cor Main, Congress.
Geutebruck F., 71 Congress.
Holland M. E. Miss, 288 Rusk.

Fig. 1 *Houston Business Directory,* 1887-88

[1]

Where Did You Find That One?

SOURCES FOR FINDING DEAD PHOTOGRAPHERS

David Haynes

The process of finding and gathering information about early photographers can be one of the most exhilarating or frustrating experiences that the photographic historian can go through. Happily, a little prior planning can smooth the road.

Most directory projects do not appear to start at the beginning. Over time you gather a little information about one photographer here, about another there, and pretty soon you have some material on a dozen or so isolated individuals. Next, it seems like it would be a terrific idea to try to collect all of the photographers who operated in a particular place. To do this effectively you need a plan and the following notes will help you formulate one.

Among the first things you must decide is your definition of the word "photographer." If the purpose of your project is to assemble a list that will help date images that have a photographer's name printed on the mount, you might be tempted to exclude the names of people who only worked for other photographers—operators, printers, colorists, and the like. However, given the fact that people tended to change occupations frequently in the nineteenth century, such exclusions are probably not wise. While you may find no direct evidence that such a person worked under his or her own name, there is no way to tell for sure. The effort required in recording these names is fairly small and the information may be very useful later on. An allied problem is whether to collect data on persons employed in related fields—photographic supply manufacturers and dealers, photoengravers, document copyists, and the like.

If you are more interested in social history, it is obviously not only important to record data about these marginal workers, but also necessary to try to find all the information you can about all your entries. What did your photographers do before and after photography? How did they fit, as individuals, in their time and place?

Another consideration is how you will record (and retrieve) your data. It is hard to imagine any directory project today that would not benefit from the application of computer technology. In addition to making it very easy to record basic data—who, where, when, source—modern data base managers allow for extensive notes, comments, and text. The major advantage of this type of program, however, is its ability to sort your data. With the touch of a few keys you can generate a copy of your list alphabetically by photographer's name, or by location, dates, sex, race, techniques used, or any other information you have entered. You could just as easily produce a list of photographers' street addresses in ascending or descending order if you wanted to.

The disadvantages of using a computer are that you have to spend time to learn how to use the program and you may have to write the data down before transferring it to computer. You also have to have a computer and the program. Modern programs are, by and large, user friendly and are not too difficult to master; but it does require time and patience. If you have a laptop available, you do not have to make notes in the library and then transfer them to the computer—you simply input on your laptop at the library. Many libraries have computers that patrons can use, and in some cases computers and their programs can be rented inexpensively. All in all, the advantages of using a computer over a notebook or card file far outweigh the disadvantages for all but the smallest projects.

Sources for data about photographers can be divided several ways. Historians would want you to consider the differences between primary sources—those created by or with the photographer—and secondary sources—those created by others after the fact. Researchers who have used a great variety of sources will tell you that printed sources are a lot easier to deal with than handwritten ones. Common sense would indicate that sources dealing with people

by occupation will be a lot more productive than those where an individual's occupation is incidental. The following is an attempt to discuss these sources in a logical manner.

First, there are a few rules.

1) You will never find all the photographers.

2) Generally speaking, the people who wrote the sources were not any more careful than we are today.

3) In the nineteenth century, few cared how anybody's name was spelled or whether the initials were correct.

4) Before 1870 many people listed as "artist" were really photographers.

5) In addition to daguerreotypist, ambrotypist, and tintypist, you also need to watch for "shadow catcher" and heaven only knows what else.

6) Make a note of all the information you find about a photographer, then you will not have to go back to get it later.

7) Carefully record the complete source of all information so you can go back when you violate rule 6.

Now to get started. The easiest way to begin is to accumulate as many names as quickly as possible. There are two different ways to do this, and the method you pick will depend on which resources are most available to you.

If you have a large collection, or collections, of early photographs readily at hand, you can spend a pleasant afternoon or two recording the names and addresses you find on the mounts. You should also record any date written on the mount, but most of these must be used with a great deal of care. In most cases it is impossible to know whether the date written on a photograph was put on it at the time the print was made, sometime later by people who owned the image, or even later by a helpful, but perhaps uninformed, librarian or collector. So, in your notes, you must specify what seems to be the provenance of any such date. No matter how knowledgeable you are, resist the temptation to assign a date to an image (and thus to the photographer who made it) based on the process, format, or costume depicted.

Another possible first step is to work with city and regional directories (Fig. 1). Before the universal appearance of the telephone around the turn of the century, the information provided by the phone book was supplied by city directories. In large cities these sources tended to appear around the middle of the nineteenth century. They were most often arranged like a phone book with an alphabetical listing of all residents in front and a classified business directory in the back. Work the business directory first, then read the alphabetical section. If you do not feel

Fig. 2 *Texas State Gazetteer, 1884-85*

that you have time to read the entire alphabetical section, at least look up each of the photographers you find in the business directory, because there is often additional information in this section. You also must check photographers who disappear from the business section in one directory in the alphabetical section of the next issue to see if they are really gone. Likewise, when a photographer appears for the first time in the business section, check for him or her in the alphabetical section of the previous issue. In Texas, at least, directories were issued for most cities biannually. City and university libraries in major cities usually have copies of the directories issued for that place. State libraries and major university libraries often hold city directories from throughout the state or region. Many of these directories are now on microfilm which can be borrowed by smaller libraries.

Regional and statewide directories are very similar to city directories except that both their alphabetical and business sections are normally organized geographically.

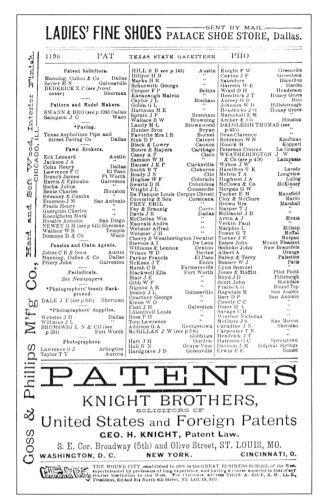

Fig. 3 *Texas State Gazetteer*, 1884-85

During the nineteenth century statewide directories in Texas were issued less frequently than biannually.

The advantages of using these directories include ease of use and ready availability, while their disadvantages stem from the facts that they only cover limited areas and times, the data at best was only collected annually, and sometimes limited to individuals who paid a fee.

These directories may be called "General Directory," "Business Directory," "Business Guide," "Gazetteer," "Railroad Guide," or some such, so it is important for you to ask your reference or local-history librarian for assistance (Figs. 2 and 3).

You will save a lot of time and probably considerable work if you discuss your project with as many librarians as possible. A good librarian will not only know likely sources to check for your area, but may also be able to put you in touch with other researchers who are doing similar projects. If someone in your area is working on another trade, cabinetmakers, for instance, it may be possible for the two of you to split the work and make notes for each other. Genealogical librarians can be particularly helpful because the majority of their patrons are looking for sources that list information about individuals.

Another step you can take is to let your colleagues and even acquaintances know what you are working on. Many people will tell you when they stumble across a reference to a photographer if they know you are interested.

Other local and regional publications that are worth a quick look are almanacs, mug books, and booster books. While none of these normally include business directories, each type offers certain possibilities. Early almanacs carried advertising, and sometimes photographs are represented. Mug books (publications composed of biographical sketches and pictures of prominent citizens) of a state or region, which are fairly common in the late nineteenth century, often include photographers and are usually indexed by name (or are alphabetical). Booster books, such as *The Industrial Advantages of Cornfield County*, often contain biographies of business leaders and almost always include the photographer who took the pictures in the book. The subjects of these sketches generally had to pay to be included, so these works are far from comprehensive. While the results of checking these sources are usually modest, so is the effort.

After you have followed either or both of these two strategies, you should have a pretty good beginning list of the photographers working in the area you are investigating. Now is the time to start the more difficult work.

Newspapers are a tremendous source for finding early photographers. You might read the word "tremendous" in the previous sentence to mean that all of the nineteenth-century newspapers for your area would make a pile miles high. Richard Rudisill read over 130,000 pages in 82 newspapers looking for photographers in New Mexico from 1854 to 1912. [1] In Texas there were more than 400 newspapers published between 1839 and the Civil War. [2] Many of these, of course, were published for a very short time and lots of issues have been lost; but, even so, there are still plenty around.

During the 1930s many early newspapers were indexed as a project supported by the Works Progress Administration. The indexes vary—some are only by name, some are only of editorial matter, some are of very limited scope. The original index is probably located in one of the major libraries of each state, but some local projects were done and the results may be in the local library— another good reason to talk to your librarian.

Fig. 4 Twelfth Census of the United States, Franklin County, Texas

Most early Texas newspapers are four or eight pages, so they are not difficult to read quickly. In many cases editors put new advertisements in a special column, and there is often a short editorial mention of new advertisers in the local news column. Some newspapers had an illustration of a daguerreotype case, or the like, that was printed as part of the photographer's ad. All of these factors make it easier to spot photographers in old newspapers. Since newspapers were, and are, printed on some of the worst paper known to man, most libraries are reluctant to let researchers use original copies if microfilm is available. Almost all microfilmed newspapers are reproduced two (or more) frames to the page, so it is much more difficult to read them in this form.

If your area is small or had few newspapers, it would certainly be worth the trouble to go through all available issues. A large or populous area, however, probably generated numerous papers. If there are too many papers for you to read them all, you should pick the most important papers and the time span when you have the fewest other sources and read those papers thoroughly, rather than just skipping around randomly. Such a procedure will maximize the results of your efforts.

Another source to consider is the national photographic press. S. D. Humphrey began publication of *The Daguerreian Journal* in 1850 and continued it as *Humphrey's Journal of Photography* until 1870. *The Photographic Art Journal*, edited by H. H. Snelling, appeared in 1851 and was absorbed by Charles A. Seely's *American Journal of Photography* (begun in 1852) in 1861. *The Philadelphia Photographer* was published from 1864 to 1888, and *The St. Louis Practical Photographer* (1877-1882) was followed by *The St. Louis Photographer* (later *The St. Louis and Canadian Photographer*) from 1883 to 1910. All of these publications were national in scope and published letters from and news notes about photographers from all over. Letters in early issues unfortunately are often signed just with initials, but some of your photographers are probably represented. Large libraries should have copies of these publications, either originals or microfilm.

OK, so you say you are tired of looking through easy-to-read printed sources. Boy, do I have a treat for you. In

many ways the most useful records for finding individuals associated with particular professions are the U.S. Census schedules (Fig. 4). This usefulness stems primarily from the fact that almost every person in the country is listed (even if only every ten years) and from the amount of data available for each individual. While the types of data vary somewhat with the decade involved, all the census entries during the period we are concerned with list the individual's name, age, race, sex, and birthplace, in addition to occupation. Some censuses list the value of a person's property, residential address (if in a city), parents' birthplaces, education, marital status, and the number of months not employed. Later censuses also record each individual's birth month and year and date of immigration (and immigration status) for the foreign born. The 1840 census is not very useful because only the name of the head of each family is listed, and actual occupations are not specified. For most states the 1890 schedules were destroyed by fire before they could be microfilmed, and the individual data no longer exists.

Before beginning to work with the actual census schedules, there are a couple of sources that you might want to check. After each census the government issues a printed report on the data. This report (usually called the compendium or the statistical view) lists a great number of statistics about the data gathered for that census.[3] Of most importance to the researcher are the tables that give the total number of individuals in each state by occupation. This tells you what you may expect. The compendium of the 1850 census, for instance, claims three daguerreotypists and seven artists in Texas (out of a total of 212,592). Does that mean you have to read about 21,260 entries to find each possible photographer? Well, yes. It gets better, though—for 1900 in Texas, you could expect to find a photographer every 4160 entries (733 photographers out of a total population of 3,048,710). In case you are interested, the other years break down as follows: 1860–one per 9906; 1870–one per 7442; 1880–one per 7999; and 1890–one per 5187.

Other sources you should know about before starting work on the census are the indexes that have already been prepared. Many of the early censuses have name indexes, primarily prepared to help genealogists. In addition to indexes that cover entire states, some county and local indexes exist. Some workers have actually published printed copies of local portions of various censuses. Ask your genealogical librarian before you start. These indexes can help you find the actual census entry for a known individual quickly, but you really do need to read the

whole thing.

In actual practice, reading a census is not too difficult. All of them are available on microfilm. The film can be used in a library or rented for home use. Basically you scan the "Occupation" column until you find an individual who meets your need, and then you record the data for that person (and household). Since the vast majority of people in most places during the period for which censuses are available (1910 is the last one that has been released) were farmers and farm laborers, you can quickly scan past occupations that begin with "F" and concentrate on the others (unless, of course, your enumerator lists "Fotographer"). Every now and then, you will want to stop and consider what some of these occupations were in the nineteenth century—stock broker or drug dealer, for instance. You might even find an old man whose occupation is listed as "Talks Politics."

Deciphering early penmanship (not to mention spelling) is only one of the joys of dealing with microfilmed manuscript records. The original document may be torn and folded over or repaired with tape that photographs black. The film may be underexposed, scratched, or variably out of focus. All you can do is try your best to record the data as accurately as possible. Then you can compare your findings against the list you have already created from printed sources. Many of your census "photographers" will not be on your list. Some will actually be photographers who did not make it into the printed sources, but most of them will actually be people who worked for other photographers—operators, printers, retouchers, framers, and the like. The chart below gives a sample of this difference.

PHOTOGRAPHERS FOUND IN SELECTED TEXAS CITIES IN 1900 BY SOURCE

CITY	CITY DIRECTORY	CENSUS	
		Compendium	Actually Found
Dallas	16	29	27
Fort Worth	10	14	16
Galveston	6	24	24
Houston	10	30	30
San Antonio	11	27	28

One of the things you will discover early on in working with the census is the difficulty in citing the records. Basically, for each census, each state or territory was divided into supervisory districts and each of these into enumeration districts. Each census taker began his or her enumeration district with page 1, household 1, family 1. When it was all done the individual sheets were bound into

volumes and every other page was rubber-stamped with a sequential number. When the originals were microfilmed each volume (or more commonly parts of two volumes) was filmed on one roll. Thus, to completely describe a page, you will have to record the state, the roll, the volume, the rubber-stamped number, the county, the division of the county, and the hand-written page number. Each entry on that page includes a household number, a family number, and a line number. The most parsimonious way to cite an individual entry is to use the state, roll, volume, rubber-stamped number, and line. The county and division within the county are normally also given.

In addition to the federal census, various states and localities have produced records that function the same way at various times and for various purposes, the "Great Registers" of California, for instance. Again, the easiest way to find out about these sources is to ask your librarian.

The next great body of manuscript records that you need to look at are tax records (Fig. 5). In 1862 the United States Congress passed an internal revenue act to help pay for the Civil War. Among many other things, this law required anyone who wished to produce photographs for sale (and almost anyone else in business) to obtain a license from the federal government. This provision went into effect August 1, 1862, and provided for a whole new bureaucracy to assess and collect the license fees. Fortunately, the act required these civil servants to record the name, occupation, location, payment, and term of each license issued. The great bulk of these records has survived—as a matter of fact, 8763 volumes measuring 933 linear feet. Unfortunately, not all of the records are microfilmed, and relatively few copies of the film have been distributed. The original records are housed in the National Archives in Washington, D.C., as part of the Records of the Internal Revenue Service in the Civil Reference Branch. Some original records are housed in the various National Archives Regional Branches around the country. The requirement for photographers to pay federal license fees was repealed in 1870 (effective date May 1, 1871), but these records still represent the best source for locating photographers during this period. Needless to say, the records are not helpful for photographers working in areas of the country not controlled by the federal government.

Again, these records are fairly easy to read. The occupation is shown in a separate column that can be quickly scanned. The Archives staff is very helpful; all you have to do is spend a couple of weeks in Washington. While the license assessment lists are the most important

records generated by the various tax statutes of the Civil War period, they are not the only ones. Federal law required photographers (and various other producers of paper goods) to purchase and affix revenue stamps to each piece produced from 1864 to 1866. Since the same stamps were used on a variety of products, however, the records do not indicate the occupation of the purchaser. At various times during this period, photographers (and other businessmen) were required to pay ad valorem or gross receipts taxes, and these records do provide additional information about individuals.

The following example will show you that using tax records is not always easy.

Where Does Your Tax Money Go?
In early 1977 I discovered that the National Archives Regional Branch in Fort Worth had several volumes of assessment lists for Texas that covered the period of the occupation tax on photographers. The archivist told me that while the archives had the records physically, they still belonged to the IRS and that he could not give me permission to look at them. An IRS employee at the Archives could not give me permission either and suggested that I write to the IRS in Austin (the office that had deposited the records) and request, under the Freedom of Information Act, permission to use them. I wrote such a request March 22. On March 30 that office wrote back and said that it had forwarded my request to Washington. After requesting two delays the IRS responded on June 28 denying my request. On July 12 I appealed the denial on various grounds. On August 10 the IRS acknowledged my appeal and promised a response by September 2. After four IRS requests for more time during the next three months, the Service finally granted my request on December 29 (nine months after my initial request). The records, by the way, do contain significant information that is not duplicated in Washington.

As you may have noticed, once someone invents a tax, other taxing entities are likely to give it a shot. One month after the federal government repealed the license requirement for photographers in 1870, the Texas legislature passed a similar tax. This tax was on the books well into the twentieth century, but the records indicate that it was only vigorously collected from 1871 to 1876. Once again, a large body of records was created and, by and large, saved. While some of these records still exist in county court-houses across the state, the majority are housed in the

QUARTERLY RETURN OF OCCUPATION TAX

Collected by *L. S. Ross* Sheriff and Collector of *McLennan* County, during the Quarter ending *30th* day of *September* 1874

No. of Receipt	From Whom Collected.	Nature of Occupation.	TIME FOR WHICH PAYMENT IS MADE.				STATE OCCUPATION TAX.		PRINTED TAX.		No. of Receipt	From Whom Collected.	Nature of Occupation.	TIME FOR WHICH PAYMENT IS MADE.				STATE OCCUPATION TAX.		PRINTED TAX.	
			Months.	Days.	No. of Performances.	Commencing.	Dollars.	Cents.	Dollars.	Cents.				Months.	Days.	No. of Performances.	Commencing.	Dollars.	Cents.	Dollars.	Cents.

Fig. 5 Quarterly Return of Occupation Tax, 1874, State of Texas

Archives Division of the State Library in Austin. Unfortunately, the occupation tax records are mixed in with an even larger quantity of other fiscal records (total of about 400 boxes) in the State Archives and are very time-consuming to use. Maybe your state imposed such a tax, and maybe the resulting records are more accessible. Ask your state archivist.

In recent years many local governmental entities, faced with an ever-increasing volume of paper and a fixed amount of space, have been forced to destroy old records that have relatively little value for the government. In many places, in fact, there is a formal plan to determine how long each type of record must be kept. Fortunately, for several decades, the Mormon Church in Salt Lake City has been quietly microfilming all sorts of local records of genealogical interest. If you know that some record existed at one time, but you cannot find it locally, check with the Saints.

If you are working on a small area and consequently have to deal with relatively few individual photographers, you can probably gather a great deal of interesting additional information about them from the local governmental records that have been kept. Land records (deeds, liens, and the like) and probate records are typically kept at the county level. All of these records are indexed by name and often give details about a person's life. Birth and death records may be kept by the city, county, and/or the state. In recent years many jurisdictions have decided that these records are not public and allow access only to family members. There are stories, however, that some researchers have gained access by claiming to be a descendant of the photographer. Death certificates are useful because they generally give a person's date of birth as well as death and sometimes record where the individual was buried. Cemetery records are normally kept by the cemetery or the organization that owns it; sometimes, however, the records for all or most of the cemeteries in a city are kept by a city agency. It is not unusual to find that a genealogical or local history society has already done some of your work for your and published some of these records or an index to them. Ask your local librarian.

Such indexes (and the WPA newspaper indexes and census indexes mentioned above) are finding aids. This type of source can be very useful to you, but to be prudent you should double-check the data in the original source if you can. There is a whole range of other secondary sources that you can now use to add to your list. Here is an example.

Who Told You That?

In 1938 Robert Taft published his classic study *Photography and the American Scene.* [5] At the time this was the most comprehensive study of photography in the United States. In many ways the same is true today. Taft was a

very careful researcher and documented all of his facts.

The only Texas photographer mentioned in the book is H. B. Hillyer "who began practice in Austin, Texas, in 1857..." A close reading of Taft's source, however, shows that Hillyer claims to have begun in 1857 and also that he worked for many years in Austin, but he does not claim to have started in that city. In actual fact he learned photography from his father in Goliad County in the mid-1850s and did not begin his career in Austin until after the Civil War.

The importance of checking the original source of statements in secondary works (no matter how well researched, written, and currently regarded) cannot be overemphasized.

One finding aid that exists for Texas and probably for other places is a published list of all printed pieces (that the compilers could find) produced in the state up to the mid-1870s.[6] The index includes an entry under "Photographers" that leads to an advertising broadside for three photographers in Austin in 1859.

Local histories exist for many cities and counties. These publications vary a great deal in accuracy, completeness, and usefulness. Some were very carefully prepared by writers who knew their subjects well and went to the extra trouble to index their work comprehensively; others, unfortunately, were quickly and carelessly thrown together and poorly indexed, if at all. Most of these books were created by or for historical societies, but some were prepared by the WPA, businesses, chambers of commerce, and similar organizations. If you find ones that are indexed, check the index for "Photography" as well as for photographers you believe might be covered. Read the acknowledgments to see if photo sources are listed, and check the cutlines under the illustrations to see if the photographer is credited.

Some state and local photographers' associations have issued histories, and these will obviously include a lot of information in our field, but most of these associations are relatively recent and will not have much on nineteenth-century photographers.[7]

Information on early photographers occasionally shows up in articles published by local and regional historical periodicals. These journals are usually well indexed, and the articles are well prepared and documented. Be sure to ask your local librarian for suggestions because there are lots of fairly obscure serials, particularly those devoted to genealogy.[8]

Every now and then a college student takes some aspect of history of photography as the topic for a thesis or dissertation. Check the indexes and abstracts of these papers published by University Microfilms in Ann Arbor to see if you can identify any that might be of interest to you. If you find any, your local library might be able to interlibrary-borrow copies for you to check.[9]

Finally, since you are holding this book in your hands, you will certainly want to check the following list for published works that cover your region or those adjacent to it. Good luck.

NOTES

1. Richard Rudisill, *Photographers of the New Mexico Territory, 1854-1912* (Santa Fe: Museum of New Mexico, 1973), p. iii.

2. The number 400 is an estimate based on the 101 newspapers reported in Thomas W. Streeter, *Bibliography of Texas, 1795-1845* (Cambridge: Harvard University Press, 1955-60) and the 347 titles from 1845 to 1861 listed in Marilyn McAdams Sibley, *Lone Stars and State Gazettes: Texas Newspapers before the Civil War* (College Station: Texas A&M University Press, 1983).

3. The full title of the report for 1880, for instance, is *Statistics of the Population of the United States at the Tenth Census (June 1, 1880), Embracing Tables of the Population of States, Counties, and Minor Civil Divisions, with Distinction of Race, Sex, Age, Nativity, and Occupations: Together with Summary Tables, Derived from Other Census Reports, relating to Newspapers and Periodicals; Public Schools and Illiteracy; the Dependent, Defective, and Delinquent Classes, Etc.* (Washington: Government Printing Office, 1883).

4. A Texas example is Ronald Vern Jackson, Gary Ronald Teeples, and David Schaefermeyer, eds., Texas 1850 Census Index (Bountiful, Utah: Accelerated Indexing Systems, 1976).

5. Robert Taft, *Photography and the American Scene* (New York: Macmillan, 1938). Dover Publications (New York) reprinted this work in 1964. Taft's source is a letter from Hillyer published in the *Philadelphia Photographer* (13:333) in 1876.

6. Ernest W. Winkler and Llerena Friend, eds., *Check List of Texas Imprints: 1846-1876*, 2 vols. (Austin: Texas State Historical Association, 1949-1963).

7. The history of the first seventy-five years of the Texas Professional Photographers Association was published as *The Diamond Years of Texas Photography* by Ava Crofford (Austin: Ava Crofford, 1975).

8. A Texas example is Wayne Daniel, "A Ragsdale Biography," *Fort Concho Report* 19, no. 2 (Summer 1987): 13-27.

9. William Russell Young, *H. B. Hillyer: Life and Career of a Nineteenth Century Texas Photographer* (MA Thesis, University of Texas, 1985).

Snyder Wolfe City, Texas.

Fig. 5 Cabinet card by Snyder of Wolfe City, Texas, c.1895.

Fig. 1 Lochman's last Carlisle studio located on Main Street on the Square. The building still stands. Taken by Lochman or A. A. Line, probably 1870-74.

Looking For Lochman:

RESEARCHING A HISTORICAL PHOTOGRAPHER

Linda A. Ries

In his pioneering work *Carte-de-Visite in Nineteenth Century Photography,* William Darrah outlines the large body of information that can be gained from studying a single image: "the photographer, its age, the photographic processes used and in the visual content of the image." It is a "unit, a document of the historic past." He concludes by calling for more research, as the "whole field of photographic documentation is still in its infancy."[1]

In Pennsylvania alone, there were thousands of photographers operating in the nineteenth century. Many of their surviving images presently languish in collections of historical societies, museums, and libraries, their subjects used occasionally to embellish a history text or exhibit. But as Darrah has stated, they can contain a wealth of additional information if one only takes time to look beyond the image itself. Just as an archaeologist uses artifacts to reconstruct a vanished culture, so, too, can the photograph historian recreate a social history from the study of collected images. But unlike the archaeologist examining cultures which often existed before the creation of written history, the photograph historian is blessed with many kinds of surviving records to help piece together the lives of early image makers. An integrated use of censuses, city directories, newspapers and other types of records can bring new "life" to a long-dead photographer, known only as a name on a daguerreotype, carte-de-visite or cabinet card. These tangential records can become the central focus of research, especially if personal letters, diaries, even the images, have not survived. Unfortunately, this appears to be the case with many historical photographers.

Charles L. Lochman, a commercial photographer operating in Carlisle in Cumberland County in the 1860s and 70s (Fig. 1) provides a good example of what can be accomplished through integrated use of historical records. Lochman was appreciated during his lifetime, as we shall see, but is unknown during ours. The immediate benefit of this approach was an evolving chronology of his professional life whereby his images could be dated with reasonable accuracy. Other historians, scholars and genealogists will find this a practical aid for their own studies. Similar research on other photographers around the world will collectively reap even greater benefits. Grouping such data will enable the photograph historian to deduce hitherto unseen patterns in their lives. What was the ratio of photographers and studios to a given population? What percentage were ethnic minority groups or women? From what social strata did they emerge? Such daunting questions are only beginning to be examined. Answers will provide new perspectives on how nineteenth–century folk perceived and valued photography. I take the reader on this odyssey in the hope that similar rewards may be reaped elsewhere. The process requires a lot of detective work, patience and a bit of luck.

My interest in Lochman began about two years ago when I gave a talk at a local historical society on early photographers in Harrisburg. I was asked afterward by a member of the audience if I could help date a Lochman photograph she brought with her. It was a vignetted carte-de-visite with the imprint "C. L. Lochman, artiste, Carlisle, PA." on the reverse. I made a rough guess of the early 1860s and suggested she try the Cumberland County Historical Society, located in Carlisle, for more information. I happened to know from previous visits to the society that Lochman's plates of the ruins of Chambersburg (burned by Rebel forces in 1864 [Fig. 2]) and other cartes-de-visite of his were there. Her request piqued my curiosity, and I decided to see if anyone knew anything more about him. They did not.

The Cumberland County Historical Society knew that Albert Allen Line had been Lochman's apprentice, but not much more. Their information was from Line's biographical statement in a 1905 county history, mentioning

Fig. 2 The ruins of Chambersburg in July 1864, by C. L. Lochman (half of a stereo plate).

"Doctor" C. L. Lochman, "one of the leading photographers of that day" with no further elaboration.[2] There were also carte-de-visite portraits of his in the Society's collection (Figs. 3 and 4), largely unidentified, but with a variety of different imprints on the reverse.

Given these facts, I decided to try the genealogical route and I began where all good genealogists begin, the federal decennial population census. I found a C. L. Lochman in Carlisle in 1860, and in Allentown in 1880 and 1900. The censuses 1840, 1850, 1870 and 1910 turned up nothing.[3] Those for 1880 and 1900 reported C. L. Lochman as a druggist and married with two children in Allentown, Lehigh County. I began to wonder if there weren't two Charles Lochmans.

I also tried Carlisle city directories; those at the historical society were sporadic, but able to show he was in that area between roughly 1859 and 1874. I knew if I could at least find his death date, I'd hopefully find his obituary in a local paper. Obituaries, of course, are rich sources for biographical and personal family information.

As the state of Pennsylvania did not keep birth and death records before 1906, I had to rely on whether or not the county in which he died kept such records. Not certain of the county, and possibly having two Charles Lochmans, I reviewed microfilm of county courthouse records to see if both Cumberland and Lehigh counties kept death registers. Neither did, but neighboring Northampton County had them. Luckily, one of these registers listed C. L. Lochman as having died on August 14, 1900. This immediately took me to the local newspaper, the *Bethlehem Globe*, which printed an obituary the following day, August 15 (Fig. 5). It was short, but revealed a wealth of new information. Though there was no mention of his Carlisle life, it satisfactorily proved that Lochman the photographer and Lochman the druggist were the same, with tantalizing leads to new areas. He married twice, and was survived by his second wife and two children, Charles and Alberta. He spent some time in Philadelphia. He was the author of a number of impressive-sounding books, including an 1873 translation of a German pharmacopeia, and an 1896 work of photographs of economically valuable native plant specimens. The obituary also confirmed something I had suspected, that he was the brother of Benjamin and William J. Lochman, all originally from Hamburg, Berks County, and all three photographers. William operated his business in Hamburg, and Benjamin operated his for over fifty years in Allentown.

I then began to examine the local newspapers, especially the *Carlisle Herald*. Newspaper research is time–consuming and often difficult, as most nineteenth–century papers are on microfilm and one has to check almost every edition in order not to miss something, but it was by far the most fruitful avenue of research. The census and city directories indicated he was in Carlisle probably between 1859 and 1874, so I simply began looking in this time period in hopes of finding something. His earliest advertisement appeared in the *Carlisle Herald* on June 8, 1859, giving not only his gallery location, but the exact date he placed the ad, fixing him in time and space.[4] Nineteenth–century newspaper ads almost always ran several months,

Fig. 3 Carte-de-visite of Ned Hastings and I. Cush dated October 1864. Imprint reads "C. L. Lochman, Artist, Main Street opposite Marion Hall, Carlisle, Pennsylvania."

Fig. 4 Carte-de-visite of an unidentified girl, no date. Imprint reads same as Figure 3. Note same chair and floor as Figure 3.

Fig. 5 Lochman's obituary in the *Bethlehem Globe*, August 15, 1900.

The First Premium,
FOR THE BEST PHOTOGRAPHS.

At the late Cumberland County Fair, has been awarded to

C. L. LOCHMAN.

MR. Lochman has the pleasure to announce to the public. that he has re-purchased his old room from Mr. M'Millan in Mrs. Neff's building, opposite the First National Bank, and guarantees that his

PHOTOGRAPHS,
CARTES DE VISITE,
AMBROTYPES, &c.

Have no superior, and in tone, finish and clearness, surpass most pictures produced. He gives his personal attention to the room, and with the best and most improved instruments and appliances warrants the finest results. A large assortment of Gilt and Rose wood Frames, and splendid Albums, for sale verp cheap. Copies of Daguerreotypes made in the most perfect manner.

Oct. 21, 1865.

Fig. 6 Lochman's advertisement in the *Carlisle Herald* October 21, 1865, announcing his first premium at the Cumberland County Fair, and that he has returned to his old gallery at 21 West Main Street.

C. L. LOCHMAN'S
First Premium

Photograph Gallery,

Market Square, East of Main St

CARLISLE, PA.

Removed from 21 West Main Street. to the gallery formerly occupied by J. C. Lesher, but entirely refitted and improved.

All the new styles of pictures made.

Duplicates from Lochman's or Lesher's negatives can be had at any time.

No.

A large lot of Frames constantly on hand and for sale low.

Fig. 7 Imprint used by Lochman while at 12 East Main Street, a stay of fourteen months.

C. L. LOCHMAN'S
First Premium
Ground-Floor Gallery.
No. 12 East Main St.,
Opposite Saxton's Store
CARLISLE, PA.

Duplicates can be had at any time.

Fig. 8 Lochman's imprint, probably used after March 1870 to around mid-1874, for the gallery in Figure 4.

sometimes as much as a year or longer. By following this ad and others, pinpointing when they were placed and when they disappeared, Lochman's movements could be traced. I am lucky in two respects, one, that the newspapers still survive, and two, that Lochman was a salesman who believed in the power of advertising, which he did heavily.

I therefore deduced the following: Lochman appeared in Carlisle at least by June 1859. From that time until 1862 he operated a photograph gallery above Imhoff's Grocery in downtown Carlisle. From 1862 to 1869 he was located at 21 West Main street opposite Marion Hall in downtown Carlisle (Fig. 6). Between 1865-1867 he was also in partnership with a George Bretz in Newville, about twelve miles northwest of Carlisle. Between March 1869 and May 1870, Lochman was located at 12 East Main Street; and finally between 1870 and 1874, on the town square (Figs. 7 and 8). He apparently left Carlisle sometime in 1874.

Lochman moved his gallery frequently as the newspapers revealed. Each time he moved, he changed the imprint in his images to reflect the new location. By comparing ads with imprints, a chronology of his photographs was established with reasonable accuracy (Table 1). His images can therefore be dated to within a few years and in some instances even less, as in the case of his 12 East Main Street location, a stay of about fourteen months.

The advertisements were not the only benefit from newspaper research. Most nineteen–century papers published columns citing local news, society information and gossip. Lochman's name was found here also, such as, local

reaction to the establishment of the Lochman & Bretz studio in the Newville paper, *Star of the Valley*. Locals were elated that they did not have to travel as far as Carlisle to have photographs made (Fig. 9).[5] I knew that photographers often competed at local fairs or festivals, so I made a point of checking the *Carlisle Herald*, which not only reported on the annual county fair, but between who won premiums and who was displaying what. I discovered that Lochman won prizes for best photographs in 1865, 1866, 1870 and 1873. In addition, the 1868 fair reported that he displayed fifteen cases of photographs, including views of the mountains around Mt. Holly Springs. I have no idea, of course, where these are today, or if they even survived, but it does indicate he was prolific.[6] Additional examination of society news revealed an 1870 feud between Lochman and a competitor, Henry P. Chapman, another photographer, who rented the gallery at 21 West Main Street shortly after Lochman vacated it in 1869. Chapman's advertisements implied that he had legally purchased Lochman's business, and was ready to receive his old customers. Lochman apparently had done no such thing, and stated so with a retaliatory notice in the *Herald*. This touched off sparks be-

PHOTOGRAPH GALLERY.—Messrs Lochman & Bretz are now prepared to take photograph likenesses at their new gallery on Main street, one door East of MILLER'S Drug Store. The gallery, the Artists and the apparatus are the best in the county, and henceforth, instead of our citizens going elsewhere to have pictures taken, persons elsewhere will come here for this purpose. So mote it be. Read the advertisement of Messers. L. & B., in another column. *

Fig. 9 Local news column in the Newville *Star of the Valley*, January 21, 1865, encouraging readers to visit the new Lochman & Bretz gallery.

tween the two during that spring and summer. At least weekly, and almost daily, one would place an item decrying the abilities of the other. The whole matter came to a head at the county fair that October, with the *Herald* reporting the judges' decision that the two men's entries were of such quality that they shared first premium. It should be noted that Lochman also took second place.[7] There are few jibes found in the *Herald* after this, and tempers seem to have cooled.

One line in the *Herald*'s county fair report for 1866 reported that Lochman also displayed a new type of writing ink, and one "liquor-saving funnel." This led me to postulate he may have been an inventor of sorts, and I began to investigate U.S. patents. The Patent Office in Washington, D.C., will search patents by name of inventor for $14.00 for each 10-year period specified. I had them search the name of Lochman for the years 1855-1875, and began a five-month wait. My hunch paid off. Between 1865 and 1874 he took out seven patents, including ones for a cork press, two types of funnels, two types of photograph frames for printing opaltypes (Fig. 10), inkstands, and a street lamp. So he was an inventor as well.

I then began examining the life of his partner, George Bretz, hoping to turn up something on Lochman. There was a biographical statement on Bretz in a Schuylkill County 1893 history, giving me the added information that Bretz was originally Lochman's apprentice before their partnership. Bretz went on to operate his own studio in Newville and later Pottville, Schuylkill County, where in the 1870s he made photographs of the Molly Maguire conspirators and was one of the first to make photographs inside a coal mine.[8] Also, a book had been published, *George Bretz: Photographer in the Mines*, mentioning Lochman in the introduction.[9] A chat with its helpful author, Tom Beck, led me to another source, a Bretz descendant, also named George Bretz, who generously shared with me the excerpts from his ancestor's diary relating to Charles Lochman. They were unfortunately cursory, as Bretz simply mentioned the dates and occasions Lochman photographed him, and entries for the important 1865-1867 period were missing. But even for these tidbits, I was grateful.

This established a good framework on Lochman's life in Carlisle, so I began investigating elsewhere. By now the reader is wondering if I attempted contacting Lochman's descendants by checking present-day telephone directories for the surname. I did. I was put in touch with Charles Lochman's great grandnephew, William, Who lives in Shillington near Reading. He is the great-grandson of

Fig. 10 Illustration for patent #59,800, a photographic printing frame by Lochman, November 20, 1866.

Lochman's brother William, the Hamburg photographer. He knew a bit about his great-grandfather, but next to nothing regarding Charles or the third brother, Benjamin. I also tried the biographical directory of photographers kept by the International Museum of Photography in Rochester, N.Y., with no results.

Additional research in genealogical files kept at the Cumberland County Historical Society provided details on Lochman's marriages, first to a Margaret Napier of Philadelphia, who bore him a son, Charles Napier Lochman. Margaret died in December 1867 and is buried in Carlisle Cemetery. In 1871 Lochman remarried, this time to Alice Weaver, who bore him a daughter, Alberta.

Realizing there was an information gap between 1822, his birth year, and 1859, I began examining newspapers in other cities, and came up with an item from the *Harrisburg Telegraph* in 1847, the earliest I have yet found. It revealed a great deal: he was a traveling daguerreotypist from Philadelphia, claiming to be a student of no less than Marcus Root, one of the earliest and best known of that city's photographers. Having established a Philadelphia connection, I started checking that city's directories and found him listed as a wholesale druggist at 402 North Third Street in 1858 and 1859, in co-partnership with a man

named John Seiberling.[10] Lochman's life after 1874 was spent in the Allentown/Bethlehem area where he engaged in a number of activities centering around photography and the drug business. In 1877-1878 he was listed in the Allentown city directory as a "druggist & chemist," with a "full assortment of pure drugs, chemicals & medicines, 'Lochman's Chemical Writing Fluid and Witch Hazel liniment.' "[11] His son Charles Napier Lochman apparently followed in his father's footsteps, being also listed in directories as a druggist for many years at the Simon Rau Drug Store in Bethlehem.[12]

Lochman's obituary mentioned a number of books he produced during the latter phase of his life, two of which I've been able to locate. They are presently the only known copies. One, the *German Pharmacopoeia*, is in the library of the Philadelphia College of Pharmacy & Science. The other, *Photographs of Medicinal, Economic and Interesting Plants from Natural Living Specimens*, is at the Academy of Natural Sciences in Philadelphia (Fig. 11). This book, a cyanotype proof copy, was inscribed by Lochman and donated by him to the Academy's library in 1896.[13] It contained an unexpected reward for my efforts, the only known photograph of Charles Lochman (Fig. 12).

At this point, at least a "skeleton" of Charles Lochman's life could be pieced together. He was born in 1822 in Hamburg, was in Philadelphia in the 1840s and studied photography under Marcus Root. He was also trained as a chemist. In 1847 he was an itinerant daguerreotypist passing through Harrisburg. In the 1850s he operated a drugstore in Philadelphia, marketing various products. In 1859 he moved with his wife to Carlisle, practicing photography at several different locations in Carlisle and Newville.

Fig. 11 Plate 9, "Dill" from *Photographs of Medicinal, Economic and Interesting Plants*.

He won prizes at local fairs, gaining the respect of the local populace. He was an inventor, taking out several patents, some relating to photography. About 1874 he moved his family to the Allentown/Bethlehem area where he engaged less in photography and more in the chemistry and drug business. His son followed in his father's footsteps and worked as a druggist. Lochman produced several publications relating to horticulture and drugs and died August 14, 1900.

The above information was disparate, obscure trivia until pieced together. Here was a nineteenth–century life, nearly forgotten, but reconstructed through bits and pieces of information culled from several institutions in Pennsylvania and elsewhere. It is possible to do this with other photographers, and I can only wonder how many of them languish in the same obscurity as Charles Lochman. The information is out there, waiting to be found.

As a postscript, I must add that William Darrah, who was interested in my research, was sent my published findings.[14] Shortly before his death the following May, I received the following from him which added an ironic twist to my odyssey:

> My big surprise, [from reading the article]...was Lochman's drug store on Main Street in Bethlehem a few doors above the Moravian Church. Not only did I know the store well, but knew Charles N. Lochman quite well. His daughter, Mrs. Walter Mitman, was my mother's closest friend and we were often in family gatherings when he was present... I never knew that CN's father was Lochman the photographer.[15]

In this way the historian himself was a resource, providing yet another lead to pursue.

I have continued my research, and with no particular end in sight, I discovered that no one really stops his research, just pauses occasionally to publish. My efforts to locate Lochman's immediate descendants continue to be fruitless, but I have found additional material on Lochman in eastern Pennsylvania and elsewhere. At Pattee Library of the Pennsylvania State University, I found the only known copy of a book of poems by Lochman, with the rather offbeat sounding title "Address for the Fiftieth Anniversary of an Odd Fellow's Lodge." At the Library Company of Philadelphia there is a broadside from the Lochman's drugstore in that city advertising "German Cattle Powder," a cure-all for various livestock diseases. A friend stumbled across and shared with me an incredible letter Lochman wrote to *Anthony's Photographic Bulletin* in 1890 encouraging use of the same lethal chemicals used by the "old

daguerreotypists" as a cure for tuberculosis![16]

It is important to realize that a lack of primary sources such as letters and diaries does not equate with a lack of research potential. Many seemingly disparate sources can together provide important insights, substituting for more traditional sources, and in some instances, take the scholar farther than traditional sources alone.

Who knows where my study of Lochman may end, if at all? More importantly, should it? Lochman was just one photographer and Darrah has stated "the photographer as an observer and historian is still a vague concept."[17] Researching Charles Lochman is an additional push toward understanding that concept.

NOTES

1. William C. Darrah, *Cartes-de-Visite in Nineteenth Century Photography*, (Gettysburg, PA., by the author: 1981), p. 199.

2. Line's collection of original glass plates, including those of the 1864 ruins of Chambersburg, are part of the Society's collection. Some of the very earliest plates are probably Lochman's, as Line was only twelve in 1864. *Biographical Annals of Cumberland County, Pennsylvania.* (Chicago: Genealogical Publishing Co., 1905), pp. 224-225.

3. The 1890 Population Census has survived only partially, due to a fire in the 1920s.

4. *Carlisle Herald,* June 8, 1859.

5. Newville Star of the Valley, January 21, 1865.

6. *Carlisle Herald* various issues, 1870; October 20, 1870.

7. Samuel T. Wiley and Henry W. Ruoff, *Biographical & Portrait Encyclopedia of Schuylkill Co., Pennsylvania,* (Philadelphia Rush, West & Co, 1893), pp. 561-562.

8. Tom Beck, *George Bretz: Photographer in the Mines,* (University of Maryland, Baltimore County Library, 1977).

9. *Harrisburg Telegraph,* January 10, 1847. Apparently Hamburg newspapers have not survived. *McElroy's Philadelphia City Directory,* 1858 and 1859 issues.

10. *Allentown City Directory,* 1877-1878.

11. Bethlehem city directories, 1880-1920.

12. The full title is *Photographs of Medicinal Economic and Interesting Plants from Natural Living Specimens, Indigenous and Introduced, Growing Without Protection in the United States.* It was part of a 1982 exhibit, "Philadelphia Naturalistic Photography," presented by the Yale University Art Gallery. The catalog of the exhibit incorrectly identifies Lochman's son Charles Napier Lochman as the author. Mary Panzer, prep., *Philadelphia Naturalistic Photography, 1865-1906,* Yale University Art Gallery, (New Haven, Conn., 1982), pp. 37-38.

13. "Charles Lochman, Cumberland County's 'First Premium' Photographer," *Cumberland County History,* Winter 1988.

14. William C. Darrah, personal letter to author, February 27, 1989.

15. Published by Charles L. Lochman, Bethlehem, PA., Manuscript collections, the Library Co. of Philadelphia; *Anthony's Photographic Bulletin,* December 13, 1890, p. 127.

16. Darrah, *Cartes-de-Visite,* p. 200.

TABLE I DATING LOCHMAN PHOTOGRAPHS

All dates are approximations of Lochman's studio locations in Carlisle and Newville obtained from following his advertisements in the *Carlisle Herald* and Newville *Star of the Valley.* Quoted information from verso of Lochman photographs.

June 1859 -November 1862	"C. L. Lochman, Artist, Carlisle, Pa."
November 1862 -January 1865	"C. L. Lochman, Artist, Main Street opposite Marion Hall, Carlisle, Penn."
January 1865 -February 1867	"Lochman and Bretz, Artists, Newville, PA."
January 1865 -October 1865	"J. McMillen (successor to C.L. Lochman) 21 W. Main St., Carlisle."
October 1865 -March 1869	"From C. L. Lochman's First Premium Photograph Gallery, Main St. Opposite Marion Hall, Carlisle, Penna." or "C. L. Lochman's First Premium Photograph Gallery, No. 21 West Main St., opposite the First National Bank, Carlisle, PA."
March 1869 -May 1870	"C. L. Lochman's First Premium Ground Floor Gallery, No. 12 East Main St. opposite Saxton's Store, Carlisle, PA."
May 1870 around July 1874	"C. L. Lochman's First Premium Photograph Gallery, Market Square, East Main Street, Carlisle, PA removed from 21 W. Main Street to the Gallery formerly occupied by J. C. Lesher."
After July 1874	"R. H. Buttorff (successor to C. L. Lochman) S. E. Corner Market Square and Main St., Carlisle, PA."

Compiled by Linda A. Ries Pennsylvania State Archives 9/88

Fig. 12 Inside front cover of *Photographs of Medicinal Economic and Interesting Plants,*
the only known portrait of Lochman.

Fig. 1 Watkins' traveling wagon at Monterey, c. 1876–78.

[3]

California Photographers:
A PERSONAL ACCOUNT OF REGIONALISM IN PRACTICE
Peter E. Palmquist

I became involved in the study of California photographers quite by accident. In the spring of 1971 I went into a small antique store not far from my home and was asked: "What do you collect?" "Nothing," I said, but the proprietor persisted. "What do you do for a living?" "I am a photographer," I replied. A few minutes later she presented me with a double handful of carte-de-visite and cabinet card portraits with the comment: "These will get you started." Later, I was astonished to find that each photograph included the photographer's name and that they were all from my local area. Moreover, I had never heard of any of them. From this tiny nucleus of images, I have acquired—over a period of 20 years—a collection in excess of 100,000 photographs. Each of these has been keyed to my listing of some 10,000 photographers (and related trades within the photographic industry) who were active in California photography before 1910.

In the beginning I did not have a clue as to how or where to begin my study of local photographers. I had never conducted research, nor had I received any training in the systematic study of historical artifacts, nor did I know anyone who had. Over the intervening two decades that I have studied the photographers of California, I have made mistakes, missed opportunities, and struggled to find the ways and means of recording their lives and works. Many of my methods are homegrown and most lack the stamp of approval of "Better Academics Everywhere."

The following account traces my techniques and experiences studying one region's photographic heritage. I break my research methods into three broad categories: assemble—evaluate—disseminate.

ASSEMBLE

Assembly, for me, means the process of gathering together the resources that will enable me to investigate the existence of photographers within my sphere of study. This includes gathering photographs, researching public records, and systematically reviewing the literature of the past.

I have read (i.e. scanned for notices, comments, etc.) nearly every newspaper published in California before 1865, and for some counties, every newspaper before 1920. Each census from 1850-1920 has been searched for possible members of the photographic trade. I am also an avid reader of any and all photography-related publications. In California this includes *The Pacific Coast Photographer (1892-1894)* and *Camera Craft (1900-1942)*; both published in San Francisco.

To this has been added a national search of photographic periodicals, where frequently I will find mention of California photographers as early as the 1850s. Particularly useful are "paid-in" biographical mentions and sketches of prominent citizens often found in the local and county histories which were popular in the late 19th and early 20th century.

Because I lack formal training in the proper use of library keys and techniques, I have compensated by becoming a browser. When open stacks are available, I will often browse each book on every shelf looking for potential ideas and information. Consequently, I have found numerous useful items which could not have been found using standard library data bases. Also, such browsing has often led to new avenues of investigation that would not have occurred to me otherwise.

While I am certain that many of my colleagues also use these same data-gathering techniques, I believe that I am unusual in at least two areas: first, that I record anyone involved in almost any aspect of the photography industry. This means gallery clerks, retouchers, and photo-printers, as well as gallery owners; Kodak sales people and those involved in photo-lithography; likewise, advanced amateur photographers, camera-club members, and fine-art (or salon) participants. I even record those who can be

shown to have worked in the photographic optics industry or photographic product production generally. (I will include a motion-picture projectionist but not a "photo-play" actor, for example.)

The second aspect, which is probably unusual, is that I value any type of information whether it relates directly to photography or not, so long as it can be tied to the life of someone who once worked in California photography. In practice this means that I try to document an individual's entire life, even if they only spent a brief time in California or in the photographic trade. I am especially interested in those photographers who, unlike Ansel Adams, failed to achieve prominence in their own lifetimes, as well as the role of women in the photographic industry (which ran to at least 20% of the trade by 1910).

My data–collecting methods are simple (perhaps "archaic" is a better word). Whenever possible I try to obtain a physical copy (xerox, for example) of the entire page or document where information is found. This reference copy is marked with the source citation and filed in a standard 9-by-12 manila folder under the photographer's name. I have never been very successful in making citation file cards and I have enjoyed having the collateral information available. (For instance, a page with a photographer's advertisement may also contain advertisements for other local businesses and situations which enable me to better understand the sociology of the era in question.)

Where possible, these pages are arranged chronologi-

Fig. 2 Advertisements for stereo daguerreotypes from San Francisco newspapers.

cally in each photographer's folder. In instances where a single page may contain references to more than one photographer, the page is xeroxed as many times as there are different individuals. My single best investment for photographic research has been a xerox copier and I make at least 50,000 copies per annum. I also like to make xerox copies (front and rear) of all original photographs and other illustrations and file these reproductions along with my basic biographical files. Likewise, when studying a specific photographer, I will xerox any and all references to that photographer from standard sources and add them to the file.

I began to collect original photographs largely because I found that in order to illustrate an article it could cost several hundred dollars when illustrations had to be purchased from historical agencies such as the California Historical Society. I discovered that this same money easily brought me large numbers of original photographs which I could use without institutional restrictions. My only criterion for acquiring original photographs (aside from their cost) is that they be maker-marked or otherwise linked to a California photographer. A major emphasis has been placed on the collection of California stereographs. Because stereographs are a published form of photography, they enable me to study trends in marketing, etc. I have about 10,000 California–subject stereographs representing over 500 different photographers, publishers and/or distributors, and it is probably the best such study collection available anywhere.

In my opinion there is no substitute for an opportunity to examine original artifacts directly, not only for the obvious information they contain, but also for the more subtle awareness such handling provides—something I often refer to as finding "the fingerprints of the artist."

In addition to the aforementioned resources, I have produced a staggering number of copy negatives and prints over the years. This production is an ongoing facet of my research. One technique, which I use whenever possible in data gathering, is a hand-held 35mm camera with which I make snapshots of all kinds of field data. I use Tri-X film, employ available light and a lens which will focus down to about two inches. I take photos of all accession information, the object itself (front, back and any special details), and even "shoot" some of my own hand-written notes. In one case, where I was using card-access files, I made more than 700 negatives in a four-hour period. (To have done this note-taking by hand would have required weeks.) I have used these 700 negatives hundreds of times during the ten or more years since they were taken. Each negative

H. H. HALSEY, DUTH FLAT, CAL.

Fig. 3
Carte-de-visite
portrait by
H. H. Halsey,
Dutch Flat,
California,
c. 1870.

Fig. 4
Carte-de-visite
backmark of
Wells & Lady,
California Art
Gallery, Alturas,
California,
c. 1870.

is also filed under the photographer's name and is seldom actually printed; instead, I often use a loupe to read the data thereon. When prints are needed, I use outdated printing paper which I "quickprint," which is to say that I do not make any attempt toward "archival" processing, etc. These prints receive only a brief rinse and are hung up to dry after which a xerox copy is made and the photo-print discarded.

I strongly recommend the hand-held camera for note taking. Usually, however, I have to convince an archive attendant that my procedure is both quiet and non-damaging to their collections. Another concern is that I might have made a "reproducible" negative and they will have lost control of its use. Basically you need to negotiate the use of a camera, but the results are well worth the effort.

With the exception of xeroxing, I treat my original photographs with the utmost respect. Each is archivally sleeved in transparent mylar. I absolutely recommend clear sleeves so that the artifact may be viewed without taking it out of its protective cover. I also store my photographs flat rather than on end. (Stereographs, however, because of the curved cards, are stored vertically.) I find this is essential in order to keep them in good condition. Each photographer is identified by a notation written on the edge of 2-ply archival board (and visible when the drop-front is opened) which is used to separate each photographer. I also use the 2-ply board where needed to stabilize the photographs themselves. Case art and tintypes, etc., are stored in their own section. I use drop-front boxes in two basic sizes: 8-by-10 (for all photographs up to that size) and 11-by-14

(for photographs of intermediate size). I also use oversize boxes when needed. My photographers are further divided into those active before 1900 and those active after 1900.

Copy negatives are made on a regular basis; first, for all images of recognized importance, and then as part of the ongoing publication process. I make my 4-by-5 negatives on a process camera; 35mm negatives are often made for less critical needs.

I also maintain a specific archive of images relating to my home county (Humboldt County, California) to which I add resources dating from the present day. My "greater California" photographers are collected mainly before 1940. In addition, I collect writings by or about California photographers.

I make every effort to obtain reproductions of important illustrations as I go along rather than at the end of a research project. Thus, when the research is finished, I can move directly into a publishing mode without the hassle of trying to obtain illustrations (often a lengthy and frustrating task) at the end of the project.

Finally, it is essential to have basic reference tools such as books and periodicals relating to the field. Because I am nearly 300 miles from a major library, I have felt compelled to assemble my own reference library. I subscribe to most journals in the field and have made the collection of out-of-print periodicals a priority. Many of these long-ago periodicals are invaluable, both for the information they contain and as sources of illustrations for ongoing work.

The most basic part of evaluating historical evidence is to determine "fields of study" as well as to create consistent access to these fields. In my case, everything is filed "by photographer." My vertical files are arranged by photographer as are my collected photographs. Even my reference library is organized, wherever possible, in patterns that reflect my major areas of interest.

My techniques for evaluating the data collected is based on a mixture of traditional and common sense approaches; review the literature, summarize the assembled data, examine and record information found on collected artifacts, etc.

The first major task is to establish the full name of the photographer or subject. Proper name spelling is frequently a problem since primary sources often contain blunders of amazing proportions. Until I am fully satisfied that I have correctly established the subject's name, I retain all name and spelling variants. Not surprisingly, one of the biggest challenges is deciphering the handwriting of census takers. Determining occupation can also be a problem. In the 1910 census, for instance, almost anyone connected with the photography industry was called a "photographer" even though other evidence clearly indicated that they worked as a photo-finisher, or in some other behind-the-scenes occupation.

Once a name has been established, I try to follow the subject through the census, directories, photographic journals and newspapers. Although reading miles of newsprint is difficult and time consuming it is one of the very best resources for evaluating the life activities of a photographer. In one case I noticed that there seemed to be a gap in a certain photographer's production. This puzzle was solved by finding that the photographer had been involved in a serious buggy accident and had been unable to work for a period of nearly a year. Newspapers (especially the gossip columns) also provide first-hand information about the photographer's family (if any) as well as serving as an excellent record of his or her advertising habits.

Over the years I have come to treat photographic partnerships as separate items, so that "Smith," "Jones," and "Smith & Jones" are considered three different entities. Certain other topical fields are also maintained, such as the "California Camera Club" or the "San Francisco Photographic Salons," etc. Women in the history of photography is another interest and one which I research on an international front in addition to those whose activities were limited to California.

The second major task—once a sizeable body of

Fig. 5 Advertisement for G. Ambrose, *Sacramento City Directory* (1850s).

material has been assembled—is to create a chronology of the photographer's life. I find this an essential step on the road to understanding a photographer's life. With a completed chronology in hand, it is easy to identify areas requiring further research. Much of my work consists of arranging tiny bits of information, no small amount of which may be contradictory.

In some cases it takes dozens of bits of circumstantial tidbits combined to indicate a fact. My work on Carleton E. Watkins brings this process home. The San Francisco earthquake and fire not only destroyed Watkins' gallery and archive of photographs; it also destroyed the business and personal records of a lifetime. As a consequence of this great loss of primary resources, I have tried to encircle rather than begin my research in the center of things (i.e. San Francisco). Major pieces of the Watkins puzzle were found as far away as Vermont and smaller pieces were found in well over 200 different locations in America and several in Europe. Although I first began work on Watkins in the early 1970s, I am still finding elements and "missing links" to what is best described as "a complex biographical maze."

Mostly I have resisted the impulse to "attribute" photographs to a photographer on the basis of pictorial style alone. I usually resort to this method only after having

collected or examined large numbers of vintage prints over a period of years. Some traits, however, are almost impossible to ignore. One photographer virtually always left a bit of untrimmed area on the edges of his photographic prints. The kicker was that each print was untrimmed on three of the four edges; never four, two or one. When I say that I have avoided dating and attribution on stylistic considerations, this does not mean that I have not looked for possible commonalities of studio backdrop, posing chair, patterns in studio floor tile, etc., with an eye to linking unknown work to identified examples from a known studio.

One of my better traits, which has served me well in evaluating photographs, is that I have spent over 35 years as a professional photographer. As a consequence, I am accustomed to handling photographic images and also have very strong ideas of how a photographer actually works. I believe I am one of only a handful of historians of photography who has been employed in the trade. Because I have lived a photographer's life, I am much more inclined to document the commonplace rather than limit my search to the so–called "masterpiece" examples of a photographer's output. My contention that Watkins was first and foremost a "commercial photographer" is a case in point.

I have sometimes been asked to compare the role of the photographic historian with that of an *art* historian. My glib answer is that the art historian "builds the pyramid of knowledge from the point down" while the photographic historian "builds from the ground up." I feel that the art historian approach has done a considerable amount of disservice to photographic history due to the lack of basic documentation across the field. An example may be made of a well-known art historian who contended that Watkins' New Series work represented a decline in his artistic vision. Obviously this critic had seen little in the way of Watkins' New Series, or he would never have arrived at this hasty conclusion. I suggest that the careful "building-block" traits of the photographic historian will establish a body of resources that will enable the art historian to do a better job as well.

One element of the evaluation process that cannot be overlooked is the need to invest many years in the process. There is no substitute for a lifetime spent in regional study. Over and over again, I have been able to use previous research as an aid to understanding ongoing projects. This is especially true of California because of its immense geographical size and the large number of photographers who have worked within its borders. Even the idea of "borders" requires revision since nearly every photogra-

Fig. 6 Photographer's manuscript identification and dated tax stamp on reverse of carte-de-visite, July 20, 1865, J. G. Smith, Vallejo, California.

pher who worked in 19th-century Nevada also spent some part of his career in California. Likewise, due to economic situations, there have been specific linkages between California photographers and the gold rushes of British Columbia and Australia, to say nothing of the natural connection between California and Hawaii. Nor can we stop here, since virtually every directory of photographers that has been published around the world contains at least one individual who also worked in California.

Note–taking is an essential part of evaluation. I confess to a number of "sins of omission" during my early attempts at recording data. For instance, I assumed that I would always remember where I found each biographical or chronological tidbit, only to find that 20 years later I haven't a clue as to its origin. The message: record the source immediately and directly on every collected document. Over the years I have lost precious time trying to recover unrecorded (or carelessly recorded) source information. While I would be the first to admit that computer filing would be a perfect solution to data management for the study of photographers, it has not worked for me. The problem stems from the fact that I began gathering data well before computers were readily available (try entering twenty years' worth of information after the fact) and affordable. I have neither financial resources nor the aptitude to enable me to move wholeheartedly into the computer age. I do, however use a computer to write but not to file-and-sort, etc. The consequences are that I do most searching by hand. Perhaps one day . . . ?

Graphic evidence of my overall drive and compulsion for collecting and preserving information is shown by the fact that I also collect myself. I maintain my own "brag books" of clippings and activities which are bound in hardcover and shelved along with my collected research

Fig. 7 Carte-de-visite backmark of
J.C. Kemp's Celebrated Great Flying
Photograph Gallery, c. 1870.

Fig. 8 Advertisement from *Overland Monthly*,
February, 1883.

notes and writings (all bound as hardcover books with gold lettering on the spine). Collectively, these form what I call the "Palmquist *Cal-Photo*" series; each volume is unique in the world.

DISSEMINATE

What is the point of knowing things if you cannot share this information with others? I believe strongly in the need to share information and in the need for dissemination of new research. To this end I try to publish whenever and wherever possible.

In the beginning, I had data but no way to share it. My first four articles were written by others, with myself as the resource. It was quickly evident that I could not continue this awkward arrangement. The problem was that I had never written anything. Undaunted, I decided to try, and wrote my first two books in longhand. I used to roll the manuscript up, unrolling it whenever I needed to cut-and-paste new information. Then (and now) I did not know a participle from a Mack Truck!

Eventually, I learned to type and purchased a "correcting" typewriter, yet the writing process remained exceedingly painful, especially since I still needed to compose in handwriting first. In 1984 I obtained an early CPM computer which I used for word processing. Today, I can compose directly on the computer screen, but the writing process is still far from easy.

Over the years I have published some 27 books (depending on how you count books) and more than 250 articles on the history of California photography. You would be surprised how many people think that I have made a "fortune" because I have completed books. The truth of the matter is that I have never made a penny by publishing. Mostly I have supported myself by doing photography and picture research for other authors. Picture books are very expensive to produce and seldom make money anyway. My experiences with *Carleton E. Watkins: Photographer of the American West* (1983) is typical. I was paid $5,000 to write the text for the book, but spent some $10,000 on the research alone. I did not receive any royalties from this book; nor have I ever received a royalty check.

The truth of the matter is that it is very hard to convince a publisher to undertake a book on photographic history unless it is written from a popular viewpoint. Worse, the process of tailoring a book for a commercial or university press is onerous and daunting. Having gone through this process many times, I am unwilling to do so again. Stubbornly, I now research, write, design, pasteup, advertise and distribute my own publications. I make small quantities and do my best to sell them to libraries and colleagues so that the money spent for printing can be returned for use in the next project. I do not recommend this process for others.

The idea of publishing electronically has been suggested to me on many occasions. So far I have resisted

because I am an independent researcher and have only my publications to document my rights of authorship. Although I do not know what will happen in the future, I have seen far too many instances where information from all sorts of sources (including myself) have been puddled together without credit. After I have established my authorship, however, I will be much more inclined to consider electronic distribution in the future.

There are also major questions as to how a researcher should report data. One has only to look at the already published checklists and directories of regional photographers to see the wide range of reporting techniques. Many listings are strictly limited to name, place and date. Most only deal with photographers and ignore all of the related occupations. My tendency, right or wrong, is to record nearly everything (see, for instance, my *Shadowcatchers: A Directory of Women in California Photography before 1901 (1990)*. In fact, my preliminary estimate suggests that it would require a book of about 50,000 pages to accommodate my assembled information on California photographers active before 1910.

Writing and publishing have not been my only avenues of distribution for my research. Lectures, exhibitions, and a wide variety of other activities have enabled me to reach a wide spectrum of the public. I often give a workshop called, "How to Care for Family Photographs," which is an outreach that pleases me very much. I have also been happy to assist others in their research. This is a two-way street and I have benefited from the help of others in every arena of my work.

EPILOGUE

While preparing for this essay, I found myself looking into a rear-view mirror and using a hindsight which is now entering its third decade. It is an interesting image and one that I could never have foreseen in that spring of 1971. Over the years I have worked along on projects which seemed appropriate and timely yet lacked anything resembling a carefully planned or cohesive *career* in photographic history. I have often doubted my priorities or wondered whether I could have done better; or even if I should leave the field to others far more qualified for this line of work. For a time I wanted to return to school in hope of obtaining the many advantages of a scholar's union card; American Studies, perhaps. Despite these concerns I always plunged ahead.

From the beginning, I kept a running "laundry list" of my activities in the field of photographic history. After 20 years this listing has reached a total of 34 pages. As an exercise for this paper, I extracted the projects relating specifically to Watkins and also those relating specifically to Women. I was startled to find that there were so many. I have listed them in a two-part Appendix at the end of this essay so the reader will see how often my major themes have been revisited again and again over the years. As I mentioned earlier, I am a strong believer in the idea that effective photographic history requires a lengthy, even lifetime, commitment.

Reflecting on my laundry list, I think I discern a pathway which has been wending its way slowly yet apparently upward. No brilliance here, only an obsessive "staying of course" toward a broader understanding of the California photographers of the past—all dead now.

Perhaps I really am an historian. If so, it would not be hard to argue that I am in truth preparing a place for myself—perhaps remembering my own 35 years as a professional photographer—a niche in the fabric of our times, past, present and future.

J. PITCHER SPOONER,
KIDD'S BLOCK,
STOCKTON, CAL.

Fig. 9 Carte-de-visite backmark of J. Pitcher Spooner, Stockton, California, c. 1875.

APPENDIX

I. Activities undertaken in connection with my ongoing research into the life and work of photographer Carleton Eugene Watkins (1829-1916); arranged in descending chronological order:

[Article] "From Babies to Landscapes 1856-1858," *The Daguerreian Annual 1991*. Arcata, CA: The Daguerreian Society, 1991. Chapter #4 of a serialized biography.

[Article] "Shadowcatching in El Dorado 1849-1856," *The Daguerreian Annual 1990*. Arcata, CA: The Daguerreian Society, 1990. Chapter #3 of a serialized biography

[Article] "Carleton E. Watkins: Portfolio and Technical Notes," *View Camera* (January/February 1990).

[Lecture] "Carleton E. Watkins: Photographer of the American West," California State University, Chancellor's Summer Arts Program (July 17, 1989).

[Lecture] "Carleton E. Watkins: Photographer of the American West," Art History Seminar, Art Dept., Humboldt State University, Arcata, CA (March 16, 1989).

[Book] *Carleton E. Watkins, Photographs 1861-1874*. San Francisco: Fraenkel Gallery in association with Bedford Arts Publishers, 1989. Served as consultant; wrote essay on Watkins.

[Lecture] "Carleton E. Watkins: Photographer of the American West," California State University, Chancellor's Summer Arts Program (July 26, 1988).

[Article] "California! 1851-1854," *The Photographic Historian* (Winter 1987-1988). Chapter #2 of a serialized biography.

[Article] "Oneonta, New York 1829-1851," *The Photographic Historian* (Winter 1987-1988). Chapter #1 of a serialized biography.

[Article] " 'It is as Hot as H—': Carleton E. Watkins' Photographic Excursion Through Southern Arizona, 1880," *The Journal of Arizona History* (Winter 1987).

[Lecture] "Watkins" Stereographs on Glass," 1985 National Stereoscopic Association Convention, St. Louis (August 16, 1985).

[Lecture] "Carleton E. Watkins: Photographer of the American West," Humanities Department, San Francisco State University, San Francisco, CA (March 27, 1985).

[Participant] "Carleton E. Watkins: Down in the Mine," round-table discussion, Montana Committee for the Humanities and the University of Idaho, Moscow, ID (1985).

[Lecture] "Carleton E. Watkins: Photographer of the American West," Department of Journalism, The University of Texas at Austin, (November 6, 1984.)

[Article] "Carleton E. Watkins: 'Prince of Photographers,' " *The Indian Trader* (February 1984).

[Lecture] "Carleton E. Watkins: Photographer of the American West," The Oakland Museum and the California Historical Society, Oakland, CA (February 4, 1984).

[Article] "Carleton E. Watkins: Photographer of the American West," *The Museum of California Journal* (November/December 1983).

[Exhibition notes] *Carleton E. Watkins, Master of the Grand View*. Sacramento, CA: Galvin Gallery, August 4-September 13, 1983.

[Lecture] "Carleton E. Watkins— His Life and Works," Galvin Galleries, Sacramento, CA (August 26, 1983).

[Lecture] "Carleton E. Watkins, Master Landscape Photographer," Art Department, Humboldt State University, Arcata, CA (May 11, 1983).

[Interview] "The Carleton E. Watkins Exhibition," television interview, CBS Morning News, Columbia Broadcasting System, NY (April 2, 1983).

[Lecture] "What Price Success? Watkins' Life and Works," Watkins Symposium, Amon Carter Museum, Fort Worth, TX (April 2, 1983). Keynote address in connection with the opening of the Watkins traveling exhibition in Texas.

[Lecture] "Carleton E. Watkins: Photographer of the American West," California Museum of Photography, Riverside, CA (March 29, 1983).

[Book] *Carleton E. Watkins: Photographer of the American West*, Albuquerque, NM: Published for the Amon Carter Museum by the University of New Mexico Press, 1983. Catalogue to accompany a year-long traveling exhibition of the same name.

[Exhibition] "Carleton E. Watkins: Photographer of the American West," (a one-year traveling exhibit), Amon Carter Museum, Fort Worth, TX (April 1-May 22, 1983); Museum of Fine Arts, Boston, MA (June 15-August 14, 1983); The St. Louis Art Museum, St. Louis, MO (September 15-October 30, 1983); and the Oakland Museum, Oakland, CA (December 16, 1983-February 19, 1984).

[Article] "Watkins' New Series Stereographs" (a series of three articles), *The Photographic Collector* (Part I—Winter 1982/1983; Part II—Spring 1983; and Part III—Summer 1983).

[Article] "Carleton E. Watkins: Master of the Grand View," *The Rangefinder* (June 1983).

[Article] "Views to Order", *Portfolio Magazine* (March/April 1983).

[Article] "Watkins' E-Series: The Columbia River Gorge and Yellowstone Stereographs," *Stereo World* (March/April 1983).

[Article] "Carleton E. Watkins at Work (A Pictorial Inventory of Equipment and Landscape Technique Used by Watkins in the American West 1854-1900)," *History of Photography* (London), October 1982.

[Lecture] "Dating the Stereographs of C.E. Watkins," annual convention, the National Stereoscopic Association, San Jose, CA (August 7, 1982).

[Article] "Taber Reprints of Watkins' Mammoth Plates," *The Photographic Collector* (Summer 1982).

[Article] "Carleton E. Watkins' Oldest Surviving Landscape Photograph," *History of Photography* (London) (July 1981).

[Article] "Carleton E. Watkins: A Checklist of Surviving Photographically-Illustrated Books and Albums," *The Photographic Collector* (Spring 1981).

[Consultant] *Light in the West: Photography and the American Frontier 1850-1890*, documentary film, Blackwood Production, Inc., NY (1980-1981). Served as the special consultant on Watkins.

[Article] *Carleton E. Watkins—What Price Success?*, The American West (July/August 1980).

[Consultant] "Watkins Photographs in the Hearst Mining Building," The Bancroft Library, University of California, Berkeley, CA (1970-1980). Made reproductions of priceless original Watkins photographs so that the original images could be retired to archives.

[Article] "Watkins—The Photographer as Publisher," California History (Fall 1978). 22

II. Activities which I have undertaken in connection with my study of Women in the history of photography; arranged in descending chronological order:

[Book] *Shadowcatchers II: A Directory of Women in California Photography 1900-1920*. Arcata, CA: published by the author, 1991.

[Exhibition] "Shadowcatchers: California Women Photographers, 1850-1920," Grace Hudson Museum, Ukiah, CA (November 14, 1990-April 7, 1991).

[Article] "A Gallery of California's lady Shadowcatchers," *The Californians* (November/December 1990).

[Article] "Miss L.M. Ayers: A Photographer 'Out of the Ordinary,' "*The Humboldt Historian* (May-June 1990).

[Video Tape] *Shadowcatchers: Women in California Photography before 1901*, (video pilot), Chico State University, Chico, CA (May 4, 1990).

[Lecture] "Shadowcatchers: Women in California Photography before 1901," Solano Junior College, Fairfield, CA: (May 3, 1990).

[Book] *A Bibliography of Writings by and about Women in Photography 1850-1950*. Arcata, CA: published by the author, 1990.

[Catalogue] *Elizabeth Fleischmann: Pioneer X-Ray Photographer*. Berkeley, CA: Judah L. Magnes Museum, 1990.

[Book] *Shadowcatchers I: A Directory of Women in California Photography before 1901*. Arcata, CA: published by the author, 1990.

[Lecture] "Mrs. Withington in Stereo," regional meeting, national Stereoscopic Association, San Jose, CA (January 13, 1990).

[Checklist] "Women in Photography: Selected Readings," *Photography in the West #2*. Manhattan, KS: Sunflower University Press, 1989. 23

[Lecture] "History of Women Photographers in America and California," conference, Women in Photography: Past and Present, 1989 International Women in Photography Exhibition, Pacific Grove Art Center, Pacific Grove, CA (November 17, 1989).

[Lecture] "Women in Photography: A Survey 1839-1989," University of Kansas, Manhattan, KS (October 26, 1989).

[Book] *Camera Fiends & Kodak Girls: Writings by and about Women Photographers 1840-1930*. New York: Midmarch Arts Press, 1989.

[Lecture] "Photographs in Petticoats: A Survey of Women Photographers in California before 1901," California Museum of Photography, University of California, Riverside, CA (May 4, 1989).

[Article] "19th Century California Women Photographers, in, Yesterday and Tomorrow: California Women Artists." New York: Midmarch Arts Press, 1989.

[Lecture] "Women in California Photography Before 1901," Art History Seminar, Art Department, Humboldt State University, Arcata, CA (May 2, 1989).

[Lecture] "The History of Women in Photography," Women in the 80's Forum, Humboldt State University, Arcata, CA (March 21, 1988).

[Exhibition] "Emma B. Freeman: With Nature's Children," Sutter County Community Memorial Museum, Yuba City, CA (January-March 1988).

[Article] "The Indomitable Abbie Cardozo," in, *Photography in the West #1*. Manhattan, KS: Sunflower University Press, 1987.

[Exhibition] "Emma B. Freeman: With Nature's Children," Grace Hudson Museum, Ukiah, CA (June-September 1987).

[Workshop] "The History of Women in Photography," Art Department, Humboldt State University, Arcata, CA (April 3, 1987).

[Lecture] "The History of Women in Photography," Public Forum sponsored by Humboldt State University, Arcata, CA (April 3, 1987). 24

[Lecture] "Women's Work: Photographs of Daily Life 1850-1920," Humboldt County Historical Society, Eureka, CA (March 10, 1987).

[Lecture] "The Romantic Eye: Emma B. Freeman's Northern California Series," Lighthouse Art Gallery, Crescent City, CA (January 17, 1987).

[Exhibition] "Emma B. Freeman," Lighthouse Art Gallery, Crescent City, CA (January 1987).

[Lecture] "Women Photographers in California: The Search Continues," First Women in Photography Symposium, Syracuse University, Syracuse, NY (October 10-12, 1986).

[Exhibition] "Louise E. Halsey: An American Pictorialist," Reese Bullen Gallery, Humboldt State University, Arcata, CA: (January 10-30, 1985).

[Catalogue] "Louise E. Halsey: An American Pictorialist." Arcata, CA: Humboldt State University, 1985).

[Lecture] "Women in Photography—The First One Hundred Years," Art Department, Humboldt State University, Arcata, CA (May 11, 1984).

[Lecture] "California Women in Photography, 1850-World War I," Women in California History, 37th California History Institute, The Holt-Atherton Pacific Center for Western Studies, University of the Pacific, Stockton, CA (April 13-14, 1984).

[Exhibition] "Emma B. Freeman Photographs," Clarke Memorial Museum, Eureka, CA (March 6-12, 1983).

[Article] "Stereo Artist Mrs. E.W. Withington; or, 'How I use My Skirt for a Darktent,' " *Stereo World* (November/December 1983).

[Consultant] *Into the Shadows: The Emma Freeman Story*, student film project, KEET-TV and Humboldt State University, Arcata, CA (1982).

[Article] "Photographers in Petticoats," *Journal of the West* (April 1982).

[Consultant] Carol Olwell, *Women of the West*. St. George, UT: Antelope Island Press, 1982.

[Checklist] "California Nineteenth Century Women Photographers," *The Photographic Collector* (Fall 1980).

[Consultant] Searles R. Boynton, *The Painter Lady, Grace Carpenter* Hudson. Eureka, CA: Interface California Corporation, 1978. Grace was also a photographer.

[Exhibition] "With Nature's Children—The Photographs of Emma B. Freeman," Humboldt Federal Savings Bank, Eureka, CA (February 1978) and McKinleyville, CA (March 1978).

[Consultant] *The Women (Old West Series)*. Arlington, VA: Time/Life Books, 1977.

[Exhibition] "With Nature's Children by Emma B. Freeman," International Center of Photography, New York City (March 18-April 17, 1977).

[Exhibition] "With Nature's Children: Emma B. Freeman," The Nautilus Gallery, Arcata, CA (March 5-24, 1977).

[Book] *With Nature's Children: Emma B. Freeman—Camera and Brush*. Eureka, CA: Interface California Corporation, 1977.

Fig. 10 Carte-de-visite self-portrait of E. A. Kusel of
Oroville, California, c. 1862.

Fig. 1 Mathienet Houbard, d'Outre-Meuse, self-portrait, daguerreotype.

[4]

Regional Photographic History in Europe
A REVIEW OF METHODOLOGY AND SOURCES

Steven F. Joseph

What approach? And which sources? The study of history has been satirized as a "crazed preoccupation with the chattels and strays of the past." History has also been likened to an echo chamber where we confront the past. The fact remains that when we, the researchers, recreate history, we are breathing our own life into it; our perceptions, our personality, our philosophic bent.

There are many ways of approaching the history of photography, all of which can give an honourable framework to our field of research. Three complementary approaches which are commonly applied include: the art historical, the technological, and the societal or broadly cultural.

Those who employ the art-historical approach tend to describe the achievements of photography as a medium, photography qua visual art, a vehicle for visual or pictorial self–expression. This approach takes over much of the methodology and the conceptual framework of mainstream art history. There is the aesthetic analysis, the bestowing of the accolade of "Master" on outstanding practitioners, and the study of oeuvres and "schools." There is a rich seam of photographic history which easily lends itself to this approach—Pictorialism, as a movement, springs readily to mind. The art-historical approach has also been a god-send to the auction houses ever since early photography became a "collectible" in the early 1970s. A handful of monographs existed to guide collectors down the path of big–name hunting but the "roll call" has changed very little over the past 20 years.

The second approach is the technological. Here the researcher attempts to set out the development of photography from a technical point of view. A descriptive methodology is strong, and the chronological flow, which it imposes, is often seen as the traditional duty of the historian. Eder, among photo-historians of past generations, is the strongest proponent of this approach.[1] As with the art-

historical approach, the technological approach may be modified and reapplied, as I will attempt to demonstrate below.

The societal approach is in many ways, the most appropriate for regional research of the type many of us have been undertaking. By "societal" I mean that photography is treated as a phenomenon, and analysed within the context of the shaping forces in society and culture. By emphasizing primary source material this approach can be dynamic and stimulating in charting the reception, growth and expansion of the role of photography. This, however, should be done within the context of the various parallel or global developments in technology, culture, arts or society. I believe that the societal approach is the most promising for researchers attempting to reconstruct an overall picture of the development of photography as a practice and a profession against the background of the complex changes which were underway in the industrial and economic systems of 19th–century Europe. The dangers of the societal approach is that it may be highjacked in the name of ideology. This produces a programmed slant and creates an intellectual superstructure which may obscure more than enlighten, being extraneous to the subject matter it claims to clarify.

I emphasize at the outset that all approaches are equally valid, providing that the fundamental duty of the historian is to respect the primary sources. In fact, the expansion of knowledge in the history of photography has been such in the 1970s and 1980s that there has inevitably been a breaking down of pre-existing schemas or presentations. Gernsheim[2] and Newhall,[3] while still the standard works, have come under assault for parochialism, bias or slackness. In this situation, no single approach is universally valid; none has the monopoly on truth; all have their part to play. This is why I would like to take up the debate in the context of regional research which I and others are

undertaking in Europe and to suggest a conceptual model for exploiting aspects, if not unifying, all three approaches.

Let us return to photography as technology. At its purest, this approach will be analytic and quite dry. It discounts all argument as to whether photography is science or an art. Such considerations are treated as irrelevant, photography being simply one technology amongst many. The reductionalist approach works within its self–imposed limits because photography brings together all the necessary factors: a combination of basic scientific principles which use a process to create a product - the durable image of objects in the camera by the action of light on a sensitive surface. Photography is the result of the association of two basic components. On the one hand there is the principle of optics (known in western Europe since the Middle Ages) whereby the projection of an external image can be made onto the ground glass at the back of the camera obscura. This is the principle behind the formation of the image. On the other hand there is the chemical component, the application of light-sensitive emulsions to a stable support. This is the principle behind making the impression and fixing the image.

The technological approach relies a great deal on the use of dates in order to reveal the technological timetable behind an invention. Thus, 1839 is the date in which an absolute novelty was revealed to the world—in layman's language an invention—the first achievement of this combination of process and product. Yet the same date witnessed the simultaneous announcement of two significant and co-existing variants - the daguerreotype and the pre-calotype. Whereas the daguerreotype as a direct positive on a metal plate which also constituted the final product, the pre-calotype (commonly but confusingly known as photogenic drawing by the inventor himself) reposed on an intermediate product—the paper negative—to create a quasi infinite number of final products, or positive images.

The technological method might start with the invention, but this is only the first of a succession of significant dates. The individual contributions of Niepce, Daguerre and Talbot, however meritorious they were, were just the rather crude beginnings of a series of modifications and improvements which mark the progress of the new technology. Thus in 1841, Goddard and others were able to increase the light-sensitivity of emulsions by the use of accelerators. In 1851, Archer successfully substituted a transparent surface—glass —with the appropriate support—wet collodion. By 1871, Maddox had replaced dry plates for wet. In 1884, emulsions were first applied to a flexible support—celluloid, and in 1888, Eastman introduced the portable roll-film camera.

The technological approach runs one invention smoothly into the next, as if only the moment of invention counted. However, the approach cannot exist in isolation. For instance, much was said in 1839, but very little actually invented. Niepce had obtained his first image some 12 years before, Talbot four years before, and Daguerre had almost certainly not improved on the results he had been achieving 18 months or two years previously. Obviously, 1839 is not particularly a milestone in the technology of photography, but rather in its socialisation.

Let me define my term. For me, socialisation is simply the process whereby a technological invention is taken up by society, acts on it and interacts with it. The process takes place within a specific cultural and geographical context, and the acceptance of the invention is governed by a set of variables, factors which differ in their impact from place to place. It is for this reason that I wish to use the example of Belgium (a western European state newly created in 1830), a constitutional monarchy sandwiched between France and Germany. In the period under discussion, Belgium relied heavily on external trade, and, especially after 1870, underwent the deep cultural change which is labelled the industrial revolution.

Whatever the geographical context, no invention can begin the process of socialisation unless two basics have been achieved. Firstly, the invention must have attained a minimum viability, such as accuracy, reliability, security of use. Secondly, the invention has to respond to a well-defined need. Important innovations have to come in their own time and only when there is this fertile combination of perceived need and technical feasibility.

Still using the technological approach, but broadening it to include the concept of socialisation, I will not attempt to uncover the timetable of socialisation as it is revealed by my own regional research. It is important to emphasize that the timetable of socialisation is not identical to the technology timetable I spoke of before. While the technology timetable deals with invention and process as the primary data for analysis, the timetable of socialisation shifts the emphasis more towards the needs of the market place.

The model which I use was first developed by the French technology historian François Russo.[4] In this model, the timetable of socialisation is divided into a limited number of periods or phases, each with specific characteristics. This base is not on a general societal or cultural theory, but on the delimited applicability of empirical data. Each phase may be supported by a case study of a person, process or phenomenon fully representative of it.

The First Phase in the socialisation of a new technology is the experimental or laboratory phase. This is the period in which the inventor or his representative hopes to market the invention, without, at the same time, fulfilling the two necessary preconditions of viability and market need. It will be recalled that Daguerre met up with great societal resistance when he tried to sell shares in his invention in 1838. Societal resistance manifested itself in a different form when the daguerreotype was put on public display in 1839; the public's enthusiasm was dampened by the lack of colour, the lengthy exposure time and the fragility of the product. In Belgium, the first phase of socialisation lasted from the announcement of the invention of photography in January 1839 to the spring of 1842.

The figure who best characterises this phase in Belgium is the printer, lithographer, journalist and polemicist Jean-Baptiste Jobard.[5] While not exactly a representative of Daguerre, he had several meetings with him in Paris that year, and purchased a camera from Isadore Niepce, son of the inventor. On 17 September 1839, he was able to announce in the columns of his own newspaper that he had succeeded in taking the first photograph in Belgium—a 7-minute exposure from the window of his Brussels town house.

Jobard announced that he had set up a company, the Sociètè belge du daguerreotype, and that "the firm...will send on site artists versed in selecting the most suitable viewpoints for monuments, mansions or factories or machines to be copied, while awaiting (the possibility) of portraits from life."[6] But Jobard's initiative was virtually stillborn. It was not that he had failed to grasp the potentialities of the new technology; rather that it had not yet attained viability.

Later on in the year, when Jobard had time to take the full measure of the new process, he also—somewhat optimistically—foresaw the application of photography to the printing press: "We announce that before another six months have passed [he wrote], Daguerreotype plates will be engraved for print-runs of thousands."[7] He was wrong of course, but it should be remembered that like many of the pioneers of the new medium, he was a lithographer by training. His predilection for photography, like Niepce's motivation for inventing it, came from a search for a technical aid to the graphic arts, a means of raising productivity by replicating hand-made objects (lithographs and engravings) in block printing. The printing press would indeed provide a major application for photography—but not yet. Jobard's fate was typical of many such precursors in that he was defeated by a new and untried technology.

In the end, the slow acting emulsion and limited aperture lenses were sufficient to preclude the possibility of his achieving commercial success.

By the time the Second Phase of socialisation occurred, Jobard was out of the running. This second phase can be defined as a period when the invention has not yet been taken up, but financial incentives and the assistance of entrepreneurs willing to shoulder the risk of commercialisation, enable the invention to become truly viable. Commercialisation now becomes a possibility.

In Belgium, the onset of this phase can be dated precisely to the second week of March 1842, when all of the financial and technological factors finally fell into place with the opening of the first two portrait studios in Brussels.[8] In portraiture, photography found or created the well-defined consumer need prerequisite for its success. The technical viability was secured to a great extent by the entrepreneur Richard Beard when he engaged a professional chemist named John Frederick Goddard to speed up the exposure times. By the winter of 1840 Beard had succeeded by employing a combined mixture of bromine and iodine as an accelerating agent. He also bankrolled the development of photographic apparatus at a reasonable price.

While Beard could not patent photography per se, he acquired rights on a series of modifications and improvements which constituted a new production process. He took out the first Belgian patents on 23 February 1841 for "an improved apparatus for transferring drawings and natural objects to metallic surfaces prepared by an improved process." The improved process consisted of the use of bromine and iodine in equal parts. The improved layout of the studio also contributed.

A year after taking out his Belgian patent, Beard announced:

> Photographic portrait establishment of the Royal Polytechnic Institution of London, and at the Bazar Pantechnique, near the Park in Brussels. The photographic process for making portraits is an improvement of Monsieur Daguerre's method. Mr. Richard Beard has just obtained a patent for Belgium. Portraits taken by this method require several seconds exposure only and possess a softness and a delicacy which can only be obtained by the process of Monsieur Daguerre.[9]

Beard's operator soon faced competition from the brothers Brand in Brussels, and from Vanmalderen in Liège. It is not known how long the Beard studio operated but the small format of the plate which the Wolcott mirror

PORTRAITS AU DAGUERRÉOTYPE,
A 4 francs et au-dessus,
SUIVANT LES DIFFÉRENTES DIMENSIONS DE
PLAQUES.

MM. MATHIEU et HOUBARD,
ARTISTE DAGUERRIENS,

Rue Portes-aux-Oies, n° 14, Outre-Meuse.

Reproduction de tableaux, de gravures, de groupes de famille, portraits et modèles pour peinture, chacun a le droit de choisir sur plusieurs épreuves.

Fig. 2 Studio label on back of a framed quarter-plate daguerreotype, Liège, about 1847. This type of printed matter is a particularly valuable source of information on the earliest years of photography.

camera was capable of holding must have finally told against him. Beard never managed to institute in Belgium the franchising system which had been so successful in England. A risk-taker by nature, he was ultimately to bankrupt himself. At least Beard had demonstrated the commercial possibilities of the new technology, but it was left to others to see photography through the next phase.

This Third Phase may be summed up as the period when invention becomes innovation. It is the beginning of socialisation proper. The technology was now being exploited and demand for it began to grow. In Belgium, phase three lasted about 15 years—from 1845 (when the first permanent portrait studios were operational) until about 1860. During this time, the practice of photography (concentrated almost exclusively in the hands of professionals) was characterised by two distinct methods of exploitation. In the larger centres of population—Brussels the capital, Liège, Antwerp and Ghent—permanent portrait studios were erected. Outlying districts and smaller towns were served by short-stay itinerant photographers who would usually operate in a hotel courtyard or garden. The town of Tournai is a case in point.[10] Traveling daguerreotypists were recorded as visiting the town in 1843 (M. Guyard from Paris), 1844 (Messrs. Guyard and Housselot), 1848 (Edouard) followed by a certain Dondez "Professeur de daguerreotype" periodically between 1852-

1857. The first permanent professional photographer in Tournai, Louis Duchatel, began operating in 1855. During this phase, sources of biographical information and studio practice are virtually confined to the daily press (advertisements and short articles) and the publici y information printed on the mounts or backs of the photographs themselves (Figs. 1 and 2).

In Phase Three of the socialisation process photography cannot yet be considered as economically significant. A handful of full-time practitioners, supplemented by their traveling colleagues, had little economic impact. Thus, in the Belgian population census of 1856 (the first time that photography is mentioned), the term "photographer" is not autonomous but subsumed into a miscellaneous list annexed to the printing trade, which included "playing cards, cardboard, wax and signets, pencil manufactures, illuminators, photographers, manufacturers of printers' ink, fount makers, type and other engravers."

The small number of patents taken out in Belgium confirms the negligible impact of photography during Phase Three. The analysis of patents is an indispensable task in the armoury of the technology historian (Fig. 3) and the aggregate data can be used in constructing the model of socialisation. We see that in the 1840s only nine patents were issued in the area, rising to 55 in the 1850s. There is a clear jump in the 1860s to a level of between 10 and 20 per year, figures which were constant well into the 1880s. The origin of individual patents can also reveal the evolution of technology transfer between countries. As we might expect, about 90% of patents are of foreign origin, showing Belgium as a "consumer" rather than "initiator" of technology, and dependent on other countries throughout the 19th century. Thirdly, the diffusion of know-how can be inferred from the rate of transfer of patent rights to third parties (the number of transfer rights is the second figure on the top of each column). This is central to the theme of acquiring, managing and exploiting new technology. We

Fig. 3 Photography patents in Belgium during the 19th century. Aggregated figures of registered patents by decade are followed by the total number of licenses granted for commercialisation by third parties.

Year	BXL	LIEGE	ANT	GHENT	OTH	TOT
1854	8	-	-	-	-	8
1860-61	23	2	5	-	-	36
1868	49	12	12	5	36	127
1873	41	20	17	14	47	139
1878	45	17	16	16	55	149
1882-83	58	20	20	17	60	175
1888	72	21	25	20	89	227

Fig. 4 Photographic studios in Belgium. Aggregates of listings in trade directories. The omission of listings for towns other than Brussels up to 1860 is particularly striking. Abbreviations: BXL = Brussels; ANT = Antwerp; OTH = Other; TOT = Total.

Fig. 5 Professional photographers in Belgium up to 1910. Published aggregate data based on unpublished census returns.

see that in the 1840s and 1850s no such transfers were made in Belgium. Photographic technology began to be used by individuals other than the patentee in a modest way in the 1860s.

The rise in the number of patents and the application of transfer rights takes us into the 1860s and Phase Four of the socialisation process. Sources in the form of printed matter, notably trade directories (Fig. 4), as well as manuscript material such as census returns (Fig. 5) and population registers also became more abundant. It is in Phase Four that society began to accustom itself to the new technology. In Belgium, the sudden take–off of photography originated in 1860 and continued for about 30 years. There is enough quantitative as well as qualitative data for us to be quite certain as to the starting date. Quantitatively, we have the census returns: from an estimated 38 persons who exercised the profession of photographer in 1856, the number had risen in 1866 to 256—in other words, a jump of 670%. Qualitatively, we have the testimony of contemporary observers. As an example, let me quote a journalist, introducing a report on the construction of a new portrait studio in Brussels in 1864:

> Ten years ago, photography was scarcely known here; only Daguerre's system was in vogue and astonished many people. Today portraits on metal plates are quite out of fashion; men of progress have put their minds to it and, aided by chemistry, have managed to reproduce on paper portraits which can be preserved indefinitely. Progress has not stopped there: to be convinced, you need only consider the number of photographic establishments founded in Brussels alone in the past few years; this is the best proof of vitality in this industrial branch. [11]

A wood engraving depicts the portrait studio run by Charles D'Hoy in Ghent about 1865 (Fig. 6). The trappings—the chair, the headrest, the skylight—are all standardised. To these have been added sophisticated accessories: instead of the plain white sheet, the subject could pose before a painted backdrop with balustrade (seen on the right) or alongside a stucco mock–Louis XV fireplace and mirror. The main point here is how formulaic this became; accessories as well as the machine on the floor with the dividing back for taking four simultaneous carte-de-visite portraits.

Another phenomenon typical of professional photography during this phase is geographic clustering. In Belgium, the capital city was the pole of attraction. During the period 1860 to 1890, between 30% and 40% of all portrait photographers in Belgium were to be found in a relatively small area of Brussels. These figures are taken from trade directories and fully emphasise the point. In 1860, Brussels had 23 out of 36 studios in the country. By 1868, this had risen to 49 out of 127. While there was a shake-out in the next decade in Brussels, the major cities of Liège, Antwerp and Ghent come nowhere near to catching up. Toward the end of Phase Three, in 1888, Brussels still had three times as many studios as Antwerp —72 to 25. Seen per head of population, the position of Brussels is just as predominant: in 1866, there was one photographer for every 6,000 inhabitants in the capital (the average for the country as a whole was 1 in 19,000). The density ratio of 1:6,000 was not reached in Liege and Antwerp until the mid-1890s, and by the country as a whole only after the turn of the century. Brussels, with its concentration of wealth, was therefore the natural environment for what was still very much a luxury commodity.

Fig. 6 Interior of portrait studio run by Charles D'Hoy in Ghent. Wood engraving taken from *Traite de photographie* by Desire Van Monckhoven, 1865 (5th ed.).

The Fifth Phase of socialisation is that of the quantitative leap. The technology experiences a wide social and geographic diffusion, and is clearly accepted within the context of everyday life. In Belgium, this point was reached about 1890. At that time professional photographers began to open studios in working–class suburbs and in the countryside. In parallel, the penetration of the activity in the population at large reached new levels, thanks to the successful marketing by George Eastman of Kodak cameras and film. The 1890s saw the formation of local amateur groups, but this also led to a fragmentation of attitudes. The last unified photographic exhibition in Belgium—equipment and images of all sorts—took place in 1891. Thereafter equipment could only be seen at industrial fairs, and exhibitions were either for all-comers or a self-selected Pictorialist elite. During the Fifth Phase, photography had still to reach a saturation point. After the consolidation which took place by 1870 the number of professionals doubled more or less every 15 years in the country as a whole. Brabant, the province of the Brussels region, housed half of the country's professionals. That is, until the beginning of Phase Five in 1890 when, due to a greater geo-graphic and social penetration, Brabant retreats by 10 or 15 percentage points.

Another characteristic of the Fifth Stage of the socialisation process is the broadening of applications. Photography began to be applied to areas of human endeavour other than that for which it was originally conceived. In the mid-1890s the two major inventions to incorporate the photographic technology were cinematography and Roentgen's X-rays. The take–up of both applications was much more rapid than for photography itself, due in part to the transformation in transport, communications and economic structures which had taken place in the previous 50 years.

Within the photographic branch itself, industrialisation meant the division of labour and a move away from artisan-dominated structures (Fig. 7). Here we are given an insight into the operations of J. Malvaux of Brussels a photographic printer whose main business was supplying line and half-tone blocks to illustrated magazines in the 1890s and early 1900s. The production process for photoblocks or plates had now been streamlined into discrete functions, each conducted by personnel specialising in a particular task.

The process began in the studio with copy camera (top left) where the objects to be reproduced were photographed onto glass plates of the required size. The negatives were then contact printed onto coated zinc plates (bottom middle) in artificial light. In the top right hand corner we see the plates being etched in an acid bath. They then get passed on (bottom right) for retouching and mounting before the blocks are finally used for printing (bottom left). Photography in this significant application had been mechanised. The man behind the camera is only one skilled operator on a long process line. Socialisation was virtually complete when on the one hand photography became integrated in the media of daily newspapers and popular magazines, and, on the other had emerged as a mass market requiring large scale industrial production of cameras and continuous production of chemicals. I abandon my analytical model of the socialisation process in photography at the dawn of the 20th century, as the technology gears up to a Sixth Phase—universality.

One of the prime problems which any historical researcher needs to address is the accuracy of the information on which hypotheses are to be built. It is an obvious lesson but one which needs to be reiterated. It is very easy for ingenious theories and sophisticated methodologies to be nullified by slap-dash research—a model with feet of clay. When a discipline is relatively young (as is the history of photography), it is doubly important that the gathering of information should be beyond reproach. I would therefore like to review in brief some primary information sources for documenting the history of photography which are perhaps still under-exploited in Europe.

Printed sources are highly diverse. At the basic level of bibliography many tasks remain. For instance, the specialist photographic periodical press in the 19th century is rich in data not just about processes but also the dynamics of the interaction between practitioners of photography and society at large. Alongside bibliographies of manuals and handbooks, in-depth analysis of these sources can offer insights as to how the state-of-the-art was perceived at a particular moment, i.e. the diffusion of technical knowledge in the sector. Handbooks are particularly useful because they tend to concentrate not on advancing innovative technology, but rather, on the practice of technology in everyday use. "Embedded" sources can also be of great interest. Throughout the period in question, the press remains a major source for the regional historian. Despite the relative inaccessibility of most of the material in newspapers, which are seldom indexed, the time-consuming task of systematically reviewing bound collections page by page will be rewarded by the discovery of information available nowhere else. Before the specialist press developed in the 1850s and 1860s, writing on photography also appeared in learned and scientific journals. The location and analysis of these embedded sources are rewarded by insights into techniques and processes, and also—to refer once more to socialisation—plot geographical spread and the social and intellectual networks by which the new knowledge spread to practitioners.

Innovation is a social process and due weight needs to be given to how theory and practice were affected by the milieux—professional, intellectual and scientific bodies—which accommodated them. Highly useful, in this context, are the membership lists of the Association belge de Photographie, printed annually in the society's journal. They give an unique insight as to the social status of amateurs as well as successive addresses of individual practitioners.

I have already mentioned the use of patents as a key manuscript source. In most countries abstracts of patents were published by the office responsible for registering them, and these can facilitate initial research. For analysis of photography as a profession, trade directories remain an indispensable source. They were generally published annually or every two years in most of the major towns and cities by the middle of the 19th century. However, they must be treated with caution, as the detail and accuracy of the data is quite variable. The date on the title page may be misleading: a so-called annual for 1860-61 may be using data collected in mid to late 1859. That is why, whenever possible, published commercial information should be supplemented by collective sources. These are often institutional and administrative documents, generally in manuscript form. I include here census returns and population registers, both of which offer a level of detail not available in published sources. Furthermore, most European countries had police forces charged with internal security. The files relating to foreigners who were obliged to register with the police (and subsequently monitored in secret!) have proved, in Brussels at least, to be an unexpected source of biographical data. Finally, mention should be made of genealogical records often deposited in manuscript form in local or regional archives (more abundant in the old monarchies of Europe) which furnish biographical data on many well-heeled amateur photographers.

To conclude: I have attempted to demonstrate how a conceptual model can illuminate the socialisation of photography in one country, Belgium. I have tried to show that diverse factors, as much social as technological, can influ-

Fig. 7 A process firm at work. The plant of J. Malvaux in Brussels in 1890, demonstrating the beginnings of industrialisation in photographic printing.

ence this process of socialisation. I have viewed the development of photography not as an unvarying linear advance, but as a series of self-contained phases. This is born out of my belief that much writing on the history of photography tends to reinforce conventional wisdom about progress or innovation because of the inclination, present from the early days, to concentrate on the introduction of technology rather than the application of technology in everyday use. I have touched upon my research strategies and use of primary source material. I do not claim that the research strategies or methodology are automatically valid elsewhere. It is for others to test if and to what extent the methodology and conceptual framework can be applied to other regions, other cultures.

In a more general way, I would stress that whatever approach is used for teasing out the historian's confrontation with the past, the thrusts should be in the direction of "the methodical compilation of verifiable data" (to quote Heinz Henisch, Professor in the History of Photography at State College, Pennsylvania). The result, therefore, has to repose on empirical criteria and include sufficient and reliable data. It may also benefit from an analytical system —an "ism" on condition that the system coincides with the empirically tested data. A worst case scenario would be for the researcher to impose highly abstract conceptual superstructures on insufficient or biased data. In the best of all possible worlds, the analysis and synthesis of data will permit us to gradually raise our level of knowledge of how photography grew. The plurality of approaches of which our young and vital discipline is capable of embracing should generate new and unconventional insights. Finally, raw data are only building blocks. Quantification is no substitute for the mortar of historical and intellectual judgment. The researcher therefore requires a broad awareness of developments outside his specific field and should evince imaginative sympathy with the past. "Gathering the chattels and strays of the past" now makes sense. Discrete pieces of information collated with care can help create a general picture and form a viable frame of reference. And it is through this frame that we can refocus on the past, capture its texture and perceptions, and begin to hear that echo.

NOTES

1. J. M. Eder (trans. E. Epstean), *History of Photography*, New York, 1945 (4th ed.), 1978 (reprint).

2. H. and A. Gernsheim, *The History of Photography*, New York and London, 1969 (2nd ed.).

3. B. Newhall, *The History of Photography*, New York and Boston, 1982 (5th ed.).

4. F. Russo, *Introduction a l'histoire des techniques*, Paris, 1986.

5. For a fuller account, see S. F. Joseph and T. Schwilden, "Sunrise over Brussels: The first year of photography in Belgium", *History of Photography*, Vol. 13 (1989), pp. 355- 368.

6. *Le Courrier Belge*, 12 September 1839.

7. *Le Courrier Belge*, 25 September 1839.

8. S. F. Joseph and T. Schwilden, "The First Daguerreian Studios in Brussels" in P. Palmquist (ed.), *The Daguerreian Annual 1990*, Eureka CA, 1990, pp. 93-100.

9. *Journal de Bruxelles*, 11 March 1842.

10. S. Le Bailly de Tilleghem, "Les premiers photographes à Tournai de 1842 à 1892" in B. Desclee (ed.), *Rene Desclee photographe tournaisien 1868-1953*, Tournai, 1988, pp. 23- 37.

11. *L'Etoile Belge*, 16/17 May 1864.

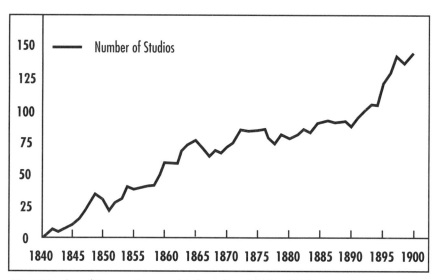

Fig. 1 Number of Boston photographic firms from 1840 to 1900.

[5]

Combining Directory Research with Demographic Analysis

Ron Polito

Whenever a regional directory of 19th–century photographers is published, the compiler invariably looks back over the enterprise with immense relief, for in most cases years will have gone into the production of this work. Hundreds of business directories, resident listings, newspapers, photographic collections, and a myriad of other sources have been examined to extract the information contained in this new volume, and while the compiler knows it is not definitive—that before the printer's ink is dry at least one new photographer's name, address or scrap of biographical information will surface and beg for inclusion—solace is taken in the fact that the directory will provide a wealth of information not previously available. Photohistorians will be able to better correlate the photographers identified with extant work and existing information; historians and genealogists will have a new tool to aid in the dating of photographic subjects. Surely it is now time to relax (a bit), to begin examining those yet unexplored resources, and to accumulate new data for the inevitable second edition.

While the above scenario is common in the field of directory research, and is, indeed, one I followed through three versions of a directory of Boston photographers, I have come to believe that it bypasses an endeavor of critical importance and value, namely the demographic analysis of the data in order to determine the broad shapes and patterns of 19th–century commercial photography in a defined region. Without this, we will never truly understand the nature of the industry or the impact commercial photography had on 19th–century society. Such analysis, however, is not an easy task, and no analysis should be viewed as conclusive, no matter how rich the directory that served as its source. As new data are uncovered, and analyzed in concert with other sources of information, the patterns and shapes may change, perhaps significantly, but even the vaporous outlines emerging from preliminary attempts are important, useful steps toward a more complete understanding of commercial photography and its relationship to American life.

What follows in this essay is a preliminary report on the beginnings of such an analysis for Boston, Massachusetts. Hampered by a directory which was not designed to accommodate demographic analysis, it comes complete with a variety of methodological shortcomings, and while in the end it poses more questions than it answers (perhaps its major virtue), the analysis does provide the basis for a fresh look into the development of commercial photography in Boston. Although engaging in rudimentary levels of inquiry, it also provides a glimpse into the possibilities of demographic analysis sufficient to open a debate regarding its utility and methodology. As new data and refined methodologies are developed, the questions addressed should become less basic, providing a more in-depth, accurate, and clearly defined shape of Boston's photographic industry.

The data used in this analysis were drawn from my directory of Boston photographers, which identifies almost nine hundred photographers active in Boston between 1840-1900.[1] As is typical of regional directories, the entries are arranged in alphabetical order along with dates of activity, work addresses, and available ancillary information. In order to obtain a sense of Boston's photographic industry beyond this array of individual names, one of the first demographic questions addressed was simply the growth of photographic studios during the 19th– century. An examination of the data indicates the number of photographic studios (not individuals) rose from 1 in 1840 to 142 by 1900 (Fig. 1).

Before proceeding further, a word of caution is in order regarding the numerical data used here. It would be inappropriate to claim these are exact numbers; directory research rarely has the advantage of complete and

Period	Avg. No. of Studios	Avg. Pop.	Ratio
1840–50	16	115,132	1:7196
1850–60	39	157,361	1:4035
1860–70	68	214,183	1:3150
1870–80	80	306,682	1:3834
1880–90	89	405,658	1:4558
1890–1900	121	504,684	1:4171
Ratio 1840–1900 Ratio 1850–1900 Ratio 1860–1900	1:4491 1:3291 1:4029		

Table I Ratio of Boston's Studios to Population

Period	Studios: % Change	Population: % Change	Difference (Studio – Pop.)
1840–50	1500%	49%	+1451%
1850–60	144%	37%	+107%
1860–70	74%	36%	+38%
1870–80	18%	43%	-25%
1880–90	11%	32%	-21%
1890–1900	36%	24%	+12%

Table II Boston's Studios & Population: Percent of Change

definitive data and so it is quite possible that more or fewer studios were in operation in any given year. However, while the current data will not permit definitive counts, the extrapolation of broad patterns of shape and change can be examined and reported.

A case in point occurs when one compares the relative growth of photographic studios to Boston's population. In Table I the growth of commercial photography is expressed as a ratio of firms to population and indicates that from 1860-1900 there was, on the average, one photographic studio for every 4,029 Bostonians. The only comparative figures available for an urban population derive from information collected by Michael Pritchard on commercial photography in London. Pritchard's data indicate that from 1861 to 1901 London's ratio of studios to population ranged from 1:17,230 in 1861 to 1:12,887 in 1901, the average over the period being 1:14,333.[2] The considerable difference between Boston and London invites further study as it implies that Boston's firms could and did sustain themselves on a significantly smaller base of potential customers.

Reconfiguring these data, one notes that while both the number of studios and Boston's population rose throughout the 19th-century, they did not do so in parallel fashion, rather three trends emerge (Table II).

1. From 1840-1870 the rate of studio growth exceeds the rate of population growth by a substantial margin.
2. From 1870-1890 the reverse occurs, the rate of studio growth is significantly less than population growth.
3. From 1890 to 1900, the rate of studio growth once again exceeds population growth, but by a less substantial margin than the 1840-1870 period.

These trends raise interesting questions. Can one reason that a low studio–to–population ratio reflects a demand for photographs sufficient to allow a studio to succeed with a smaller pool of potential customers? If so, can one then generalize about the changing patterns of demand for photographic images (and, by implication, their social value)? Or can one say that these trends illuminate a varying pattern in competition throughout the century, a period of greater competition when the ratio is low and less competition when the ratio is high? At this juncture, answers to these questions would be highly speculative, but if combined with other sources of information, say the anecdotal information about business trends which pepper the photographic journals of the time, or an analysis of studio openings and closings within given periods, one might find some clarity emerging to support conjecture.

Another conundrum highlighted by this rudimentary venture into demographic analysis arises from the data on studio growth presented in Figure 1. Although the number of Boston studios increased from 1840 to 1900, this graph demonstrates an interesting, uneven pattern of growth and decline. My first thought was to compare this to the general economic trends of the 19th–century (Table III). As one might expect, there are, indeed, cycles of studio decline that parallel economic slowdown (1849-53, 1876-83, 1889-90). However, there are also cycles of studio growth, some significant, during other periods of economic regression (1862-65, 1883-89, 1890-97). The cycle of studio growth (+27%) that parallels the recession of 1864 might be explained by the unusual demand for photographs created by the Civil War, but no such apparent explanation can be applied to the period from 1890 to 1897, which enjoyed significant growth (+57%) during a decade of enduring economic hardship.

Table III further implies that the number of studios remained stable during the depressions of 1857, 1860-61, 1873-75, and even increased slightly (+15%) during the recessionary period of 1883-85. When this is viewed in the

Period	Boston Studios	U.S. Business Conditions[1]
1840–49	Growth (+330%) Decline: 1842–43	1837–39: Depression
1849–53	Decline (-32%) followed by Recovery Low Point: 1851	1847–48: Depression 1851: Slowdown
1853–54	Growth (+36)	
1854–58	A Flat Period	1857: Depression
1858–60	Growth (+41)	
1860–62	A Flat Period	1860–61: Depression
1862–65	Growth (+27%)	1864–65: Slowdown[2]
1865–71	Decline (-14%) followed by Recovery Low Point: 1878	1868–69: Depression
1871–72	Growth (+12%)	
1872–76	A Flat Period	1873–1875: Depression
1876–83	Decline (-13) & slow Recovery Low Point: 1878	1878: Depression
1883–89	Growth (+15%)	1883–85: Slowdown[2] 1884: Depression
1889–90	Decline: 1889–90 (-5%)	1889–90: Depression
1890–97	Growth: 1890–97 (+57%)	1893–95: Depression
1897–1900	Decline: 1897–98 (-4%) followed by Recovery 1898–1900 (+6%)	

1. Lightner, Otto, *The History of Business Depressions*, New York: Burt Franklin, 1922, reprinted 1970
2. Frickey, Edwin, *Production in the United States: 1860–1914*, Cambridge: Harvard University Press, 1947.

Table III Boston photgraphic studios: Patterns of Growth

context of the following 1875 report on economic conditions in Boston's photographic community, one might be led to speculate regarding the social value people placed on photographs, even in difficult times.

> It should be noted to the credit of this branch of industry that scarcely any failures are reported, and that most of the craft, if they have not made desired financial progress, have nevertheless 'held their own' and hopefully look for the return of better dividends in the good time coming. As a matter of course and as a mark of propriety people are trying to practice economy in the 'doing without' what are termed luxuries...I think, however, I noted the fact in a former letter that 'photographers' were gradually becoming household, or, perhaps, family 'necessities', for the remark is often heard, that rather than risk the opportunity of securing the pictures of those near and dear to us, we will sacrifice something in the matter of appetite, dress and amusement...[3]

However seductive this line of speculation, the caution against "conclusion" raised at the beginning of this essay deserves renewed attention, for the interpretation of the data in apparent support of this assumption becomes more intriguing when the pattern of Boston's population growth, described in Table II, is factored into the analysis. During the period under discussion (1872-89), Boston's population increased at a rate significantly greater than studio growth, providing existing studios with an expanded base of potential customers. Thus, one might be led to a counter-

speculation—that while individual studios may have held their own during these difficult economic periods, the industry actually lost ground, and that the individual customer's demand for photographs, and perhaps the value he placed on them, were significantly diminished.

What then, based on the interrelationships of studio growth, economic trends, and population pattern, really emerges from the mists surrounding the nature of commercial photography in Boston? Unfortunately, with the relatively crude data currently available, little more than shades and shadows. However, this does not make these avenues of inquiry unimportant and with improved data these apparitions should become more corporeal.

Given the limits of my current data-base I have not been able to explore further the possibilities of demographic analysis. As indicated earlier, one intent of this essay is to open a debate regarding the potential of this approach, so what appears here raises more questions about Boston's photographic industry than it answers. With less restrictive data, I would have explored other questions accessible by demographic analysis and important in discerning the shape of 19th–century commercial photography. For example, calculating the length of time photographers operated in one location could provide insights into the failure rate of studios and help clarify the popular assumption that photography was an extremely transient enterprise, as would plotting the movement of photographers across studio, city, and state lines.

Such exploration, however, will have to wait until data are compiled for the next edition of the Boston directory. That should be within the next two years, and this time they will be in a format more readily accessible for demographic analysis. Then, there will be a time to relax (a bit), and hopefully compare the patterns that emerge with those defined by colleagues in other geographic regions.

NOTES

1. Ronald Polito, *A Directory of Boston Photographers: 1840-1900*, 2nd ed., revised (Boston: University of Massachusetts at Boston, 1985). (A new directory for the State of Massachusetts is being compiled by Chris Steele and the author and will be published in 1992 by Picton Press of Camden, Maine.)

2. Michael Prichard, *A Directory of London Photographers: 1841-1908* (Bushey, England: ALLM Books, 1986), Figure 6.

3. "Pencillings from Boston," *Anthony's Photographic Bulletin*, VI (November 1875), 338.

Fig. 1 Reverse of cabinet card portrait by J. F. Standiford, c. 1890

Ruminations After a Bibliography of Directory Research

Richard Rudisill

Why would anyone in his right mind spend over twenty-five years seeking biographical details about photographers? Most rational people probably wouldn't have a plausible answer to this question, and its absence might well suggest that photographic historians are not rational people. But what if the question be put otherwise, "Why would a fascinated person spend so long in such an activity?" All at once the inquiry expands to: "How else can we know anything about an old picture that's not identified?"

Right mind or not, anyone who has had more than a casual contact with photographic images from an earlier day has probably felt the attraction of pictorial details, yet tinged with a certain green frustration as to what they really mean. The hard fact is that an engaging picture offers thin informative rewards without access to the context that produced it. A photograph can show the way something appeared on a particular occasion, but who or what? When, where, why, and who cared enough to make that appearance last are equally critical questions.

Photo-historical researchers may eventually come to see a few characteristics of pictures they often push aside in their single-minded quest for information: Photographs Exist! In themselves they are objects which require proper care to survive. They also need various sorts of attention to yield meaning, and they must be looked at carefully, reacted to and interpreted. Yet, at the same time, photographs can persist even when they might not still exist. Many people, and historians in particular, tend to define some of their images of life in terms of photographs they may not actually possess as objects. "Migrant Mother," "The Steerage," a portrait of Abraham Lincoln, the appearance of the surface of Mars (which nobody on this Earth has ever seen except as a photograph, itself without form until copied from a video monitor). Some photographers and scholars admit to carrying lasting inner pictures which have never manifested but which influence their owners' thoughts and feelings throughout their lives.

This retention of inward vision implies that photographs evoke. Why else do so many people, who are not photographers or students of the medium, concern themselves to make and keep inner or outer pictures? Why else did the daguerreotype so richly affect the public mind of its time? Conferring immortality and providing symbols are potent enough functions, but they in turn rely upon another key element inherent in the nature of pictures—that, whether present or recalled in absence, photographs are illusions. This often means that emotional involvements with photographs can be deeper and stronger than would normally be the case with other kinds of objects. It also means that easy categories of pictures, such as "art" or "documentary" may be dangerous at worst and pointless at best. Each image has its own particular message to give and for that reason, deserves respect for itself.

The late photographer Laura Gilpin used to get quite barbed with people who made emphatic distinctions in her work between art and record. It is likely she would not have felt Edward Weston was offering a completely innocent thought when he declared that his ideal was to attain in his pictures "significant presentation of the thing itself—without invasion in spirit or technique—with photographic beauty." Nearly everyone in the photographic field has heard that statement before, but, depending on one's outlook, it can be either a calling of high art or one of the most poisonous warnings ever given by a photographer against trying to put asunder the soul from the substance, since photographs are in their unique way part and parcel of being human.

The truly sensitive element in photography is not the film or the camera: it is the photographer, although the fact does not guarantee that every photographer knows exactly what he is doing or what has been done. The photographer

and the process cannot function in isolation. The surroundings will be reflected, consciously or not. A picture may not convey anything unless someone else sees it and responds, but it will imply its own situation through whatever it does convey. Thus photographs ultimately serve to manifest relationships between the subject and context pictured; the photographer's perception, the illusory object that is the picture, and the viewer's response. Anything else must ultimately fall as literature or philosophy or some other non-photographic concern, not by judgment but by definition, since these topics are as valid on their own terms as that of photography.

When all parts of the relationship occur within one person, the meaning passed on is at its most nearly complete. Usually, though, the viewer is apart from the photographer by time or distance and their only link is the picture that remains. If the photographer has been sensitive enough, the picture can be read unaided, or it may have been helped by a caption. If not, the picture may languish incomplete or illegible in its message. Traditionally the burden to convey a picture's meaning has rested on the photographer in absentia, because viewers may have been unable or unwilling to reconstruct the lost meaning the photographer might have intended. Such a failure is one of the key shortages in the field of photographic studies—too often teachers, critics, researchers, historians, editors, and dealers consider pictures in isolation. Some photographers' chosen pictures have been denoted masterpieces of great price, automatically respected in an aesthetic canon and severed from their common nature as photographs and from their shared original human purposes. There is simply not enough basic context information being researched today or across the area of photographic history studies as a whole.

This lack is most apparent to curators in collections of historical pictures when they must learn as much as possible about subject-content to satisfy the needs of research visitors. If an historic building is to be restored to its original form, early pictures must not be confused with images of an intermediate appearance due to inaccurate dating. Most actual picture research returns over and again to the necessities of subject, location, date, and photographer in order to achieve effective results.

Aesthetic appeal or technical elegance may strengthen or magnify any image, but these characteristics alone cannot fill gaps in the visual recording of human experience. A recent photography auction catalogue presented a profile head portrait of a dried corpse and stated only that it was a picture of a "cadaver." By itself, poignant though it

was, it seemed worthless to most viewers interested in anything beyond the grotesque. To an experienced photographic historian, however, it offered significant information when seen to be a portrait of the legendary Egyptian Pharaoh Rameses II, possibly made by Sir Gaston Maspero (Chief of the Egyptian Antiquities Service) or more likely by his assistant Emil Brugsch when they oversaw the recovery of an entire cache of major royal mummies in 1881. This photograph was one of a series of insightful portraits which have left clear impressions around the world for over one hundred years. They have permanently defined a public sense of not only Rameses but also of his nobly serene-appearing father Seti I. Thus, it was an approximate recognition of a photographer's work which allowed the other facts to be recovered and to show that the image was one of the primary modern views of a major historic personality. In more ordinary terms, this process occurs constantly in the photographic field. Whenever reasonable dates or tentative locations can be determined for puzzling images, it helps to check details of the careers of the photographers who made them. While this one type of information may not always lead to full clarity, details of the photographer will help point research in the right direction more effectively than other means. Luckily, researching photographers is usually far easier than trying to explain single pictures without context, hence the expansion of such research in photographic history around the world in the past decade.

As early as the 1850s, identifying photographers biographically and listing them as serious practitioners was seen as useful. A trend was followed in such publications as Samuel Dwight Humphrey's *Daguerreian Journal* (1850) and *The Photographic and Fine–Art Journal* (1851-1854), edited by Henry Hunt Snelling, to encourage professionalism in the new field of image making. These magazines offered competent workers some degree of honor or respect and made the exchange of professional concerns more available. From the beginning there was published interest about individual styles and specialized technical methods, as well as editorial encouragement to standardize materials, quality, and prices. In 1863 an international directory of current European photographers appeared in Leipzig, and another in Vienna in 1879 (which even included entries from America) for the purpose of making wider communication possible among studios. By the turn of the century such publications had appeared in some numbers to offer commercial information, but other forms were also beginning to appear under varied impulses to scholarship. *The Evolution of Photography* (1890) by the

Englishman John Werge, with its descriptive sections on a number of leading American studios, and some of the historically general volumes of Henry Peach Robinson and Gaston Tissandier, reflected a degree of awareness that knowing more about the picture makers might strengthen the meanings of their pictures, especially if enlightening basic information were given for numbers of individuals from the same times and places. It appears that, yet dimly, intuitive understanding was dawning, even so early, that grouped amounts of data were informative for comparisons or for stylistic summations, even while they offered encouragement to define national or regional manners of work. In 1900, in his article "Early History of Daguerreotypy in the City of Washington," *Records of the Columbia Historical Society*, Vol. III (1900), pp. 81-95, Dr. Samuel C. Busey, a photographic historian only by secondary interest to medicine, brought an orderly, if roughly pioneering, science-minded approach to bear on collecting details of the lives and careers of photographers in the District of Columbia in one of the first localized historical surveys of its kind. The field owes much to these forerunners even though it has not adequately followed their examples.

Fortunately, a few scattered persons did eventually see the value of collecting career details to illuminate the regional history of photographs. In 1948 Theodosia Teel Goodman published a general article about "Early Oregon Daguerreotypers and Portrait Photographers," *Oregon Historical Quarterly*, Vol. XLIX, No. 1 (March 1948), pp. 30-49. This isolated statement was joined a few years later when Charles van Ravenswaay, still using the form of an article, issued one of the first modern works to operate as an historical directory: "The Pioneer Photographers of St. Louis," *Bulletin of the Missouri Historical Society*, Vol X, No.1 (October 1953), pp. 49-71.

In 1958 the field achieved a landmark of historical research by the gift of one of the truly insightful and devoted photographic archivists in America, Mrs. Mary Frances Rhymer, when she and a volunteer at the Chicago Historical Society anonymously issued a full-scale directory of the photographers active in the city in the 19th-century. Their *Chicago Photographers 1847 through 1900* offered an alphabetical listing of individuals or firms, also giving year-by-year addresses throughout local careers. Since the details were extracted at great labor from business and city directories, portions were incomplete or in error, but the overall tabulation remains solidly useful today and is still a sound example to be followed.

In response to the Chicago publication, Opal Harber employed the same format to compile her *Photographers and the Colorado Scene 1853-1900* (Denver: Western History Department, Denver Public Library, 1961). Recognizing that the exploration and settlement of the trans-Mississippi and Rocky Mountain West mainly occurred within the time of photography, Harber aptly foresaw that having reliable contextual details about photographers and pictures could add a significant new range of source material to traditional methods of examining history in the region.

All of these initiative models were studied when an effective form was needed for my initial work published as the *Photographers of the New Mexico Territory 1854-1912* (Santa Fe: Museum of New Mexico, 1973). The various forms used earlier were partially combined to accommodate the diverse types of information to be collected from less standard sources than were used elsewhere. The added lesson here was that each project has to fit the circumstances which produce it—just as do the photographs and the picture makers about which all these efforts at understanding have been made.

During the ensuing fifteen years a number of powerful influences have descended upon the photographic field. As auction and gallery sales of pictures burgeoned and shockingly raised prices of both contemporary and historical items, a wider sense dawned as to how much basic research information is still required in order to validate these offerings of commerce. As the world has celebrated the sesquicentennial of photography with heavy books and monumental exhibits, large efforts have been made to provide foundations of historical detail upon which to explain the medium and its significance in a number of European countries.

At the same time communication among individuals has spread as more working projects have demonstrated the usefulness of sharing their compiled results.

While it is still true that "directory" research material is most accessible at the local level, the fact is clear that the significance of the material reaches beyond its points of origin. As in a mosaic, the pieces must be connected together if their overall effect is to be seen clearly. Dr. Heinz K. Henisch, founding editor of the *International History of Photography*, observed on the tenth anniversary of the journal, that

> While the history of photography as such has flourished, it is gratifying to note that researchers in related disciplines have come increasingly to recognize the value of photohistorical source material.

Indeed, photolithograph is itself a multidis-

ciplinary endeavour, belonging as much to art history and the history of technology as it belongs to social history and the history of ideas.[1]

Even as the needs of other fields have come to photography for help in understanding their own aspects of human experience, corresponding needs have grown for the photographic field to perceive its own nature and functions more completely—in part through a better knowledge of who did what as a picture maker and why. The decidedly regional and the world-scale interdisciplinary are but the ends of a spectrum. Dr. Henisch's words and the ideals of international cooperation relate quite reasonably to the view of Charles Thomas, compiler of a thorough history and directory work on a limited British area, who has urged that

> [because] early photography . . . became an integral part of Society . . . would-be researchers should leave the well-trodden paths of national and international photography as an art form; leave aside the now thoroughly explored technical and scientific aspects; and concentrate, using the tools of historical research, upon what might be described as the geography, the economics and the sociology of the whole subject. The reward is or should be one of human interest. As for the question 'Where should one begin?', [sic] even our preliminary survey confined to Cornwall and Scilly affirms the answer that many other workers have begun to suspect. There is no national picture. There are scores of local pictures, whose sum may amount in the end to a full depiction of photography—art, business, social record, mirror of the past as it really was . . . Elucidation must begin at home, a prime attraction to any local historian; and it must be sought the hard way, at town, city or county level.[2]

Though these two views may at first seem slightly contradictory—as the separated parts of a continuum will until reconnected—they are both true thoughts of guidance for the field of photographic directory research, needing only to accept in the field's own terms the advice offered by the American novelist John Steinbeck, when he wrote of the discipline of studying marine biology in the context of full human experience:

> [A]ll things are one thing and that one thing is all things—plankton, a shimmering phosphorescence on the sea and the spinning planets and an expanding universe, all bound together . . . It is advisable to look from the tide pool to the stars and then back to the tide pool again.[3]

If contemporary researchers into photographic history at all levels can only hold fast to the accuracy of insight, dedication, and sense of wonderment that moved the early photographers they study, then all will be well with the field.

NOTES

1. Heinz K. Henisch, "The First Ten Years," *History of Photography*, vol. 10, no. 4 (October-December 1986), p. 264.

2. Charles Thomas, *Views and Likenesses: Early Photographers and their Works in Cornwall and the Isles of Scilly 1839-1870* (Truro, Cornwall: Royal Institution of Cornwall, 1988), pp. 157-158.

3. John Steinbeck, *The Log from the Sea of Cortez* (New York: The Viking Press, Compass Books edition 1962), p. 217.

PART II

Directories Of Photographers:
AN ANNOTATED WORLD BIBLIOGRAPHY

Compiled by Richard Rudisill
Curator of Photographic History
Museum of New Mexico

Preface

Since a bibliography of sources for career details on early photographers has little precedent, a number of improvisations have been required to give this project its present form. A primary decision was to include only sources carrying information for numbers of photographers. In practice this may mean citations about so few as two or three individuals or it may reflect encyclopedic works. Sources on early photographers are reported more fully than those for today's people, while some references cover the full historical range. It has been accepted that modern picture makers will soon be historical, so some works are included for their scope or on-going form.

When annotations were added to the original listing of books and articles, they were kept impressionistic because of the diverse needs of the researchers who might call upon them. No single compiler could personally examine all the works cited, so comments are sometimes offered more as clues than as last words. While adverse remarks appear in a few entries, they are meant to encourage care in more full exploration. Only slight effort has been put to making stringent analyses, because the whole field does not yet encompass all the variety of potential sources. The most basic need at present is to locate, preserve, and organize facts—what the founding editor of *History of Photography*, Dr. Heinz K. Henisch, has aptly termed "the methodical compilation of verifiable information." As he has noted, the field owes much to "talented and dedicated amateurs." It should never become so formalized as to discard their contributions, and a tolerant set of comments is given here for most items listed. As the field's base of information grows, however, working methods must inevitably be refined and made at least communicatively standard to allow now separated works to be collated together in the future. While research in depth is usually easier to do at the regional level, local interest should be kept aligned to universal necessities.

Every effort has been made to retain the distinctive character of non-English citations. Some entries have been translated before they came to the editor, and a few have been transliterated from non-Roman alphabets so as not to leave out valuable or unique sources because of mechanical limitations. Fortunately, agreement has been reached among the persons readying the text for print that diacritical marks for such languages as Spanish, Estonian, Icelandic, and Hungarian are parts of correct spelling even if they must be drawn into the text by hand, and apologies are due in any cases of error or omission. Corrections are always welcome and communication is especially desired from persons already working on "directories" in local parts of the world not shown in this volume. Future revisions are to be made, and all further details offered will be prized in themselves and as additions to a network for communication across the field.

An accumulative work such as this inevitably builds upon generous help from many persons beyond those whose names appear at its head. In this present result of sixteen years' activity there are dozens who should be acknowledged, including everyone who has shared research ideas around the world. In mechanical terms, however, only a few can be fit into the space allotted for maximum gratitude. These must include Arthur Olivas (Photo Archivist, Palace of the Governors, Museum of New Mexico, Santa Fe, a working colleague second to none); David Haynes (Institute of Texan Cultures, San Antonio, innovative and practical workman); Peter Palmquist (Coastal Californian and ultimate free-lance historian who has set example and energy for us all); Ron Polito (University of Massachusetts, Boston, computerized purveyor of new ideas); Carl Mautz (Californian free-lance explorer of research and initiator who has made this publication occur); Steven Joseph (England and Belgium, matchless researcher and generous international colleague); Linda

An example of regional research containing names,
addresses, dates analysis and bibliography.

Ries (Pennsylvania State Archives, researcher extra-
ordinaire); Paula Fleming (U.S. National Anthropological
Archives, Washington, D. C., enthusiastic corrector of the
trees in the forests of misattribution); Joan M. Schwartz
(National Archives of Canada, Ottawa, who pleasantly
demonstrates model concerns for working standards and
quality the field so needs); Dr. Michael Weber (Director,
Arizona Historical Society, Tucson, who provided the
original approval and support from which all following
results have grown); and Dr. Thomas E. Chavez (Director,
Palace of the Governors, Museum of New Mexico, who has
offered personal and professional encouragement through
a decade of trying times). It is hoped this volume will be the
foundation of a useful and lasting structure all our efforts
have built together.

> *Richard Rudisill*
> Curator of Photographic History
> Palace of the Governors
> Museum of New Mexico, Santa Fe

[1]Heinz K. Henisch, "The First Ten Years," *History of Photography*,
vol. 10, no. 4 (October-December 1986), p. 264.

Introduction

In 1971 I was asked to organize an exhibition of photography in the New Mexico Territory, to be sponsored jointly by the Museum of New Mexico and the Albuquerque Museum. Since little was known about the topic in general, the first step taken with the help of Arthur Olivas, Photo Archivist of the Museum of New Mexico was to survey approximately 95,000 pictures in collections around the state. While a number of photographs had been defined for use as exhibits, little basic historical information appeared about the medium of photography or about the people who practiced it: some names, some dates, some clues, very little else. Fortunately, work remained by several major figures of the West—John K. Hillers, William Henry Jackson, Edward S. Curtis, Timothy O'Sullivan, and Adam Clark Vroman. Groups of pictures by other competent but little-known persons suggested further research—Ben Wittick, Nicholas Brown, Jesse Nusbaum, George C. Bennett, and Aaron B. Craycraft. Most of the remainder faded into an unexplored wilderness far short of our goal.

Our next effort was to explore the literature, but so little had ever been published on the overall topic or its individuals that this trail soon ran out as well. Since a display so thin on information would offer little but "nice pictures", the remaining year and a half went primarily to examining 147,000 pages of over eighty broken runs of newspapers issued between 1847 and 1912. By taking verbatim notes and collating bits of scattered evidence, we were able to unearth forgotten pictures in several communities, interview a few living photographers we found who had worked before statehood, or pursue letters and reminiscences. Eventually we assembled information for about 500 early photographers.

We found that search and organization of the verbal material often brought pictures into clarity of meaning. Attributions were corrected or discovered, and groups of work could be related to explain each other. At this point a partial loss of funding for the overall project of a show and two publications was resolved by cancelling an exhibit catalogue, which would certainly go out of date, in favor of a directory of the Photographers of the New Mexico Territory 1854-1912, which might grow and need revision but should remain as a solid cornerstone for later work.

Once the exhibit had come and gone in 1973, the directory proved so useful for dating pictures in the Photo Archives or helping researchers extrapolate other sorts of information that it was soon employed by archaeologists, historians, ethnologists, writers, and even artists to verify information accumulated from looking at file prints. Research details found since have been collected into files of raw notes pending a future revision, mainly because of the book's value as a tool for in-house cataloguing and reference. Material on a least 250 additional persons or firms has been collected, and the total has grown to where the next edition of the directory should be significantly more helpful to researchers than originally expected.

New impetus to appreciate the value of a directory also occurred when a letter arrived from David Haynes of the Institute of Texan Cultures in San Antonio, wondering if we had any information on the photographer J.C. Burge, who had pictured the corpse of the outlaw John Wesley Hardin in El Paso, Texas in 1895. When we replied by sending a copy of the page on Burge from the New Mexico directory, Haynes purchased the book as a sample and began to collect details from a remarkable variety of sources on the early photographers of Texas. We have exchanged information for years and spread our contacts with other researchers to share details on picture makers common to all our regions.

By 1975 researchers and students were regularly inquiring about "directory" work and methods, so we made up a six-page handout, *Introduction to Directory Research*. It noted three earlier kinds of publications as

usable ways to organize research details. It also suggested some of the various types of research sources accessible in the United States. Limited bits of advice on working methods closed the text. Two appendices filled out the whole—one showed copies of typical note cards and sample pages from previous works; the other gave a short bibliography of published works or current "works in progress." Our intentions were three: to emphasize the value of gathering regional details on numbers of photographers, to offer practical suggestions from our working experience, and to encourage communication about research data. The central point for these emphases was to define "directory" materials as whatever can provide identifying biographical and career details, dates, locations, notable subjects or techniques, and clues to further research.

Within five years revised versions of this modest handout were being sent out to over a hundred inquiries annually. The bibliography and projects list grew so much larger than the basic text that it was being sent out independently, and it has now here attained a published life of its own, with cited works in almost twenty-five languages from English to Icelandic to Thai.

We hope publication and later revisions will now encourage more work in this essential aspect of photographic history, help to improve the reliable quality of information collected, serve as a research tool in itself, and help fulfill the value originally perceived to be in such compilations as early in the life of photography as the 1850s. It is also our wish that the work now being done at the regional and local level will continue in depth, but we welcome a time when the accumulated local timbers can be brought together to build national and international bridges. Many early photographers were pioneering itinerants, and we shall not fully understand their contributions until our mutual efforts tabulate their wanderings into knowable form together with all we have learned about their fellows who stayed put.

PHOTOGRAPHERS OF THE NEW MEXICO TERRITORY
1854 – 1912

COMPILED BY RICHARD RUDISILL

Directories of Photographers:
AN ANNOTATED WORLD BIBLIOGRAPHY
Compiled by Richard Rudisill
Curator of Photographic History, Museum of New Mexico

A. PUBLISHED WORKS:

1. General and International:

Adressbuch für Photographie und Verwandte Facher (Vienna: Bodo Kralik), 1981.

> Reprint of a directory originally issued by *Photographische Correspondenz* in Vienna and Leipzig in 1879. Extensively international, with 137 entries for Vienna, 420 for Paris, and includes even some listings for the United States.

Adressbuch für Photographie und Verwandte Facher (Vienna and Leipzig), 1879.

> An address book for photography and related fields. A modern edition has been issued in Vienna by Bodo Kralik, 1981; see entry above under this title.

Auer, Michèle and Michel. *Encyclopédie Internationale des Photographes de 1839 à nos Jours* (Hermance, Switzerland: Editions Camera Obscura), 1985, 2 volumes.

> A very expansive treatment arranged as a biographical dictionary; includes a bibliography and indices. French and English texts.

Beaton, Cecil, and Gail Buckland. *The Magic Image* (Boston: Little, Brown & Company), 1975.

> Entire book is in format of biographical dictionary of many prominent figures throughout the history of photography.

Billeter, Erika, editor. *Self-Portrait in the Age of Photography: Photographers Reflecting Their Own Image* (Houston, Texas: [Houston Foto Fest]), 1986.

> A reduced English edition of a larger exhibit catalogue produced in 1985 under the same title for the Musée Cantonal des Beaux-Arts in Lausanne, Switzerland. The section "The Works" (pages 233-247) lists the 200 photographic artists featured and provides years and places of birth and death for each. Many painters and otherwise

unreported photographers are included.

Biographical Index of Photographers in the George Eastman House Collection (Rochester, New York: International Museum of Photography at George Eastman House), 1979.

> Three microfiche indices—one alphabetical, one geographical, one by process; available directly from the George Eastman House, 900 East Avenue, Rochester, New York 14607.

Bloom, John, and Diana C. Du Pont, compilers. "Biographies of the Artists," *Photography: A Facet of Modernism* by Van Deren Coke with Diana C. Du Pont (New York: Hudson Hills Press in association with the San Francisco Museum of Modern Art), 1986, pp 166-188.

> Includes biographies and portraits of approximately sixty-five photographers ranging from the early 20th–century to the present throughout the artistic field of Europe and North America.

Borcoman, James. *Intimate Images: 129 Daguerreotypes 1841-1857—The Phyllis Lambert Gift* (Ottawa: National Gallery of Canada), 1988.

> The partially illustrated catalogue of an exhibition celebrating a major gift of daguerreotypes. Pages 8-22 give an itemized list of the pieces shown and include some biographical entries or at least dates for most of about thirty-seven known daguerreotypists represented from England, France, Germany, Switzerland, and the United States. Since several of these persons have not previously been known in the literature, and the research is solid, this is a significant contribution for the early period.

Browne, Turner, and Elaine Partnow. *Macmillan Biographical Encyclopedia of Photographic Artists & Innovators: Over 2000 Leaders in Photography from the 1800s to the Present* (New York: Macmillan), 1984.

> Has received very mixed reviews; apparently sadly in-

complete and equally sadly arbitrary in selecting who is a "leader."

"Catalog," *Photographs: Sheldon Memorial Art Gallery Collection, University of Nebraska-Lincoln* (Lincoln, Nebraska: Nebraska Art Association), 1977, pp 115-202.
> Gives alphabetical listing of 201 photographers throughout the history of the medium; includes biographical dates and notes on education, awards, solo exhibitions, locations of work in collections, and some small reproductions of pictures.

Darrah, William C. A personal collection of 57,000 Cartes-de-Visite. 48,500 items are filed alphabetically by country or state (of the United States) to illustrate works by over 21,000 different photographers. Another 8,000 items are filed in the Synoptic Collection by subject categories including "imprints and photographers." The whole is accompanied by Darrah's own index of 50,000 3 x 5" cards of information on photographers.
> Reported in *Pennsylvania Historic Photography Group Newsletter* Vol 1, No 2 (Spring/Summer 1991), p 2 as having "A useful four-page descriptive guide . . . available for the visitor's perusal." The collection is housed under "controlled" access at the Special Collections Department, Pattee Library, The Pennsylvania State University, State College, Pennsylvania 16803.

_____. "Nineteenth Century Women Photographers," *The Photographic Collector* Vol 1, No 2 (Summer 1980), pp 6-9.
> A brief introductory essay on research in this overlooked aspect of history, followed by an initial and admittedly limited two-page listing by name, location, and estimated date period. .

_____. *The World of Stereographs* (Gettysburg, Pennsylvania: W. C. Darrah, Publisher), 1977.
> Extensive international and American listings of stereoscopic photographers with estimated time periods of work.

Dimock, George. *Caroline Sturgis Tappan & The Grand Tour: A Collection of 19th-Century Photographs* (Lenox, Massachusetts: Lenox Library Association), 1982.
> An exhibit catalogue for a body of early photographs collected during world travels. "Appendix I: Biographical Notes on the Photographers," pages 74-75, gives limited details on sixteen photographers around the world, including some not reported elsewhere.

Dimond, Frances, and Roger Taylor. *Crown & Camera: The Royal Family and Photography 1842-1910* (Harmondsworth, England: Penguin Books), 1987.
> Page 213 carries "A Chronology of Photographers Granted Royal Warrants in the Reign of Queen Victoria" ranging from 1849 to 1900 and as far as India. On pages 215-219 Roger Taylor gives biographical sketches for ninety-seven photographers and firms represented in the exhibition for which this volume was the catalogue.

Edwards, Gary. *International Guide to Nineteenth-Century Photographers and Their Works Based on Catalogues of Auction Houses and Dealers* (Boston: G. K. Hall & Co.), 1988.
> A 591-page work declared as "offering comprehensive coverage of over 1000 international nineteenth-century photographers." Attempts to give for each name the nationality, life dates, chief subject matter, working dates, processes and formats used, general location of studio, and sales catalogue citations. Inevitable errors and heavy emphasis on European and American photographers, but many persons noted who have previously been unreported.

Eskind, Andrew H., and Greg Drake, editors. Index to American Photographic Collections second enlarged edition (Boston: G. K. Hall & Co.), 1990.
> A general guide to holdings of work by 32,465 photographers in 535 American collections. The "Photographer Index," pages 319-701, itemizes individuals as reported by the collecting institutions, and thus shows considerable variation in names. Where possible mention is made of nationality and life or estimated activity dates. The index "is derived from the Photographers' Biography File, an on-going and essential component

of the George Eastman House Interactive Catalog. This on-line bibliographic database contains additional biographical information . . . [such as] the sources of life dates, spelling variations of photographers' names and other information subject to error or dispute . . . ; every effort will be made to keep the on-line [file] up to date." The Biographical Index is also available in a set of twenty-one microfiche, requiring 43X magnification, for US$95 from Light Impressions, 439 Monroe Avenue, Rochester, New York 14607-5717, U.S.A.

Evans, David, and Sylvia Gohl. *Photomontage: A Political Weapon* (London: G. Fraser), 1986.
> Noted in Pajerski* Catalogue 9 as an "overview" of the subject.

Faber, Monika, editor. *Das Innere der Sicht: Surrealistiche Fotografie der 30er und 40er Jahre* ([Vienna]: Österreichisches Fotoarchiv im Museum Moderner Kunst), 1989.
> An exhibition catalogue noted in Pajerski Catalogue 9 as considering work by over forty photographers working in this special area.

Fralin, Frances, editor. *The Indelible Image: Photographs of War—1846 to the Present* (New York: Harry N. Abrams, Inc., Publishers for the Corcoran Gallery of Art, Washington, D. C.), 1985.
> The extensive catalogue for a major exhibition; pages 17-21 give short biographies of the seventy-four photographers represented.

Gernsheim, Helmut. *Creative Photography: Aesthetic Trends 1839-1960* (New York: Bonanza Books), 1962.
> The section "Short Biographies of Photographers Illustrated," pages 231-247, gives information on 122 notable photographers throughout history.

Glassman, Elizabeth, and Marilyn F. Symmes. *Cliché-verre: Hand-Drawn, Light-Printed—A Survey of the Medium from 1839 to the Present* (Detroit: The Detroit Institute of Arts), 1980.
> Major exhibition catalogue; gives biographical statements on all the major practitioners of the particular medium.

Greenough, Sarah, et al. *On the Art of Fixing a Shadow: One Hundred and Fifty Years of Photography* (Boston: Bulfinch Press/Little Brown and Company), 1989.
> The section "Artists' Bibliographies" (pages 483-496), compiled by Megan Fox, gives years and places of birth and death for the 221 photographers featured along with

*Pajerski refers to booksellers Fred and Elizabeth Pajerski of New York City.

bibliographic references on each.

Gruber, L. F. *Grosse Photographen unseres Jahrhunderts* (Darmstadt, Germany), 1964.
> A biographical dictionary of 20th-century photographers.

Haller, Margaret. "Historic Names in Photography," [Chapter 4] and "Fifty Twentieth-Century Names" [Chapter 5], *Collecting Old Photographs* (New York: Arco Publishing Co., Inc.), 1978, pp 28-77 and 78-90.
> "Historic Names" lists about 312 persons with dates and commentary; there are errors in spelling and information. "Fifty Names" deals in the same flawed way with celebrated later persons.

Hambourg, Maria Morris, and Christopher Phillips. *The New Vision: Photography between the World Wars—Ford Motor Collection at the Metropolitan Museum* (New York: The Metropolitan Museum of Art; distributed by Harry N. Abrams, Inc.), 1989.
> A major book celebrating a large exhibition of the donated collection of the Ford Motor Company. Both the main section of "Plates" (pages 109-272) and "The List of Text Illustrations" (pages 300-304) give nationalities and life dates for over seventy-five major international figures from the period 1919-1939.

Holme, Bryan, editor-in-chief, et al. *Landscape* [in the series *The Library of World Photography*] (Boston: Hill & Company, Publishers), 1987.
> A handsome survey of 210 outstanding images from the entire history of photography. Pages 213-220 give biographical paragraphs for most of the photographers represented.

Hülsewig-Johnen, Jutta, et al. *Das Foto als Autonomes Bild: Experimentelle Gestaltung 1839-1989* (München: Kunsthalle Bielefeld), 1989.
> "Biografien," pages 207-216, give life details for seventy-eight makers of experimental photographic images throughout the 150 years of the medium.

Insbusch, Catherine Evans, and Margaret Munsterberg. "Catalog," *Photography and Architecture 1839-1939* by Richard Pare (Montréal: Callaway Editions for Canadian Centre for Architecture), 1982, pp 217-272.
> Gives biographies for eighty notable architectural photographers or partnerships—including several unresearched elsewhere—active during the first century of photography. Somewhat difficult to use because names are given according to the order of plates in the book

rather than alphabetically. Some particularly good research.

International Center of Photography Encyclopedia of Photography (New York: Crown Publishers, Inc.—A Pound Press Book), 1984.

> A full-scale international enyclopedia with numerous biographical entries on notable individual photographers throughout the history of the medium. Also includes "Appendix I: Biographical Supplement of Photographers," eighteen pages covering mostly recent individuals.

Jaquer, Edouard. *Les Mystères de la Chambre Noire: Le Surréalisme et la Photographie* (Paris: Flammarion), 1982.

> Noted in Pajerski Catalogue No. 5 as including "biographies of surrealistic photographers...as well as mainstream photographers who alluded to surrealism."

Johnson, William S. *Nineteenth-Century Photography: An Annotated Bibliography 1839-1879* (Boston: G. K. Hall & Co.), 1990.

> An absolute tome of research. Pages 1-720 give entries alphabetically, with bibliographic notations, for thousands of photographers or writers on photography from the first forty years of the medium. Many entries give solid biographical notes; many more have at least life or career dates. Six additional sections offer historical surveys of literature in general history, by individual country, by year, by application, and by "Apparatus, Equipment, Cameras & Lenses" for a total of over 950 pages. Inevitably omissions and errors exist in the first issue of any such massive work, but the level of detailed information is quite high and offers one of the most substantial additions to the overall literature yet produced.

Krichbaum, Jörg. *Lexikon der Fotografen* (Frankfurt-am Main: Fischer Taschenbuch Verlag), 1981.

> Entire book of 198 pages gives 500 biographies of photographers from 1830 [sic] to 1980.

Lang, Robert J. *Panorama Documentation Project—List of Museums and Other Organizations with Panoramas—List of Panoramic Photographers,* third printing January 1991.

> Compiled for the International Association of Panoramic Photographers, the listing contains information on over 1100 panoramic photographers active over the last 150 years. It is backed by a computerized data base of biographical information. Available from the compiler at 100 Cooper Court, Port Jefferson, New York 11777.

_____. *Lexikon der Fotografen von den Anfangen bis Heute* (Köln), 1980.

A dictionary of photographers throughout the history of the medium.

Lloyd, Valerie. *Photography: The First Eighty Years* (London: P. & D. Colnaghi & Co. Ltd.), 1976.

> Gives some degree of reference on about ninety early photographers worldwide with main emphasis on English, Scottish, and French; occasional errors.

Mathews, Oliver. *Early Photographs and Early Photographers: A Survey in Dictionary Form* (New York: Pitman Publishing Corporation), 1973, pp 6-44.

> Gives sketchy biographies of scattered early photographers in various parts of the world; sometimes unsound or confusing.

_____. *The Album of Carte-de-Visite and Cabinet Portrait Photographs 1854-1914* (London: Reedminster Publications Ltd.), 1974.

> Includes an alphabetical list of 750 photographers and firms notable for work in these formats.

Naef, Weston J. *The Collection of Alfred Stieglitz: Fifty Pioneers of Modern Photography* (New York: The Metropolitan Museum of Art/Viking Press), 1978.

> The "Catalog," pages 253-495, gives biographical data, portraits, samples of signatures or logos, and other information for fifty important photographers of the Pictorialist era drawn from a major collection of the Metropolitan Museum.

Naggar, Carole. *Dictionnaire des Photographes* (Paris: Editions du Seuil), 1982.

> A book of 445 pages, in French. Gives biographies of photographers throughout history, together with listings of critics, magazines, and other related items.

Naylor, Colin, editor. *Contemporary Photographers*, second edition (Chicago: St. James Press), 1988.

> A considerably expanded version of the 1982 edition listed below under George Walsh, Michael Held, and Colin Naylor, editors.

Oppenheim, Jeane von. "About the Photographers," *The Imaginary Photo Museum* by Renate and L. Fritz Gruber (New York: Harmony Books), 1982, pp 238-265.

> Biographical dates (by year only) and short outline statements about the several dozen photographers included in the 1980 Photokina exhibit. Data are largely compiled from sixteen generally standard references in the history of photography.

Ovo Magazine [Canada] Vol 15, Nos 59/60/61 (1986), "Notes," pp 152-165.

Section gives short biographies for seventy contemporary photographers whose work is illustrated in this special anniversary international issue of the magazine.

La Photographie d'Art vers 1900 (Brussels: Credit Communal), 1983.

The book for a major exhibition of international Pictorialist photography; includes essays by Pool Andries, Roger Coenen, and Margaret Harker. An extensively illustrated alphabetical catalogue gives one-page biographies for all thirty-eight photographers.

Photomontages: *Photographie Experimentale de l' entre-deux-guerres* (Paris: Photo Poche #31), 1987.

Includes biographies of several notable workers in this genre.

Schiffman, Winifred, compiler. "Artist Biographies and Bibliographies," pp 193-237 of *L'Amour Fou: Photography and Surrealism* by Rosalind Kraus and Jane Livingston (New York: Abbeville Press, Publishers, for the Corcoran Gallery of Art), 1985.

Gives biographical data and source references for twenty-four key figures of this 20th-century international use of photography.

Sipley, Louis Walton. *Photography's Great Inventors* (Philadelphia: American Museum of Photography), 1965.

Includes biographical sketches and portraits for 112 individuals.

Tooming, Peeter. *Hōbedane Teekond* [The Silver Journey] (Tallinn, Estonia: Valgus), 1990.

A short general history of photography which includes explanations of early processes and a brief history of cameras. The book also contains a "calendar of the most important events in the photographic field around the world," mainly drawn from various standard works, and a "lexicon" of the leading persons in photographic history in which some "Estonian inventors and photographers are included." Some illustrations show work by Estonian photographers as well as Russian and Baltic items so that a bit of career information can be gleaned by careful examination. Estonian language text.

Travis, David. *Photographs from the Julien Levy Collection Starting with Atget* (Chicago: The Art Institute of Chicago), 1976.

Gives one-page biographies for twenty-eight major photographers active in the first half of the 20th century in Europe and America.

Walsh, George, Colin Naylor, and Michael Held, editors. *Contemporary Photographers* ([London]: Macmillan Publishers [Journals Division] Limited), 1982.

A genuine tome by numerous advisors and 155 essayists. 830 pages of text provide biographical details, exhibit records, collections, publications, a statement where possible by the photographer, and a short essay about the photographer. 650 subjects from around the world are covered, including many whose careers were earlier than the title suggests. For an expanded second edition see above under Colin Naylor, editor.

Weiermair, Peter. *Photographie als Kunst 1879-1979* (Innsbruck, Austria: Allerheiligenpresse), 1979.

Gives biographies for several hundred Pictorialist photographers.

Welling, William. *Collector's Guide to Nineteenth-Century Photographs* (New York: Collier Books), 1976, pp 117-127.

Section gives listings and biographical notes on some early English, Scottish, and American photographers plus membership lists of several turn-of-the-century societies.

Wiemann, Wolfgang. "Biographien," an exhibition catalogue *Pictorialismus in der Photographie* (Zürich, Switzerland: [Galerie] Zür Stockeregg), 1984, pp 63-65.

Gives biographical statements for fourteen, mostly well-known, practitioners of the Pictorialist aesthetic.

Witkin, Lee D., and Barbara London. *The Photograph Collector's Guide* (Boston: New York Graphic Society), 1979.

Pages 63-275 give biographical data, career assessments, specimen signatures or logos, and bibliographical and collection data for 234 major, mostly recent, photographers. Pages 313-323 give biographical or activity dates and locations for 1000 daguerreotypists around the world. Pages 325-388 give biographical or activity dates and general locations for several thousand additional photographers.

2. Africa (also see Middle East: Egypt):

Bull, Marjorie, and Joseph Denfield. *Secure the Shadow: The Story of Cape Photography from Its Beginnings to the End of 1870* (Cape Town, South Africa: Terence McNally), 1970.

Appendix A, pages 222-253, lists photographers and studios active in South Africa 1846-1870 with selected

biographies; Appendix B, pages 254-257, categorizes by geography.

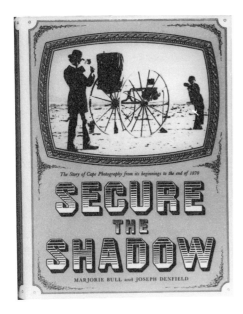

Monti, Nicholas, editor. *Africa Then: Photographs 1840-1918* (New York: Alfred A. Knopf), 1987.
"The Photographers," pages 161-172, gives biographical and career information on 115 photographers from many countries who were active in various parts of Africa, including Egypt.

3. Asia:

China:

Worswick, Clark, and Jonathan Spence. *Imperial China: Photographs 1850-1912* (n.p.: Penwick Publishing, Inc.) 1978.
Pages 150-151 give an "Index of Commercial and Amateur Photographers of China, 1846-1912," listing eighty-five photographers and firms with date periods and locations or topics of work.

Dutch East Indies (see Indonesia)

India:

Falconer, John. "Ethnological Photography in India 1850-1900," *The Photographic Collector* [London] Vol 5, No 1 ([1984]), pp 16-46.
A long article rather than a true directory, but rich with details on several significant, specifically ethnographic, photographers.

Thomas, G. "The First Four Decades of Photography in India," *History of Photography* Vol 3, No 3 (July 1979), pp 215-226.
A general introductory article on the subject giving some individual career details.

Indonesia:

Groeneveld, Anneke, et al. *Toekang Potret: 100 Years of Photography in the Dutch Indies 1839-1939* (Amsterdam: Fragment Uitgeverij and Museum voor Volkenkunde, Rotterdam), 1989.
A well-illustrated general history in both Dutch and English. Pages 177-192 offer a listing of "Commercial Photographers and Photographic Studios in the Netherlands East Indies 1850-1940: A Survey" compiled by Steven Wachlin.

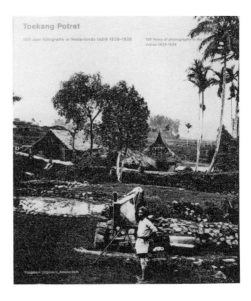

Wachlin, Steven. "Beeldvorming in de Fotografie, 1839-1939," *Geschiedenis in de Klas* Vol 10, No 29 (1989) pp 2-41.
A Dutch text article survey of the Western image of the Dutch East Indies through photography. Includes short biographical sketches of five notable studios and partnerships.

Japan:

Ozawa, Takesi. "The History of Early Photography in Japan," *History of Photography* Vol 5, No 4 (October 1981), pp 285-303.
A general article on the subject; gives details on a number of individuals including some from noble families not otherwise reported.

Worswick, Clark. *Japan: Photographs* 1854-1905 (New York: Penwick Publishing, Inc. & Alfred A. Knopf, Inc.) 1979.

> Pages 129-139 provide historical survey text on Japanese photography in the 19th–century; pages 144-149 give annotated catalogue of 106 photographers.

Malaya:

Falconer, John. *A Vision of the Past: A History of Early Photography in Singapore and Malaya* (Singapore), 1978.

> An overall history including a four-page listing of individuals and firms.

Philippines (see Spain)

Singapore:

Falconer, John. "G. R. Lambert & Co., and Some Notes on Early Photographers in Singapore," *The Photographic Collector* [London] Vol 5, No 2 ([1984]), pp 212- 231.

> A textual article which briefly discusses several particular individuals and firms.

Thailand:

Nawigamune, Anake. *Early Photography in Thailand* (Bangkok, Thailand: Sangdad Publishing House), 1987.

> A small paperback volume of 190 pages, almost totally in Thai but with numerous interesting plates (some from other known publications). The three-page English summary identifies the first four photographers in Siam and gives some biographical details for those and a few others. Available at US$8 ($2 for the book; $6 for air post) directly from Sangdad Publishing House, 8/50 Soi Lat Phroa 23, Bangkok 10900, Thailand.

4. Europe:

General and International:

Allgemeines Adress-Handbuch Aüsubender Photographen von Deutschland, den Osterr. Kaiserstaaten, der Schweiz und den Hauptstädten der Angrenzenden Länder als Brüssel, Kopenhagen, London, Paris, Petersburg, Stockholm ct. ct. (Leipzig), 1863.

> A general address book of practising photographers of Germany, the Austrian Empire, Switzerland, and the capitals of neighboring countries including Brussels, København, London, Paris, St. Petersburg, Stockholm, and others.

Arbasino, Alberto, and Daniela Palazzoli. *I Viaggi Perduti* (Milan: Bompiani), 1985.

> An expansively illustrated volume on early travel photography. "Note Biografiche," pages 181-190, give information on fifty–six photographers who were important early figures in this genre, including several not discussed elsewhere.

Arts Council of Great Britain. *"From today painting is dead," The Beginnings of Photography.*

> Exhibition catalogue which gives capsule biographies of a number of early photographers, mainly British and French.

"Biographies," *European Photography* Vol 4, No 2 (April-June 1983), p 27.

> Gives short biographical notes in both German and English for twelve current European photographers popular in the galleries. Similar sections appear in various issues of the magazine.

Hans, Frank. *Vom Zauber Alter Licht-Bilder: Frühe Photographie in Österreich 1840-1860* (Vienna: Verlag Fritz Molden), 1981.

> "Photographen der 1840er und 1850er Jahre in Österreich," pages 93-110, is a directory of 429 early photographers or firms active between the daguerreotype and the collodion wet-plate; gives locations, biographical or working dates, with more extensive accounts of several noted persons. Listings include areas of Austria, Hungary, Yugoslavia, Poland, Romania, Trieste, and Venice— various parts of the Austro-Hungarian Empire.

Lobjoy, Martine, et al. *Les Miroirs qui se Souvennent 1787-1987: Daguerréotypes d'Hier et d'Aujourd'hui et Autres Procedés Photographiques* [Exhibition catalogue for the Bi-centennial of the birth of Louis Jacques Mande Daguerre]

(Corneilles-en-Parisis, France: Syros Alternatives), 1987.

> Pages 20-34 list historical items in the exhibition interspersed with biographical entries, including some for otherwise obscure persons. Pages 82-93 give biographical details for several modern photographers and practitioners of older processes.

Mitry, Jean. *Schriftsteller als Photographen 1860-1910* (Lucerne, Switzerland: Verlag C. J. Bucher), 1975.

> While not actually a directory, this work provides information otherwise not explored in photographic history by showing a selection of pictures and giving some biographical data for seven major literary figures who were also photographers.

Nazarieff, Serge. *Der Akte in der Photographie 1850-1930* (Berlin: TACO), 1987.

> The overall book is mainly a presentation of stereoscopic images of nudes. Pages 155-156 give German, English, and French "Biographical Notes on the Early Photographers" for seven notable photographers, some otherwise missed in the general literature.

"Photographers in the Exhibition," *The Frozen Image: Scandinavian Photography* (New York: Abbeville Press, Publishers, for the Walker Art Center, Minneapolis), 1982, pp 199-201.

> A listing of 165 photographers; gives names, life dates, birth places, and countries of main work. Covers Norway, Sweden, Denmark, Finland, and Iceland.

Sidwall, Åke, et al. *Fotografi 150 År: Svensk och Utländsk Fotografi ca 1840-1989 ur Museets Samlingar* (Stockholm: Fotografiska Museet i Moderna Museet), 1989.

> An historical survey of photography from the collections of the Photographic Museum, Stockholm, as exhibited in July-September 1989. The "Katalog," pages 91-95, gives biographical data for the 135 international photographers represented, with particular strength in less well-known Swedish persons.

Albania:

Girard, Gérard. "Notes on Early Photography in Albania," *History of Photography* Vol 6, No 3 (July 1982), pp 241-256.

> An article rather than a directory; gives some biographical information on six photographers active between 1864 and 1930 plus illustrations of some early work.

Austria:

Auer, Anna, Monika Faber, et al. *Geschichte der Fotografie in Österreich* (Bad Ischl, Austria: Verein zur Erarbeitung der "Geschichte der Fotografie in Österreich"), 1983, 2 vols.

> A major work in all ways. Volume 1 is a textual history of 376 pages; volume 2 is a 220-page biographical dictionary of Austrian photographers. The work is available primarily from the publisher at Postfach 117, A-4820, Bad Ischl, Austria.

Bayer, Adelheid. *Die Photographie in Wien von 1844 bis 914 in Spiegelbild der alten Adressbücher* (Vienna: University of Vienna—unpublished thesis), 1965.

Frank, Hans. *Biographischen Lexikon der Österreich-ischen Photographen 1860-1900* (Unpublished typescript), 1980.

> Cited on page 209 of Volume 2 of *Geschichte der Fotografie in Österreich* by Anna Auer, Monika Faber, et al. (Bad Ischl, Austria: Verein zur Erarbeitung der "Geschichte der Fotografie in Österreich"), 1983.

Katalog der Jubiläums-Ausstellung der Photographischen Gesellschaft in Wien Anlässlich ihres 40 jährigen Bestandes (Vienna), 1901.

> A catalogue of the Jubilee Exhibition of the Photographic Society in Vienna on the occasion of their fortieth anniversary.

Rosenberg, Gert. *Auflistung der k. k. Hof-Photographen bis zum Jahre 1900* (Unpublished typescript), 1980.

> A listing of the Imperial and Royal House photographers through 1900. Cited on page 209 of Volume 2 of *Geschichte der Fotografie in Österreich* by Anna Auer, Monika Faber, et al. (Bad Ischl, Austria: Verein zur Erarbeitung der "Geschichte der Fotografie in Österreich"), 1983.

Schiffer, Armgard, and Ernest M. Fürböck. *Geheimnis-volles Licht-Bild: Anfänge der Photographie in der Steiermark* (Graz, Austria), 1979.

> Described in Pajerski Catalog 7 as "Exhibition catalogue on history of photography in the area of Styria, Austria."

Vom Porträt zur Ansichtskarte: Gmundener Photographie-geschichte seit 1856 (Gmunden, Austria), 1981.

> An exhibit catalogue of photography of a single city in Upper Austria.

Waibl, Gunther. *Mariner Photographers in Brunneck* [Austria] (Brunneck, Austria), 1982.

> A small publication on photographers in the area of a town in the Austrian Tyrol. Includes a brief listing of photographers.

Belgium:

Antheunis, Georges, et al. *Fotografie Te Gent: Focus op Fotografie van 1839 tot 1940* (Gent, Belgium: Museum voor Industriele Archeologie en Textiel and Gemeente Crediet), 1987.

> Two separate printings offer the material in Flemish and French for an exhibition catalogue with scattered lists of members of the Belgian Photographic Association to 1900.

Coppens, Jan. "Scottish Calotypists in Belgium," *The Photographic Collector* [London] Vol 5, No 3 ([1986]), pp 320-330.

> A solid article rather than any true directory. Covers two overlooked amateur pioneers, George Moir and John Muir Wood, and touches work by Talbot. Illustrated usefully.

Cresens, André. *150 Jaar Fotografie Te Leuven* (Brugge, Belgium: Uitgeverij Marc Van De Wiele), 1989.

> Contains a table of commercial photographers active in the city of Louvain, Belgium 1855-1939 plus various membership lists of area camera clubs at the turn of the century. Flemish text.

Dupont, Pierre-Paul. *Un Demi-Siècle de Photographie à Namur des Origines à 1900* ([Brussels]: Crédit Communale), 1986.

> Includes scattered lists of professional (pages 51-60) and amateur (pages 132-139) photographers active in one Belgian city. Two separate printings offer the material in French and Flemish.

Fotografie uit de Pionierstijd [An offprint from an article in *Openbaar Kuntbezit in Vlaanderen* Vol 23, No 3 (1984)].

> Noted in Pajerski Catalogue 9 as an "Overview of the early years of photography emphasizing Belgian photographers . . . mostly from the collection of the Provinciaal Museum voor Fotografie, Antwerp."

Grandorge, Isabelle, et al. *Photographies d' Hier de 850 à 1940* [Catalogue for exhibition 2-18 August 1985] Huy, Belgium: Maison de la Culture), 1985.

> Pages 9, 12, 14, and 16 give a listing with some biographical details for twenty-three photographers or firms included in the exhibition.

Hostyn, Norbert. "De Fotografie te Oostende tot 1914," *De Plate* [A local history magazine for Ostend, Belgium] Vol 9 (1980) [Not regularly paginated].

> An article in seven parts giving career details on twenty-five professional photographers.

Magelhaes, Claude, and Laurent Roosens. *De Fotokunst in België 1839-1940* (Deurne-Antwerpen, Belgium: Het Sterckshof, Provinciaal Museum voor Kunstambachten), 1970.

> An exhibit catalogue in Flemish, French, English, and German; gives very brief biographical notes on seventy-six photographers from the first hundred years in Belgium.

Michiels, Guillaume. *Uit de Wereld der Brugse Mensen: De Fotografie en het Leven te Brugge 1839-1918* (Brugge, Belgium: Uitgaven Westvlaamse Gidsenkring), 1979.

> Pages 20-46 give biographical sketches on thirty-six professional photographers active in Brugge [Bruges] in the period 1842-1918; text in Flemish.

La Photographie en Wallonie des Origines à 1940 (Liège, Belgium: Musée de la Vie Wallone), 1979.

> Exhibition catalogue with biographical details on fifty-five professional and amateur photographers active in the French region of Belgium, particularly Liège, in the first century of the medium.

Roosens, Laurent. "Joseph Ernst Buschmann and Guillaume Claine: Two Belgian Calotypists," *History of Photography* Vol 2, No 2 (April 1978), pp 117-122.

> An article with biographical details on two very early and overlooked people.

Bulgaria:

Boev, Peter. [*The Art of Photography in Bulgaria* (Sofia, Bulgaria: September Publishing House)]; 1983.

> A general history of Bulgarian photography

emphasizing the period 1840 to about 1930. Gives biographical information for several individuals in an expanded treatment of the English text listed next below. Text in Bulgarian.

_____. "Early Photography in Eastern Europe: Bulgaria," *History of Photography* Vol 2, No 2 (April 1978), pp 155- 172.
An article surveying the earlier period of the country's photographic history. A number of individuals are given biographical statements. Useful as an introduction to the book listed next above.

Cornwall (see United Kingdom)

Croatia (see Yugolslavia)

Czechoslovakia:

Mrázková, Daniel, and Vladimir Remĕs. *Tschechoslowakische Fotografen 1900-1940* (Leipzig, German Democratic Republic: VEB Fotokinoverlag), 1983.
A textual history covering a period in only half of which there was a unified nation of Czechoslovakia. Primary emphasis is given to major names, starting with Mucha, but sixteen biographies are included.

Scheufler, Pavel. *Praha 1848-1914: Cteni Nad Dobovými Fotografiemi [Prague 1848-1914: What Period-Style Photographs Tell Us]* (Prague: Panorama), 1984.
Pages 275-279 give twenty-eight biographical entries on the most prominent photographers of Prague in the 19th–century. Text in Czech.

Skopec, Rudolf. "Early Photography in Eastern Europe:" Bohemia, Moravia and Slovakia," *History of Photography* Vol 2, No 2 (April 1978), pp 141-153.
An article surveying the early period of the region's photographic history. A few individuals are given biographical treatment.

Denmark:

Haugsted, Ida. "Christian Tuxen Falbe and the Pioneer Daguerreotypists in Denmark," *History of Photography* Vol 14, No 2 (April-June 1990), pp 195-207.
A general text article giving some biographical or career details for a number of primary but little-known photographers.

Ochsner, Bjørn. *Fotografer i og fra Danmark til og med år 1920* ([København]: Biblotekcentralens Forlag), 1986,

2 vols.
One of the most comprehensive genuine directories yet done anywhere. The main body of the two volumes is an alphabetical listing of photographers in and from Denmark with sometimes quite extensive biographical coverage, locations, and other cogent details. The information is also stratified in several ways including a register by town, a list of notable amateurs, a list of foreign workers in Denmark, a listing of Danish workers abroad, and a list of persons involved with producing illustrated books— all serving as guides to the master text. Includes an introductory section giving essential terms and abbreviations in Danish text. Pretty completely replaces the 1969 edition, with twice the included material.

England (see United Kingdom)

Estonia:

Teder, K. "Early Photography in Eastern Europe: Estonia," *History of Photography* Vol 1, No 3 (July 1977), pp 249-268.
A general article on the subject; gives some career details on individuals. Almost the only source available in English.

Tooming, Peeter. *Tahelepanu, Pildistan! Eesti Foto Minevikust 1840-1940* [Sketches from the Past of Estonian Photography] (Tallinn, Estonia: Kirjastus "Kunst"), 1986.
A general book with an "essay-like approach" to the subject. While there is no systematic or separate listing of photographers, considerable information can be found by extrapolation from picture captions and the overall text. Estonian text but with an English summary and "List of Photos" on pages 279-295.

Vende, V. "Eesti soost päerapiltniknd [First Photographers in Estonia]," *Sirp ja Vasar* (February 25, 1983).
Reported in *Photohistoria: Literature Index of the European Society for the History of Photography* (December 1984-January 1985) as a "Presentation of the first photographers in Estonia of Estonian nationality."

Finland:

Hirn, Sven. *Ateljeesta Luontoon: Valokuvaus Ja Valokuvaajat Suomessa 1871-1900* (Helsinki: Suomen Valokuvataiteen Museon Säätiö), 1977.
Continuation in time of earlier item noted below. Textual history of late 19th–century photography in Finland. Includes list of photographers plus a general summary of the text in Swedish and English.

____. "Early Photography in Eastern Europe: Finland," *History of Photography* Vol 1, No 2 (April 1977), pp 135-152.

An introductory article on the subject giving a few details on specific persons. Most useful in conjunction with the two Finnish-language books cited here by the author.

____. *Kameran Edestä Ja Takaa—Valokuvaus Ja Valokuvaajat Suomessa 1839-1870* (Helsinki: Suomen Valokuvataiteen Museon Säätiö), 1972.

Gives biographical statements on various early photographers plus date periods and many illustrations of typical pictures, logos, and some advertisements from newspapers. Includes a two-page English summary of overall history; text in Finnish.

France:

Buerger, Janet E. *French Daguerreotypes* (Chicago: University of Chicago Press), 1989.

Described in Pajerski Catalogue 9 as "Cultural history, with the first complete catalogue of the work of 68 identified & other unidentified daguerreotypists in the collection at the George Eastman House." Biographical dates are given for many individuals.

Christ, Yvan, editor. *La Mission Heligraphique: Photographies de 1851* ([Paris: Direction des Musées de France]), 1980.

An exhibit catalogue which extensively details the history, itinerary, and works resulting from a national project to calotype the architectural patrimony of several regions of France. Biographical pages are given in French on the four photographers who carried out the project: Baldus, Le Secq, Le Gray, and Mestral.

Debize, Christian. *La Photographie à Nancy au XIXe Siècle* [Unpublished thesis done in 1982 in the Department of Art and Archaeology, The Sorbonne, Paris].

A two-volume work; Volume II is an extensive listing of professional photographers in Nancy, France, 1848-1920.

____. *Photographes et Photographie d'Art à Nancy au 19e Siècle* (Nancy, France: Centre Regional d'Etudes d'Art et d'Histoire), 1983.

An exhibit catalogue. Pages 114-119 give a "Dictionnaire des photographes professionnels nancéiens: 1843-1920" with biographical details on fifty-eight persons. Pages 120-122, "Notices biographiques et critiques de quelques photographes amateures," give data on six others.

Henry, Jean-Jacques, et al. *Photographie, Les Débuts en Normandie* (Le Havre, France), 1989.

An exhibition catalogue of photography in Normandy 1850-1899. Described in Pajerski Catalogue 9 as "including the work of LeSecq & over 30 other primarily French photographers."

Jammes, André, and Eugenia Parry Janis. *The Art of the French Calotype, with a Dictionary of Photographers, 1848-1870* (Princeton, New Jersey: Princeton University Press), 1983.

Gives "a critical dictionary of photographers in France who worked with paper negatives."

Jammes, Isabelle, editor. *Albums Photographiques édités par Blanquart-Evrard 1851-1855* ([Vincennes, France]: Department des Relations Publiques de Kodak-Pathé), 1978.

Gives limited biographical notes on ten selected photographers whose work was printed by Blanquart-Evrard's legendary printing establishment of the 1850s.

Marbot, Bernard. "Catalogue," *After Daguerre: Masterworks of French Photography (1848-1900) from the Bibliothèque Nationale* (New York: The Metropolitan Museum of Art), 1980, pp 71-179.

Gives biographical and career data on 102 photographers in the exhibition along with bibliographic citations wherever possible.

Mid 19th Century French Photography: Images on Paper (Edinburgh: The Scottish Photography Group Ltd.), 1979.

An exhibition catalogue. Pages 43-46 give a checklist of several noteworthy photographers with biographical data.

[Morand, Sylvain.] *Charles Winter, Photographe: Un Pionnier Strasbourgeois 1821-1904* (Strasbourg, France: Musées de Strasbourg), 1985.

Exhibit catalogue. Page 102 lists twenty-two professionals active around 1870. [The author is reportedly compiling a full directory of Strasbourg photographers.]

Morand, Sylvain and Marianne. "Les Débuts de la Photographie à Strasbourg: Les Daguerreotypistes de 1839 à 1850," *Annuaire de la Société des Amis de Vieux-Strasbourg* (Strasbourg, France), 1983, pp 109-119.

A substantial list of the initial photographers.

Nori, Claude. *French Photography from Its Origins to the Present* (New York: Pantheon Books), 1979.

Gives dates and sketchy biographical commentaries on a fair number of photographers throughout the history of the medium.

Norton, Russell. "Preliminary Checklist of French Stereo Card Photographers and Publishers," *The Photographic Collector* [London], Vol 5, No 3 (Spring, [1986]), pp 278-296.

A five-year research project to identify the many French stereograph producers generally indicated only by initials. Biographical details and studio addresses are given for some entries and date periods for others. A landmark of research into an important field. It is to be hoped the compiler will continue the work.

Paris et le Daguerréotype (Paris: Paris Musées), 1989.

The splendid "Catalogue" for this monumental exhibition, pages 205-263, gives life dates for all of the initial daguerreotypists of the city.

Germany:

Assion, Peter, et al. *Photographie auf dem Land um 1900: Karl Weiss Photograph in Buchen. Mit einem Beitrag zur Frühgeschichte der Photographie im badischen Frankenland* (Buchen, Germany), 1982.

Noted in Pajerski Catalogue 7 as primarily an illustrated catalogue of pictures by Karl Weiss "as well as a history of photography in the Odenwald area of Germany." No indication whether a directory is included but extrapolation from the text is likely possible.

Benteler, Petra. *German Photography after 1945* (Kassel, Germany), 1979.

Gives brief biographical sketches for fifty photographers covered by the book.

Berlin fotografisch: Fotografie in Berlin, 1860-1982 (Berlin), ca 1982.

Listed in Pajerski Catalogue 2; described as an extensively illustrated overview of photography in Berlin, mainly in the 20th–century. "Includes brief biographies of photographers."

Coke, Van Deren. *Avant Garde Photography in Germany 1919-1939* (New York: Pantheon Books), 1982.

A section, pages 46-53, gives biographical statements about fifty-six photographers of significance in this genre.

Dost, Wilhelm. *Die Daguerreotypie in Berlin 1839-1860* (Berlin), 1922, reprinted in *The Daguerreotype in Germany: Three Accounts* edited by Robert Sobieszek (New York: Arno Press), 1980.

Includes listing of all daguerreotypists working in Berlin before 1860.

"Fotografen in Rheinland-Pfalz 1839-1915 (ohne Koblenz)," *Spurensuche: Frühe Fotografen am Mittelrhein* (Koblenz: Landesmuseum Koblenz), 1989, pp 64-65.

Section gives a simple listing of approximately eighty names by town only for early photographers of the Rheinland area excluding Koblenz (which is covered in the listing by Horbert and Lammai cited below). Both items are most useful in conjunction with the historical text of the book.

Frecot, Janos, and Helmut Geisert. *Berlin: Fruhe Photographien Berlin, 1857-1913* (Munich), 1984.

An expansive picture book covering the second half of the Nineteenth century. Pajerski Catalogue 9 notes, "all photographers & collections identified." While the book is not in any sense a directory, time periods for individuals can be surmised.

Frenzel, Rose-Marie, and Wolfgang G. Schroter. *Hermann Walter. Fotografien von Leipzig 1862-1909* (Leipzig, German Democratic Repubic: VEB Fotokinoverlag), 1988.

> A biographical treatment of one important person; includes some details of others active during his career in Leipzig.

Gebhardt, Heinz. *Königlich Bayerische Photographie 1838-1918* (Munich: Laterna Magica), 1978.

> A very thorough study; rich in detail and handsomely illustrated with pictures, logotypes, and line cuts of studios, equipment, and practices. The entire book is scattered with biographical listings including the pioneers, the seventy-five royal photorahers from 1857 to 1912, the itinerants, the small-town photographers, and others. The overall volume is accessible by an index of persons. If every area of the world were so well documented, the entire field would be greatly advanced.

Goergens, Harald, and Alfred Löhr. *Bilder für Alle: Bremer Photographie in 19. Jahrhundert* (Bremen, Germany: Bremer Landesmuseum für Kunst-und Kulturgeschichte [Focke-Museum]), 1985.

> Nicely-done exhibition catalogue with historical essay and color-toned plates. Pages 88 and 89 give a membership list of the Photographischen Gesellschaft of Bremen for 1902. Pages 105-116 comprise a full directory of professional photographers in Bremen 1843-1935, including names with addresses by years for about 365 persons and studios.

Hesse, Wolfgang. Ansichten aus Schwaben (Tübingen, Germany: Verlag Gebr. Metz), 1989.

> Very thorough textual study. No actual directory but chronologically coherent and seems to cover all commer-

cial photographers in the south German city of Tübingen up to 1900.

Hoerner, Ludwig. *Photographie und Photographen in Hannover und Hildesheim* (Hannover & Hildesheim, Germany), 1989.

> A textual survey of early photography in one part of Prussia. Page 116 gives a listing of photographers active in the city of Hildesheim 1843-1914.

Hoffman, Detlef, Jens Thiele, et al. *Lichtbilder Lichtspiele: Anfänge der Fotografie und des Kinos in Ostfriesland* (Marburg, Germany: Jonas Verlag), 1989.

> An extensive textual collection of essays covering the introduction and growth of both photography and cinema in the northern German area of East Friesland. Three essays by Christian Timm (pages 156-241) carry a thorough story of photographers from 1839 to 1900; other sections deal with established family studios and with itinerants.

Horbert, Wolfgang, and Klaus Lammai. "Koblenzer Fotogeschichte: Eine Atelier-Chronologie der Jahre 1842 bis 1935," *Spurensuche: Frühe Fotografen am Mittelrhein* (Koblenze: Landesmuseum Koblenz), 1989, pp 101-106.

> Section covers a studio chronolgy of the history of photography in one city with eighty different entries by date and address. (Also see related item above from same volume.)

Kempe, Fritz. *Daguerreotypie in Deutschland: Vom Charme der Frühe Fotografie* (Seebruck am Chiemsee, Germany: Im Heering-Verlag), 1979.

> A full book on the topic. While there is no separate directory section, the extensive chapters on various areas and individuals give substantial information and dates for many primary photographers.

Maas, Ellen. "Photographische Ateliers 1860-1910 und Ihre Inhaber," *Anzeiger des Germanischen Nationalmuseums 1977* (Nürnberg, [Germany]), 1977.

> Pages 123-136, "Verzeichnis," offer a directory in some detail of around 500 portrait photographers in Germany preceded by a ten-page article generally covering the topic. Footnote 1 mentions another publication which also has a listing specifically for the city of Lüneberg.

Mayer-Wegelin, Eberhard. *Frühe Photographie in Frankfurt am Main 1839-1870* (Munich: Schirmer/Mosel), 1982

> Pages 45-58, "Kurz-Biographien," give biographies for several major people and some illustrations of work; pages 73-74, "Anhang," list sixty-five photographers

active in the city with date periods of work.

Neite, Werner. "Die Photographie in Köln 1839-1870," *Jahrbuch des Kölnischen Geschichtsvereins e. V.* No. 46 (1975), Appendix—"Verzeichnis der Photographen in Köln."

Gives names, dates, and addresses for sixty-nine photographers active in Cologne, Germany between 1839 and 1870 as collected from city directories.

Peters, Ursula. *Stilgeschichte der Fotografie in Deutschland: 1839-1900* (Köln: Du Mont Buchverlag), 1979.

Includes about thirty short biographical notes.

Richter, Peter-Cornell. *Mit Licht Gezeichnet: Aus der Tagebuch* (Freiburg, Germany: Herder), 1985.

A ninety-six-page book noted in the April 1986 *Newsletter of the European Society for the History of Photography*; defined as an "anthology of short biographies of twenty-one early photographers."

Siener, Joachim W. *Von der Maskierten Schlittenfahrt zum Hof-Photographen: Die Photographie und Stuttgart 1839-1900* (Stuttgart, Germany), 1989.

An exhibit catalogue. A list of photographers is blended into the index on pages 184-189.

Spurensuche: Frühe Fotografen am Mittelrhein (Koblenz, Germany), 1989.

An exhibition catalogue. Pages 102-106 offer a full listing of professional photographers active in the city of Koblenz, 1842-1935, compiled by Wolfgang Horbert and Klaus Lammai.

Stadtmuseum Erlangen. *Ausstellungskatalog Nr. 22: Frühe Fotografien in Erlangen 1843-1914* (Erlangen, Germany), 1977.

An exhibit catalogue on early photography in one German city. Cited on page 110 of the book Silber und Salz, but no indication is given whether it is truly a directory.

Steen, Uwe. "Die Anfange der Photographie in Schleswig Holstein," *Nordelbingen* Vol 56 (1987).

An article presumably giving basic information on early photographers in the region of northern Germany bordering Denmark. The author may be contacted directly at 20 Dannewerkerstrasse, 2381 Busdorf, Federal Republic of Germany.

Wilhelm, Angelika. "Die Geschichte der Photographie in Leipzig von 1839 bis 1950," *Historische Kameras und Leipziger Photographien; Ausstellungskatalog* (Leipzig: German Democratic Republic), 1983.

An article rather than a true directory on the history of photographing the city of Leipzig.

Greece:

Xanthakis, Alkis X. "Greek Photographers of the 19th Century" [pages 25-28] and "Biographical Notes of Greek and European Photographers Established in Greece" [pages 205-208], *Athens 1839-1900: A Photographic Record* (Athens: Benaki Museum), 1985.

A short essay and a section giving biographies of thirty-five photographers included in an extensively illustrated exhibition catalogue.

Hungary:

Karlovits, Károly. "Early Photography in Eastern Europe: Hungary," *History of Photography* Vol 2, No 1 (January 1978), pp 53-74.

A general article on the subject. Considers several individuals and more of the literature than many sources.

Szilágyi, Gábor, and Sándor Kardos. *Leletek: A Magyar Fotográfia Történetéből* (Budapest: Képzőművés-zeti Kiadó), 1983.

A substantial, illustrated book on Hungarian photography. Pages 461-468, "A kőteben szereplő zerzők," offer small biographical statements on ninety-nine persons throughout the history of photography in the area; heavy emphasis on recent people.

Vajda, Pal. *Creative Hungarians: A Selected Bio-Bibliography* (Budapest: Offprint ex Technikatorteneti Szemle) Vol XI (1979), pp 35-74.

> Contains biographical data about seven Hungarian photographers.

Iceland:

Baldvinsdóttir, Inga Lára. *Ljósmyndarar á Íslandi 1846-1926* (Unpublished Master's thesis done at the University of Iceland, Reykjavik), 1984, 2 vols.

> A comprehensive work: Vol 1 is a textual history of history of photography in the country; Vol 2 is a complete directory giving names, dates, genealogy, education, descendants, and samples of logos when possible. The research is extremely complete and follows the ancient tradition of listing names alphabetically by first name since family names shift with each generation. The work is in Icelandic which somewhat relates to other Scandinavian languages, old German, and older English. Inquiries may be directed to the author at Garjhúsum, Eyrargotu 46A, 830 Eyrarbakka, Iceland.

Ireland:

Henggeler, Joseph, as told to Laurance Wolfe. "Stereo Emeralds: A Look at Nineteenth Century Irish Stereo Views," *Stereo World*, Vol 14, No 1 (March-April 1987), pp 22-30.

> Article gives some biographical details and a small chart gives locations and general dates of activity for eight stereoscopic photographers. A note in the article indicates that the researcher has a ten-page synopsis of his notes available without charge other than a self-addressed stamped envelope [or international reply coupons]: Joseph Henggeler, Box 1298, Fort Stockton, Texas 79735, U.S.A.

Italy:

Bechetti, Piero. *Fotografi e Fotografia in Italia 1839-1880* (Rome: Edizioni Quasar), 1978.

> Pages 51-127 list several hundred photographers by town with some biographical dates or working period dates. Italian text.

_____. *La Fotografia a Roma dalle Origini al 1915* (Rome: Editore Carlo Colombo), 1983.

> A large, handsomely-produced volume with limited general text, 297 plates, and a ninety-one–page section of biographies of photographers active in Rome from the beginning to 1915; extensively illustrated with pictures, logotypes, and portraits of photographers. Italian text.

_____. "Photographers in Rome," *Rome in Early Photographs: The Age of Pius IX—Photographs 1846-1878 from Roman and Danish Collections* translated by Ann Thornton (Copenhagen, Denmark: The Thorvaldsen Museum), 1977, pp 39-51.

> An English text giving biographical entries for sixty-six photographers or publishers covered by the title of the catalogue.

Colombo, Cesare, and Susan Sontag. *Italy: One Hundred Years of Photography* (Florence, Italy: Fratelli Alinari, distributed in the United States of America and Canada by Rizzoli International Publications, Inc.), 1988.

> The "Biographical Catalogue," pages 185-190, gives brief sketches of eighty-eight international photographers active in Italy since 1888.

Fotografia Italiana dell' Ottocento (Milan: Electa Editrice & Florence: Edizioni Alinari), 1979.

> Pages 137-184, "I Fotografi," give a relatively detailed biographical directory of about 220 photographers active in Italy before 1900.

Keller, Judith, and Kenneth A. Breisch. *A Victorian View of Ancient Rome: The Parker Collection of Historical Photographs in the Kelsey Museum of Archaeology* (Ann Arbor, Michigan: The University of Michigan), 1980.

> The section "Parker and His Photographers" by Judith Keller, pages 9-11, includes a limited biographical chart of the seven little-known photographers represented in the Parker Collection who worked between 1865 and 1877.

Museo Nazionale del Cinema. "Elenco di Fotografi in Piemonte nel Secolo XIX," *Notiziario* Anno XV, Nos 31-32-33 (1976), pp 11-16.

Gives a directory of 19th–century photographers in the Piedmont region of Italy.

Latvia:

Kreicbergs, Jānis. "Early Photography in Eastern Europe: Latvia," *History of Photography* Vol 1, No 4 (October 1977), pp 319-325.

A brief introductory article on the subject; mentions some individuals. Essentially no other available source. No bibliography.

Lithuania:

Juodakis, V. "Early Photography in Eastern Europe: Lithuania," *History of Photography* Vol 1, No 3 (July 1977) pp 235-247.

A very general introductory article on the subject but gives some detail on individuals. Essentially the only source available in English.

Netherlands:

Leijerzapf, Ingeborg Th., editor. *Fotografie in Nederland 1839-1920* (s'Gravenhage, [Netherlands]: Staatsuitgeverij), 1978.

A handsomely-illustrated history of photography in the Netherlands; pages 89-108, "Biografeën," give capsule accounts of the careers of many early persons and groups. Dutch text. Two companion volumes carry the illustrated textual history up to 1975 but without the biographical format given as much attention as in this first volume.

Mensonides, H.M. "Een Nieuwe Kunst in Den Haag; Encyclopedisch Overzicht van de Eerste Haagse Fotografen," *Die Haaghe Jaarboek* 1977.

Gives an overview of early photography in The Hague, Netherlands, plus a biographical listing of persons active between 1839 and 1870.

Northern Ireland (see United Kingdom)

Norway:

Bonge, Susanne. *Eldre Norske Fotografer—Fotografer og Amatørfotografer i Norge frem til 1920* (Bergen, Norway: Universitetsbiblioteket), 1980.

A substantial work, over 500 pages, in Norwegian, available directly from the University of Bergen Library. Gives biographical or career data for hundreds of persons. Information is listed alphabetically, by geography, by

foreign work, by foreign workers in Norway, and by date periods. Altogether a solid and thorough study.

Sollied, Ragna. *Eldre Bergenske Fotografer* (Bergen, Norway: Eget Forlag), 1967.

A full-scale directory of the early photographers of the city of Bergen. Reflects thorough research and includes a few portraits and a "Chronological Overview." Norwegian text.

Poland:

Garztecki, Juliusz. "Early Photography in Eastern Europe: Poland," *History of Photography* Vol 1, no 1 (January 1977) pp 39-62.

A general article introducing the subject and one of the few sources in English. Gives career details of a few individuals.

Lejko, Krystyna, and Jolanta Niklewsak. *Warszawa na Starej Fotografi 1850-1914* (Warsaw: Państwowa Wydawnictwo Naukowe), 1978.

Pages 94-109, "Warszawskie Zaklady Fotograficzne w XIX I Początkach XX w. Reprezentowane w *Zbiorach Muzeum* Historycznego," appear to be an accounting of early photographers represented in a regional historical museum and in the overall exhibition for which this catalogue was done.

Sobota, Adam. "Art Photography in Poland, 1900-1939" *History of Photography* Vol 4, No 1 (January 1980), pp 18-34.

A general article on the subject; gives a few career details for some individuals. Intended to complement the Garztecki article cited above.

Portugal:

Magalhaes, M. J. "O Porto e la fotografia," *Gaia [Gabinete de Historia e Arqueologia de Vita Nova de Gaia]* Vol 5 (1987), pp 361-374.

> An article on some aspects of the history of photography in Portugal with some discussion of the pioneer photographers in Oporto, the capital.

Pavão, Luis. *The Photographers of Lisbon, Portugal from 1886 to 1914: Occasional Papers No. 5 of the Rochester Film & Photo Consortium* (Rochester, New York: University Education Services, International Museum of Photography at George Eastman House), 1990.

Romania:

Săvulescu, Constantin. *Cronologia Ilustrată a Fotografiei din Romania Peioada 1834-1916* (Bucharest, Romania: Association of Art Photographers), 1985.

> While this book is the first survey of early Romanian work, the title *Illustrated Chronology of Photography* in Romania was chosen by the author because he felt the basic research did not yet warrant the full-scale interpretation of a true history. Even so, there is nothing else on the subject and this work reflects twenty years of searching for the scarce details. Because the book is arranged as chronological notes, some sense of notable people and careers can be discerned. Romanian text with picture captions summarized in English..

_____. "Early Photography in Eastern Europe: Romania," *History of Photography* Vol 1, No 1 (January 1977), pp 63- 77.

> A general article surveying the subject with only a few details on individuals. Most useful in conjunction with the author's Romanian-language book cited above.

Russia (also see U.S.S.R.):

Mamasakhlisi, A. V. "Early Photography in Georgia," *History of Photography* Vol 2, No 1 (January 1978), pp 75-84.

> A general article introducing the subject of a specific area within the context of Russia. Notes some individuals. No other available source in English. No bibliography.

Morozov, Sergei. "Early Photography in Eastern Europe: Russia," *History of Photography* Vol 1, No 4 (October 1977), pp 327-347.

> A general article on the subject. Gives details on several individuals as one of the few sources available in English. Most useful in conjunction with the author's Russian-language book cited next.

_____. *Russkaya khudozhestvennaya fotografiya, 1839-1917* [Russian Artistic Photography] (Moscow: Iskustvo), 1955, second edition 1961.

> Title cited and transliterated on page 347 of *History of Photography* Vol 1, No 4 (October 1977.) Only copy seen was a photocopy in the Royal Library of Denmark. The work is evidently a narrative history with some illustrations, but it does give notes on the careers of a number of early persons. It is unfortunately out of print and the author has died, so it is very difficult to locate.

_____. *Russkie putishestvenniki-fotografy* [Russian traveler-Photographers] (Moscow: Geographical State Publishers), 1953.

> Cited and transliterated on page 347 of *History of Photography* Vol 1, No 4 (October 1977).

Scotland (see United Kingdom)

Serbia (see Yugoslavia)

Spain:

Fontanella, Lee. *La Historia de la Fotografía en España* (Madrid: El Viso), 1981.

> Appendix A, pages 260-274, lists 19th-century photographers or studios by name with towns, addresses, and some date periods; Appendix B, pages 275-280, lists photographers grouped under town names.

Fontcuberta, Joan, et al. *Ideas & Chaos: Trends in Spanish Photography*, 1985.

> The section "Biographies" by Roser Barnich, pages 211-215, gives short entries on leading Spanish photographers for a significant period.

Mondejar, Publio Lopez. *Cónica de la Luz: Fotografía en Castilla-La Mancha (1855-1936)* ([n.p.]: Ediciónes El Viso for the Fundación Cultural de Castilla-La Mancha), 1984.

> Pages 179-201 give biographies, mostly with portraits, of eighty-nine photographers active in one region of Spain.

Sougez, Marie-Loup. *Historia de la Fotografía* (Madrid: Ediciónes Catedra, S.A.), 1981.

> Pages 207-255 give biographical details about many Spanish photographers.

Yañez Polo , Miguel Angel, et al. "Censo General de los Fotógrafos que han Operado en España desde 1839 a 1986," *Historia de la Fotografía Española* edited by Miguel

Angel Yañez Polo, Luis Ortiz Lara, and José Manuel Holgado Brenes (Sevilla, Spain: La Sociedad de la Fotografía Española), 1986, pp 519-609.

A ninety-page "Census" of photographers listed by name with some specific addresses, town locations, and periods of work. Other parts of the book include more detail about some individuals, particularly an appendix (pages 383-387), which analyzes the holdings of an archive in Valencia. Three other brief sections discuss early photography in Cuba, the Philippines, and Maracaibo, Venezuela. .

_____. "Sevilla 1842-1900: Sus Fotografos," *PhotoVision* #12 (1985), pp 5-7 [Spanish] and pp 42-46 [English].

A short illustrated article with biographies of a few of the earliest photographers of Seville, Spain. "Censo de Fotografos del Siglo XIX en Sevilla," page 43, is a listing of 123 photographers by name and date period.

Sweden:

Söderberg, Rolf, and Pär Rittsel. *Den Svenska Fotografins Historia 1840-1940* ([Stockholm?]: Bonnier Fakta), 1983.

A full-scale illustrated textual history that includes biographies and career summaries for dozens of Swedish photographers scattered through various sections of the text plus an extensive bibliography giving citations for individual persons.

Switzerland:

Breguet, Elizabeth. *100 Ans de Photographie Chez les Vaudois 1839-1939* (Lausanne, Switzerland: Payot), 1981.

Biographies of photographers are scattered through the text.

Il Ticino e i suoi Fotografi/Das Tessin und seine Photografen (Bern, Switzerland: Benteli), 1987 [also issued as an article in Vol 5 of *Schweizer Photographie* published by the Schweizerische Stiftung fur die Photographie].

An article in Italian and German on the photographers of one Swiss region. Gives a limited listing.

Loetscher, Hugo, et al., editors. *Photography in Switzerland* (Teufen, Switzerland: Niggli), 1974.

Includes a section of brief biographical career notes on Swiss photographers.

United Kingdom (England, Cornwall, Northern Ireland, Scotland, and Wales):

Adamson, Keith. *Commercial Photographers in Doncaster* [England] (Bath, England: Royal Photographic Society Historical Group Newsletter Supplement), 1982.

An eight-page listing of eighty-five commercial photographers operating between 1842 and 1938, compiled from local directories and newspapers.

_____. "More Early Studios," *Photographic Journal* [of the Royal Photographic Society] Vol 128, No 1 (1987), pp 32-36.

While not a directory, this article discusses the daguerreotype studios licensed by Richard Beard in 1842 in eight English cities.

_____. "Professional Photographers in Sheffield and Rotherham [England], 1843-1900," *Supplement to Royal Photographic Society Historical Group Newsletter* No 61 (June 1983).

A compilation of 220 Sheffield and thirty-four Rotherham professional photographers derived from newspapers and local directories.

_____. *Professional Photographers in York* (Bath, England: Royal Photographic Society Historical Group).

A true directory compiled from local city and business directories.

Adamson, Keith I. P. and Adrian Budge. "Professional Photographers in Leeds [England], 1842-1900," *Royal Photographic Society Historical Group Newsletter* Supplement (1983), pp 12.

A directory, compiled from newspapers and local directories, of 279 photographers active in one city.

Aston, C. E. J., M. Hallett, and J. McKenna. *Professional Photographers in Birmingham 1842-1914* (London: Historical Group Quarterly Supplement, Royal Photographic Society, and City of Birmingham Polytechnic), 1987.

Noted in *Photohistorica [Literature Index of the European Society for the History of Photography]* #34/35 (May 1988) as a listing "of 729 professional photographers compiled from local directories, magazines and newspapers."

Bloore, Carolyn. "Biographical Appendix," *Amateurs, Photography, and the Mid-Victorian Imagination* by Grace Seiberling with Carolyn Bloore (Chicago: The University of Chicago Press), 1986, pp 23-148.

Gives thirty-five biographies and several portraits of the members "of the Photographic Exchange Club [of Great Britain] and of most of the participants in the exchange within the [later Royal] Photographic Society" in 1855 and 1857, including major figures and several noteworthy amateurs.

Buchanan, William. "Photography Comes to Glasgow: A Survey of the Fifteen Years 1839-1854," *Scottish Photography Bulletin* (Spring 1988), pp 4-17.

An article with an extensive chronological approach, giving fair details of numerous early individuals including H. W. Treffrey, the first Glasgow photographer.

[Budge, Adrian]. "Index of Leeds Photographers, 1839-70," *Early Photography in Leeds 1839-1870* ([Leeds, England]: Leeds Art Galleries), 1981, pp 38-42.

Gives names, date periods, addresses, and comments for eighty-four professional and twenty-five amateur photographers.

_____. "Yorkshire & Photography: The Early Years," *The Photographic Collector* Vol 4, No 1 (1983), pp 10-23.

An article on aspects of early portrait studios, landscape photographers, and miscellaneous other photographers in Yorkshire, England.

Colbourn, M. *Photographers in Dyfed 1857-1920, (Cardiganshire, Carmathenshire, Pembrokeshire)*, Royal Photographic Society Historical Group Supplement #79 (1987).

An eight-page listing of photographers compiled from South Wales directories for the period.

Dimond, Frances, and Roger Taylor. *Crown & Camera: The Royal Family and Photography* 1842-1910 (Harmondsworth, Middlesex, England: Penguin Books), 1987

Pages 210-214 give an essay and a listing of photographers granted Royal Warrants in the reign of Queen Victoria. Pages 215-219 give biographical data for the photographers in the exhibition for which this work is the catalogue.

Gee, Ian, and Douglas Randell. *Victorian and Edwardian Photographers in Altrincham* (Bath, England: Royal Photographic Society Historical Group Supplement 88), 1988.

A comprehensive listing for the period 1863-1909 derived from city directories.

Gill, Arthur T. *Brighton* [England] *Photographers in Victorian Times: Compiled from Local Directories* (London: Royal Photographic Society Historical Group Leaflet), 1979.

An eight-page listing of 300 photographers active at more than 160 addresses between 1854 and 1898.

_____. *Photographers in Eastbourne [England] 1877-1910 Compiled from Local Directories: Supplement to Royal*

Photographic Society Historical Group Newsletter No 65 (Summer 1984).

Hallett, Michael. *Professional Photographers in Worcestershire 1851-1920* (Bath, England: Royal Photographic Society Historical Group).

A full directory compiled from local city and business directories.

Harker, Margaret F. "Select Biographies of the Links," *The Linked Ring: The Secession Movement in Photography in Britain, 1892-1910* (London: Heinemann—A Royal Photographic Society Publication), 1979, pp 145-164.

Gives reasonably detailed biographies of sixty-two members of The Linked Ring selected from a larger total membership.

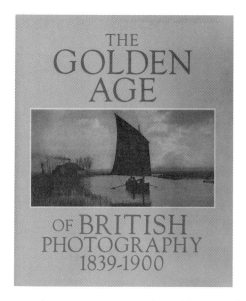

Haworth-Booth, Mark, editor. *The Golden Age of British Photography 1839-1900* ([Millerton, New York]: Aperture), 1984.

Gives biographies or career annotations on forty leading British photographers or groups along with samples of work and essays on various trends of the period.

Heathcote, Bernard V. and Pauline F. "The Feminine Influence: Aspects of the Role of Women in the Evolution of Photography in the British Isles," *History of Photography* Vol 12, No 3 (July-September 1988), pp 259-273.

A charming article giving a matrix of details for a table of twenty-two "Women who were proprietors of photographic studios in the British Isles, 1841-55," on page 271.

_____. *Leicester* [England] *Photographic Studios in Victorian and Edwardian Times* (Bath, England: Royal Photographic Society Historical Group), 1982.
> An eight-page listing of 179 photographers active between 1844 and 1910, compiled from trade directories.

_____. *Nottingham Photographic Studios in Victorian Times* (Bath, England: Royal Photographic Society Historical Group).
> A full-scale directory compiled from local city and business directories.

Heathcote, Pauline F. "The First Ten Years of the Daguerreotype in Nottingham," *History of Photography* Vol 2, No 4 (October 1978), pp 315-324.
> Very general article on the subject. Mentions the first few licensed daguerreotypists in the area but gives no biographical details.

Historical Group, Royal Photographic Society. [A continuing series of listings of photographers in various British towns, already including Cheltenham, Dorset, Glasgow, Gloucester, Hastings and St. Leonards, Herefordshire, and Wigan, as well as others noted separately above and below under their compilers.]

Jones, Stephen K. *The Commercial Camera in Cardiff 1855-1920: Including Caerphilly, Cogan and Penarth* (Bath, England: Royal Photographic Society Historical Group), 1980.
> A twelve-page list of commercial photographers in a few towns in Wales, compiled from local directories.

Linkman, Audrey, compiler. *Manchester Photographers 1901-1939* (Manchester, England: Documentary Photography Archive), [1988].
> A comprehensive listing derived from trade directories. Available from the publisher at Cavendish House, Cavendish Street, Manchester M15 6BG, England.

"List of Photographers," *Royal Photographic Society Historical Group Newsletter* Vol 61, (1983), p 10.
> A listing of twelve compilations of photographers active in various towns in Great Britain between 1840 and 1900.

McCoo, Don. *Paisley Photographers 1850-1900* (Glasgow, Scotland: Foulis Archive Press), 1986.
> A small booklet listing photographers in the area of Paisley, Scotland. Available directly from Don McCoo, 2 Millarston Drive, Paisley, Scotland PA1 2XD, Great Britain.

Middleton, C.S. *The Broadland Photographers* (Norwich, England: Wensum Books Ltd.), 1978.
> While not a directory in any true sense, the work gives biographical details and an extended sample of works by three significant photographers of a celebrated region of England: Peter Henry Emerson, George Christopher Davies, and J. Payne Jennings.

Murray, Hugh. *Photographers of York: The Early Years 1844-1879* (York, England: Yorkshire Architectural and York Archaeological Society in association with Sessions of York), 1986.
> The Appendix, pages 126-127, gives a list of thirty-four "Commercial Photographers in York 1844-1879."

Norgate, Martin, et al. *Photographers in Wiltshire* [Wiltshire Monograph No. 5] (Trowbridge, Wiltshire, England: Wiltshire Library & Museum Service), 1985.
> A relatively thorough examination of the photographic history of a single county. Reported by Peter Palmquist without details as to sources. Available in mimeographed form directly from the Library.

Pictorial Photography in Britain 1900-1920 (London), 1978, 95 pp.
> "Contains a chronology, biographies and a bibliography."

Pritchard, Michael. *A Directory of London Photographers 1841-1908* (Bushey, Hertfordshire, England: ALLM Books), 1986.
> A complete directory giving an alphabetical listing of individuals and studios, with addresses and date periods of occupancy for 2535 entries. One added section lists "Proprietors, managers and employees" with cross references to their studios, one gives "earliest known studios in [twenty-seven] selected towns and cities" elsewhere in England, and a map locates the nineteen cities where Richard Beard's daguerreotype licenses were granted. Available from ALLM Books, 21 Beechcroft Road, Bushey, Watford, Hertfordshire, WD2 2JU, England.

_____. *Victorian & Edwardian Photographers in Kingston-Upon-Hull & Beverly* [England] *Supplement to Royal Photographic Society Historical Group Newsletter* No 66 (Autumn 1984).

_____. *Victorian and Edwardian Photographers in Watford* [England] (Bath, England: Royal Photographic Society Historical Group Newsletter), 1980.
> A two-page listing of thirty-two photographers active between 1862 and 1910.

Read, Gillian. *Manchester* [England] *Photographers 1840-1900* (Bath, England: Royal Photographic Society Historical Group Newsletter Supplement), 1982.

> A twenty-page compilation of 800 photographers; described as "a useful aid to the dating of photographers and their work."

Smith, Bill, and Michael Pritchard, compilers. *Hertfordshire Photographers 1839-1939* (Stevenage, England: [n.p.]), 1985.

> A sixteen-page booklet listing around 300 photographers and "Allied Trades" by name, address, and working date period; gives some cross reference. Compiled mainly from regional directories. Mr. Smith is also noted as "researching photographers in [the town of] Hitchin and the north of the county [of Hertfordshire]."

Smith, Brian Turton. *Photographers in Bath* [England] *1841-1910: Compiled from Local Directories* (Bath, England: Royal Photographic Society Historical Group), 1980.

> An eight-page listing of 167 photographers.

Smith, Mervyn L. *Photographers in Abingdon* [England] *1863-1909* (London: Royal Photographic Society Supplementary Publication No. 44), 1979.

> A listing of eleven photographers with some added notes on family histories.

Stevenson, Sara, and A. D. Morrison-Low. *Scottish Photography, A Bibliography: 1839-1989* (Glasgow, Scotland: Salvia Books in conjunction with the Scottish Society for the History of Photography), 1990.

> A forty-eight-page bibliography "compiled to help those interested in Scottish photography to find out more about individual photographers, either from contemporary journals or later historical assessments . . . For inclusion [a] photographer must either have been born in Scotland or practiced photography in the country." Can be ordered directly from Ray McKenzie, Treasurer, Scottish Society for the History of Photography, Glasgow School of Art, 167 Renfrew Street, Glasgow, Scotland G3 6RQ, United Kingdom.

_____. *Professional Photographers in Oxford* [England] (Bath, England: Royal Photographic Society Historical Group Newsletter Supplement), 1982.

> A four-page list compiled from local directories covering the period 1842-1910.

Stewart, E. *Portrait Photographers in Glasgow* [Scotland] *1853-1904* (Unpublished dissertation done at the Glasgow School of Art), 1983.

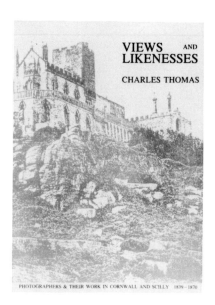

Thomas, Charles. *Views and Likenesses: Photographers & Their Work in Cornwall and Scilly 1839-1870* (Truro, Cornwall: Royal Institution of Cornwall), 1988.

> The entire book is an illustrated biographical compilation on the lives and works of the photographers of this area. A two-page appendix adds details in a "Preliminary List of Professional Photographers in Cornwall and Scilly, By Decades, 1871-1900."

Victoria's World: A Photographic Portrait Drawn from the Gernsheim Collection (Austin, Texas: The Art Museum of the University of Texas), 1968.

> The section "19th Century Photographers" gives brief biographies or career sketches for forty-three photographers or firms, mainly British.

Walker, Brian Mercer. *Shadows on Glass: A Portfolio of Early Ulster Photography* (Belfast, Northern Ireland: The Appletree Press Ltd.), 1976.

> Gives one–or two–page biographical sections on eleven photographers active in Northern Ireland on either side of 1900.

Wilson, J. *Professional Photographers in Kingston-upon-Thames and Surrounding Areas 1854-1911* ([n. p.]: Kingston upon Thames Heritage Centre and the Historical Group of the Royal Photographic Society), 1984.

> A fifteen-page listing of 157 commercial photographers compiled mainly from local directories.

U.S.S.R. (also see Russia):

Mrázková, Daniela, and Vladimir Remes. *Early Soviet Photographers* (Oxford, England: Council of the Museum

of Modern Art), 1982.

> The section "The Photographers," pages 86-87, gives short biographies of sixteen of the primary photographers of the period between the 1917 Revolution and World War II.

Morozov, Sergei. *Sovetskaya Khudozhestvennaya fotografiya* [Soviet Artistic Photography] (Moscow: Iskusstvo Press), 1958.

> Cited and transliterated on page 347 of *History of Photography* Vol 1, No 4 (October 1977).

Shudakov, Grigory, Olga Suslova, and Lilya Ukhtomskaya. *Pioneers of Soviet Photography* (New York: Thames and Hudson), 1983.

> The section "Biographies" by Aleksandr Lavrentiev, pages 249-252, gives solid information on twenty photographers from the initial period of the U.S.S.R. The essay "Soviet Photographers, 1917-1940" by Grigroy Shudakov, pages 9-27, comprises a short history of Russian photography from the beginning in the 19th century and gives at least life dates for numerous Soviet photographers not detailed in the "Biographies."

Wales (see United Kingdom)

Yugoslavia:

Debeljkovič, Branibor. *Die Alte Serbische Photographie* (Beograd, Yugoslavia: Museum für Angewandte Kunst), 1980.

> While not a directory, this exhibit catalogue covers the period from the first photographer of the Serbian region, Anastas Jovanovič, in 1841 to World War I. A survey text in German and eighty-two plates with dates and some attributions give information otherwise not available.

Grčevič, Nada. "Early Serbian Photography," *History of Photography* Vol 3, No 3 (July 1979), pp 233-252.

> A very general article surveying the development of Serbian photography. Gives slight biographical or career information on a few individuals but is outweighed by the item cited above except for being in English and offering a useful bibliography. This issue of *History of Photography* also carries a related article, "The Roots of Modern Photography in Czechoslovakia" by Peter Tausk, pages 253-271.

_____. "Early Photography in Eastern Europe: Croatia," *History of Photography* Vol 1, No 2 (April 1977), pp 153-167.

> A general article introducing the subject and giving a few

details on individuals. Most useful in conjunction with the author's Croatian-language book cited next .

_____. *Fotografija Devetnaestog Stoljeća u Hrvatskoj* (Zagreb, [Yugoslavia]: Drustvo Povjesničara Umjetnosti Hrvatske), 1981.

> A full-volume illustrated textual history of photography in the Croatian area of modern Yugoslavia; includes a three-page listing by town of early photographers. Text in Serbo-Croatian.

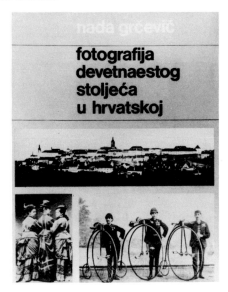

5. Latin America:

General and International:

Billeter, Erika, et al. *Fotografie—Lateinamerika von 1860 bis Heute* (Bern, Switzerland: Benteli Verlag), 1981.

> An expansive exhibition catalogue with informative essays by several leaders in the field of Latin-American photographic research. Pages 381-399, "Biografien der Fotografen," give information on several dozen photographers ranging from Mexico south to Argentina and into the Caribbean. Portraits of many persons are given and sections of reproductions of work by most are included. German text but was also issued in an English edition; emphasizes recent period but gives details for some noteworthy early people.

Crovetto, Pier Luigi, and Ernesto Franco. *PhotoAmerica: Obiettivi sull' America Latina* (Ivrea, Italy: Herodote).

> Catalogue in Italian for a large exhibition overview of photography of Latin America in the 20th–century. Pages 149-156 give biographical and career data on ninety-seven photographers from all nations of the region.

Hoffenberg, H. L. *Nineteenth-Century South America in Photographs* (New York: Dover Publications, Inc.), 1982.
Page 152 offers a "partial list of the photographers represented in this volume," noting twenty-four individuals with some dates and reference notes.

Testimonios Escritos Relativos al Origen de la Fotografía Rioplatense (Buenos Aires: C.I.F.A.A.), 1987.
A volume of facsimile texts from the early period of photography in the Argentina-Brazil-Uruguay borderlands. Some texts give particulars on individuals significant in the introduction of the medium in various areas.

Argentina:

Asociación Amigos del Museo de Arte Moderno. *Vida Argentina en Fotos* (Buenos Aires: Centro Cultural Ciudad de Buenos Aires Museo de Arte Moderno), 1981.
An illustrated exhibition catalogue for an overview of the history of Argentine photography. A five-page section, "Datos biograficos," gives limited details on sixty-nine photographers or organizations throughout the history of photography, including some, such as Nadar, who were never in the country.

Casaballe, Amado Becquer, and M. A. Cuarterolo. *Imágenes del Río de la Plata: Cronica de la Fotografía Rioplatense, 1840-1940* (Buenos Aires, Argentina: Editorial del Fotógrafo), 1985.
Review in *History of Photography* Vol 13, No 1 January-February 1989], pp 104-105 indicates coverage of early history in Brazil, Uruguay, and Argentina. A two-page "Catalogue of the Principal Photographers" active in the 19th–century gives locations and decades for over sixty persons.

Gómez, Juan. *La Fotografía en la Argentina, su Historia y Evolución en el Siglo XIX, 1840-1899* (Buenos Aires: Abadía Editora), 1986.
A full volume on the early Argentine history of photography. For a reduced treatment in English, see the next item below.

_____. "Photography in Argentina: History and Evolution in the 19th Century," *History of Photography* Vol 14, No 2 (April-June 1990), pp 181-193.
A general text article reduced into English from the publication next above. Gives some biographical and career details on a number of early photographers.

Riobó, Julio Felipe. *La Daguerrotipia y los Daguerrotipos en Buenos Aires* (Buenos Aires: [probably self-published]),

1949.
One of the early historical treatments in South America. A general text rather than a directory but useful for details on some individuals.

Brazil:

Ferrez, Gilberto. *A Fotografia No Brasil 1840-1900* (Rio de Janeiro: Fundação Nacional de Arts and Fundação Nacional Pró-Memória), 1985.
A full textual survey of 19th-century photography in Brazil with many illustrations. No separate biographical material but extensive information throughout. Portuguese text.

_____. *Bahia: Velhas Fotografias 1858/1900* (Rio de Janeiro: Livraria Kosmos Editora), 1988.
A full-scale history of early photography of the Bahia region of Brazil. Seven individuals or firms are discussed and work illustrated. Portuguese text.

Ferrez, Gilberto, translated by Stella de Sá Rego. *Photography in Brazil, 1840-1900* (Albuquerque: University of New Mexico Press), 1990.
A complete English edition of the author's *A Fotografia No Brasil*, cited above.

Ferrez, Gilberto, and Weston J. Naef. *Pioneer Photographers of Brazil 1840-1920* (New York: The Center for Inter-American Relations), 1976.
Gives text details and selections of work for fifteen early photographers or studios with occasional mention of others.

Kossoy, Boris. *Origins e Expansão de Fotografia no Brasil: Século XIX* (Rio de Janeiro: Edisão Funarte), 1980.
Includes an appendix listing several Nineteenth century photographers with dates and addresses.

Vasquez, Pedro. *Brazilian Photography in the Nineteenth Century* (Rio de Janeiro: Museu de Arte Moderno de Rio de Janeiro), [1988].
A fourteen-page fold-up exhibit catalogue giving general historical information without specific biographical notes. Largely an English version of the opening sections of the following book.

_____. *Dom Pedro II e A Fotografia No Brasil* (Rio de Janeiro: Fundação Roberto Marinho and Companhia Internacional de Seguros), [1988?].
A full and extensively illustrated history of early photography in Brazil with emphasis on the encouraging interest

in the medium by the Emperor. No separate biographical material but a one-page list with dates of appointment of the photographers to the imperial household. Portuguese text.

Chile:

Rodriques Villegas, Hernán. "Historia de la Fotografía en Chile: Registro de Daguerrotipistas, Fotógrafos, Reporteros Graficos y Camarógrafos—1840-1940," *Boletin de la Academia Chilena de la Historia* No 96 (1985), pp 189-340.

> The only published item thus far located for a major nation of South America. Has also been issued as an offprint in a severely limited edition briefly available through the Pajerski catalogue. Spanish language. Reported by Steven Joseph as having an "extensive listing of photographers."

Colombia:

Pasto: A Través de la Fotografía ([Bogotá, Colombia]: Banco de la Republica), [1986?].

> Described in Pajerski Catalogue 9 as photographs 1900-1940s of a town in southwest Colombia and including a "list of photographers active there in 19th & 20th centuries," by decade, covering thirty-three persons.

Serrano, Eduardo. *Historia de la Fotografía en Colombia* ([Bogotá, Colombia: Museo de Arte Moderna de Bogotá]), 1983.

> The section "Fotógrafos Colombianos 1840-1950," pages 317-325, compiled by Myriam Acevedo, provides short biographies for numerous photographers as a detailed reference supplement to one of the most elaborately produced books thus far in the field.

Cuba (also see Spain):

Salon and Picturesque Photography in Cuba, 1860-1920: The Ramiro Fernandez Collection (Daytona Beach, Florida: Museum of Arts and Science), 1988.

> An exhibition catalogue noted in Pajerski Catalogue 9 as giving a "wide variety of Cuban images, with a chronological review of Cuban photography."

Guatemala:

Del Cid F., Enrique. "Primeros Fotógrafos que Trabajaron en esta Guatemala de la Asunción," *El Imparcial* (September 2 and 17, 1962).

> A two-part newspaper article on the early photographers of Guatemala City. Cited as a source for the Muñoz chapter noted below.

Muñoz, Luis Luján. "La Fotografía en Guatemala" [Chapter 3 of] *Fotografías de Eduardo Santiago Muybridge en Guatemala (1875)* (Guatemala City: Cenaltex, Biblioteca Nacianal de Guatemala), 1984.

> An extended catalogue for an exhibition prepared by the National Museum of History and the National Library. This chapter gives a textual survey of the history of photography in the country with some dates and details on a number of individuals.

Mexico:

Casanova, Rosa, and Olivier Debroise. "Directorio de Daguerrotipistas, Ambrotipistas y Fotógrafos [Directory of Daguerreotypists, Ambrotypists, and Photographers]," *Sobre la Superficie Bruñida de un Espejo: Fotógrafos del Siglo XIX* (Mexico City: Fondo de Económica), 1989, pp 54-63.

> The section of a general text history of the first two decades gives entries for ninety-one persons or firms, including previously unknown details on a number of daguerreotypists from the United States.

Fernandez Ledesma, Enrique. "Nomina de los Más Notables Daguerrotipistas, Ambrotipistas y Fotógrafos, que Trabajaron en la Ciudad de México y en Otros Lugares del País, de 1845 a 1880," *La Gracia de los Retratos Antiguos* (Mexico City: Ediciones Mexicanas, S.A.), 1950, pp 148-156.

> Lists about 140 early photographers by place only.

Verdugo, René, et al. "Cronología de fotógrafos en México," *Imagen Historica de la Fotografía en México* (Mexico City: Instituto Nacional de Antropología e Historia), 1978, pp 36-38.

Includes an admittedly incomplete listing by approximate date periods of daguerreotypists in Mexico City, some photographers active in scattered towns elsewhere in the country during the 19th Century, and some notable photographers active in the 20th Century up to 1940. The form of presentation makes the chronology hard to use.

Peru:

McElroy, Keith. *Early Peruvian Photography: A Critical Case Study* (Ann Arbor, Michigan: UMI Research Press), 1985.

> Appendix A, "Photographers Documented as Active in Peru in the Nineteenth Century," pages 87-90, lists 111 photographers by name, dates, and locales.

_____. *Fotografía en el Perú: Siglo XIX* (Lima, Peru: Galería del Banco Continental), [1975].

> Gives listing of 123 photographers active in Peru during the 19th–century. Spanish text.

_____. "The Daguerrean Era in Peru, 1839-1859," *History of Photography* Vol 3, No 2 (April 1979), pp 111-123.

> A general article on the subject; mentions some individuals and gives a chart of working date periods for several. A shorter version of the item cited next above.

Surinam:

Wachlin, Steven. "Survey of Photography in Surinam 1839-1939," *Photography in Surinam* (Amsterdam: Fragment Uitgeverij and Museum voor Volkenkunde, Rotterdam), 1990.

> A section of over fifty biographical sketches of mainly commercial photographers who worked in this former Dutch colony before 1940. Well illustrated and researched, as are the other items in this series. Dutch and English texts.

Venezuela (see Spain)

6. Middle East:

General and International:

Beelden van de Orient/Images of the Orient: Photography and Tourism 1860-1900 (Amsterdam: Fragment Uitgeverij in cooperation with the Museum voor Volkenkunde, Rotterdam), 1986.

> Pages 88-89 give brief sketches on the thirteen photographers featured in the book as having worked in the Middle East; parallel texts in Dutch and English.

Chevedden, Paul E. *The Photographic Heritage of the Middle East: An Exhibition of Early Photographs of Egypt, Palestine, Syria, Turkey, Greece, & Iran, 1849-1893* (Malibu, California: Undena Publications), 1981; also published as pages 67-106 of *Occasional Papers on the Near East*, Vol I in the system *Monographic Journals of the Near East*.

> Gives limited data on nine photographers or firms. Contains some common errors.

Çizgen, Engin. *Photography in the Ottoman Empire 1839-1919* (Istanbul, Turkey: Haşet Kitabevi A.Ş.), 1987.

> A full-scale illustrated history of photography throughout the Middle East. Pages 46-179 offer a general listing and map along with biographies for dozens of firms and photographers previously known only as surnames on old pictures. A major contribution. Available through dealers or directly from the publisher: Haşet Kitabevi A.Ş., 469 Istiklal Caddesi, Beyoğlu-Istanbul, Turkey.

[Dewitz, Bodo von, editor.] *An der Süssen Ufern Asiens— Ägypten, Palastina, Osmanisches Reich: Reiseziele des 19. Jahrhunderts in Frühen Photographien* (Köln: Agfa Foto-Historama), 1988.

> A catalogue for an exhibition held in the Römish-Germanischen Museum 7 October-4 December 1988. The "Katalog," pages 147-168, lists the 129 pieces in the exhibit and gives limited biographical or career information for twenty-seven photographers or firms, including a few not seen elsewhere. Text in German.

Faber, Paul, et al., editors. *Images of the Orient: Photography and Tourism 1860-1900* (Amsterdam: Fragment Uitgeverij for Museum voor Volkenkunde, Rotterdam), 1986.

> An exhibit catalogue covering North Africa and the Middle East rather than the Asian area. Limited biographical data are given on thirteen individuals or firms. Dutch and English texts.

Perez, Nissan N. *Focus East: Early Photography in the Near East (1839-1885)* (New York: Harry N. Abrams, Inc. in association with The Domino Press, Jerusalem, and The Israel Museum), 1988.

> "Part II—A to Z of Photographers Working in the Near East," pages 123-233, gives career or biographical data for 257 photographers or firms active during the first four decades of the medium. The geographic coverage is relatively restricted, mainly touching Egypt, Palestine, and Syria, with slight notice of Arabia and Lebanon.

Thomas, Ritchie. "Some 19th Century Photographers in Syria, Palestine and Egypt," *History of Photography* Vol 3,

No 2 (April 1979), pp 157-166.

A general article discussing the commerce of tourist photography in the later 19th century; gives business date periods for some individuals.

Vaczek, Louis, and Gail Buckland, editors. *Travelers in Ancient Lands: A Portrait of the Middle East, 1839-1919* (Boston: New York Graphic Society), 1981.

Includes appendix catalogue of photographers with estimated periods of work, locations, and some biographical notes—not very complete or extensive.

Egypt (also see Africa):

Jammes, Marie-Thérèse, and André Jammes. *En Egypte en Temps de Flaubert: Les Premiers Photographes 1839-1860* ([Vincennes, France]: Departement des Relations Publiques de Kodak-Pathé), [n.d.].

A handsome small exhibition catalogue which gives a short essay, illustrations, and biographical data on eleven primary photographers of the area.

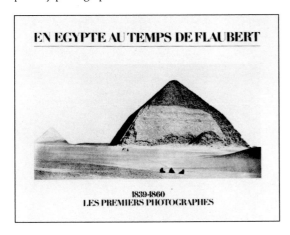

Osman, C. "Postcards from Egypt," *Royal Photographic Society Historical Group Newsletter* No. 64 (1984), pp 10-13.

As reported in *Photohistoria: Literature Index of the European Society on Photography* (December 1984-January 1985), "The article mentions names of several photographers active in Egypt between 1890 and 1914."

Iran:

Stein, Donna. "Early Photography in Iran," *History of Photography* Vol 7, No 4 (October-December 1983), pp 257-291.

An article reflecting solid research and sources. While not a directory as such, the text is extensive in treatment of the subject and discusses four early photographers in some depth, including the Shah Nasr ed-din. Essentially the only readily available western material on the subject.

_____. "Recent Research on the History of Photography in Iran," *History of Photography* Vol 10, No 1 (January-March 1986), p 82.

Basically a letter, this item gives bibliographic citations for three published works which, taken together, appear to provide some listings and career details on a number of early photographers in Persia/Iran.

Palestine:

Onne, Eyal. *Jerusalem: Profile of a Changing City* (Jerusalem: Mishkenot Sha'ananim and The Jerusalem Institute for Israel Studies), 1985.

Review in *History of Photography* (October-December 1986) notes a "table of photographers" and mentions that attention is given to local photographers as well as the famous ones. Emphasis is on the 19th–century. Text in English and Hebrew.

_____. *Photographic Heritage of the Holy Land 1839-1914* (Manchester, England: Institute of Advanced Studies, Manchester Polytechnic), 1980.

Includes a "General name index of photographers who worked in the Holy Land" covering 131 individuals or groups and giving some details of nationality, technique, notable publications, and date periods. Some errors.

Turkey:

Allen, William. "Sixty-nine Istanbul Photographers, 1887-1914," *Shadow and Substance: Essays on the History of Photography in Honor of Heinz K. Henisch* edited by Kathleen Collins (Bloomfield Hills, Michigan: The Amorphous Institute Press), 1990, pp 127-136.

An illustrated article briefly discussing the character of late 19th–century commercial photography in the capital of the Ottoman Empire. Photographers are listed alphabetically with street addresses and years of citation for their appearance in the Annuaire Oriental du Commerce. While this annual business directory was published from 1880 until "well into the 20th–century," the listing here has been derived from only seven scattered volumes, these being all so far available to the compiler.

7. North America:

General and International:

Darrah, William Culp. "Nineteenth-Century Women Photographers," *Shadow and Substance: Essays on the History of Photography in Honor of Heinz K. Henisch* edited by Kathleen Collins (Bloomfield Hills, Michigan: The

Amorphous Institute Press), 1990, pp 89-103.

>One of Prof. Darrah's last published contributions to the field is an article explaining the working methods and limitations he imposed upon his research in addressing this topic. Pages 98-103, "A Checklist of American Women Photographers," comprise an alphabetical listing by name, general locations, and estimated decades of work in the 19th–century for 272 women recorded exclusively from card-mount imprints. While the listing is admittedly incomplete and at times in error, it offers the first continent-wide effort in published form to deal with the subject. The title of the listing is misleading in that a number of entries included are from Canada.

Di Laura, Mark A. "Niagara Falls," *Stereo World* Vol 17, No 4 (September/October 1990), pp 4-23.

>The first part of a three-section article on photographers of Niagara Falls. While this section gives primary attention to Charles Bierstadt, it does so in a context of dealing with other persons active at the time. Parts 2 and 3 center similarly on George Barker and George E. Curtis, so that the total offers considerable detail on a number of individuals.

Canada:

Burant, James. *Photographers and Photographic Studios, St. John, New Brunswick 1845-65* (Ottawa: National Photography Collections, Public Archives of Canada), 1973.

>A comprehensive directory for the pre-Confederation period covered. Available directly from the publisher at 395 Wellington Street, Ottawa, Ontario K1A ON3, Canada.

_____. *Photography in Pre-Confederation Halifax* [Nova Scotia] *1839-1867* (Ottawa: National Photography Collection, Public Archives of Canada), 1975.

>A comprehensive directory for the period covered. Available directly from the publisher at 395 Wellington Street, Ottawa, Ontario K1A ON3, Canada.

_____. "Pre-Confederation Photography in Halifax, Nova Scotia," *The Journal of Canadian Art History* Vol IV, No 1 (Spring 1977), pp 25-44.

>An article utilizing some of the research from the item cited next above.

Harper, J. Russell. "Daguerreotypists and Portrait Takers in Saint John [New Brunswick]," *The Dalhousie Review* Vol XXXV (1955).

>An article offering some details on a number of primary individuals.

Koltun, Lilly. *Pre-Confederation Photography in Toronto* (Ottawa: National Photography Collection, Public Archives of Canada), 1976.

>A comprehensive treatment; pages 58-165 comprise a directory of early Ontario photographers 1839-1867. Available directly from the publisher at 395 Wellington Street, Ottawa, Ontario K1A ON3, Canada.

Koltun, Lilly, editor, et al. *Private Realms of Light: Amateur Photography in Canada/1839-1940* (Markham, Ontario: Fitzhenry & Whiteside), 1983.

>The major catalogue for an exhibition held at Public Archives Canada in 1983. Five sequential chapters were written by members of the Archives staff to cover the entire period of amateur work in Canada. The section "Biographies of Photographers," pages 304-328, gives extensive details for fifty-seven significant persons, often giving portraits, collections holdings, and facsimile signatures. Altogether a substantial and valuable contribution worthy of wide emulation.

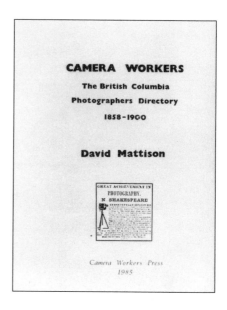

Mattison, David. *Camera Workers: The British Columbia Photographers Directory 1858-1900* ([Victoria, British Columbia]: Camera Workers Press), 1985.

>A full-scale directory of over one hundred pages; includes biographical dates, samples of logos or print marks, samples of advertising, a geographical index, and a date index. Available at about $21 Canadian pre-paid from David Mattison, 2236 Kinross Avenue, Victoria, British Columbia V8R 2N5, Canada.

_____. *Eyes of a City: Early Vancouver Photographers 1868-1900* [City of Vancouver Archives Occasional Paper No 3] (Vancouver, British Columbia: City of Vancouver

Archives), August 1986.
> Page 73 gives a list of "Vancouver Commercial Photographers and Studios, 1886-1900."

Robson, Scott, and Shelagh MacKenzie. *An Atlantic Album: Photographs of the Atlantic Provinces, before 1920* (Halifax, Nova Scotia: Nimbus Publishing Limited), 1985.
> "Biographical Notes on the Photographers" [pages 159-164] give short accounts of the lives of thirty-four photographers, mainly active in new Brunswick, Newfoundland, Nova Scotia, and Prince Edward Island. Includes a brief but useful bibliography.

Rowat, Theresa. "Photography in Prince Edward Island 1839-1873," *Photographic Canadiana* Vol 13, No 1 (1987), pp 2-7.
> An article on the early history of photography in Prince Edward Island beginning with the first daguerreotypist, J. W. Wilmot, who opened in Charlottetown in 1842.

Schwartz, Joan M. *Images of Early British Columbia: Landscape Photography, 1858-1888* (Unpublished Master's thesis done at the University of British Columbia), 1977.
> Includes a chapter on "Photographers of Early British Columbia."

Triggs, Stanley G. and William Notman. *The Stamp of a Studio* (Toronto: Coach House Press for Art Gallery of Toronto), 1985.
> Pages 163-166 offer "Biographies of the Montreal Studio Photographers."

United States:

General and Regional:

Darrah, William C. *Nineteenth Century North American Women Photographers*.
> Reported in *Stereo World* (May/June 1985), p 32, as a computerized list of over 200 women photographers. Previously available directly from the compiler, but now uncertain since he has died.

_____. *Stereo Views* (Gettysburg, Pennsylvania: Times and News Publishing Co.), 1961.
> Gives listing state by state and rough time period of 1000 American stereo photographers; earlier and less certain version of Darrah's *The World of Stereographs* noted above under "General and International."

Drake, Greg. "Nineteenth-Century Photography in the Upper Connecticut Valley: An Annotated Checklist,"
Dartmouth College Library Bulletin Vol XXV (NS), No 2 (April 1985), pp 72-91.
> Lists 125 photographers of a region partly in Vermont and partly in New Hampshire, giving biographical details for several persons.

Fleming, Paula Richardson, and Judith Luskey. *The North American Indians in Early Photographs* (New York: Harper & Row, Publishers), 1986.
> A full study of the photographing of the North America Indians, extensively illustrated. The first serious effort to straighten out the many confused attributions of this field. In addition to the textual information, two sections function as directories of early photographers: "Appendix 1 Delegation Photographers c. 1840-c. 1900" (pages 230-232) and "Appendix 2 Selected Frontier Indian Photographers c. 1840-c. 1900" (pages 232-245).

Jutzi, Alan. *Prominent American Photographers*.
> A listing by photographer of information and holdings in the Henry E. Huntington Library, 1151 Oxford Road, San Marino, California 91108.

Kelbaugh, Ross J. *Directory of Civil War Photographers* (Baltimore, Maryland: Historic Graphics), 1990, Vol I.
> Covering Maryland, Delaware, the District of Columbia, and parts of Virginia and West Virginia, this is the first of a projected six volumes based on federal tax records. This volume lists over 700 individuals. Available for US$10.95 plus shipping cost directly from the compiler at Historic Graphics, 7023 Deerfield Road, Baltimore, Maryland 21208.

Ketchum, Robert Glenn. *Photographic Directions: Los Angeles, 1979* ([Los Angeles]: Security Pacific Bank), 1979
> Back section of fourteen pages gives biographical chronologies for the thirty-eight American photographers included in the exhibition.

Mautz, Carl. *Checklist of Western Photographers: A Reference Workbook* (Brownsville, California: Folk Image Publishing), 1986.
> Covers twenty-two states or territories plus "Indian Territory" and "Traveling Photographers." Admittedly incomplete, this work touches several areas thus far unexamined in any other public form. Some errors of spelling and locations but gives names, approximate dates, and locations for over 4500 photographers. Available from Folk Image Publishing, P.O. Box 9, Brownsville, California 95919, U.S.A.

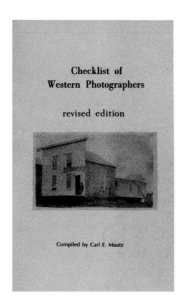

Checklist of
Western Photographers

revised edition

Compiled by Carl E. Mautz

Moutoussamy-Ashe, Jeanne. *Viewfinders: Black Women Photographers* (New York: Dodd, Mead & Company), 1986.

A general history with illustrations and sections detailing some careers. Pages 177-182, "Bio-Bibliography," gives brief citations of biographies for forty-three persons 1860-1960. A following "General Listing: 1860-1980" simply lists names in two sections and then rearranges into a "Geographical Index."

Newhall, Beaumont. *The Daguerreotype in America* (Greenwich, Connecticut: New York Graphic Society), 1968, pp 139-156.

Section gives biographical data, notes on bodies of work, and bibliographic citations for further research.

Ouimet, Beth. "Dobyns & Company: River City Daguerreian Network," The Daguerreian Annual 1990: *Official Yearbook of The Daguerreian Society* edited by Peter E. Palmquist, pp 42-50.

While an article rather than a directory, this item gives scattered but substantial details of dates and locations for about twenty daguerreotypists involved with Dobyns's chain of galleries in eight cities, mainly of the southeastern quarter of the United States.

Rinhart, Floyd, and Marion Rinhart. *American Daguerreian Art* (New York: Clarkson N. Potter, Inc.), 1967, pp 112- 131.

Section gives biographical notes on several notable American daguerreotypists.

_____. *The American Daguerreotype* (Athens, Georgia: The University of Georgia Press), 1981.

Gives many short biographies.

Robinson, William F. *A Certain Slant of Light: The First Hundred Years of New England Photography* (Boston: New York Graphic Society), 1980.

"Checklist of Photographers and Their Work," pages 220-234, lists eighty–four individuals and firms with limited biographical data, notes on bodies of work, and bibliographical citations.

Smith, James H., & Co. ["A list of all the professional photographers in the United States and Canada"] (Chicago: James H. Smith & Co.), 1893.

Noted in Wilson's *Photographic Magazine* Vol XXX, No 439 (July 1893), p 327, with the added comment that "No amateurs or employes [sic] are included. It was largely compiled by *direct correspondence*, and it is, therefore a list which is as nearly *perfect* and *reliable* as it is possible to secure. It contains the names and addresses of 9170 photographers in the United States and 500 in Canada, alphabetically arranged." While clearly not biographical in nature, this source would be as nearly comprehensive for its early period as anything else ever done. Unfortunately so rare that no copy has yet been located by this researcher or several others who have reported this notice.

Trachtenberg, Alan; Peter Neill; and Peter C. Bunnell; editors. "Glossary [sic] of Photographers," *The City: American Experience* (New York: Oxford University Press), 1971, pp 615-620.

Gives brief biographical notes on the fifty-four photographers from 1840 to 1970 included in the anthology of text and pictures.

Turner, William A. *Even More Confederate Faces* [Available directly from the compiler at 6917 Briarcliff Drive, Clinton, Maryland 20735].

Includes 300 mostly unpublished photographs, a "profile" of the firm of Bendann Bros. of Baltimore, and a "listing of over 100 known photographers of Confederate soldiers." No dates are given; most names have addresses.

Union Guide to Photograph Collections in the Pacific Northwest (Portland, Oregon: Oregon Historical Society), 1978.

Scattered biographical and limited other data throughout the entries about specific picture collections in Idaho, Montana, Oregon, and Washington. Pages 405-408 comprise a "Photographers Index" which allows particular entries to be located.

Welling, William. *Photography in America—The Formative Years 1839-1900* (New York: Thomas Y. Crowell Company), 1978.

General format is year-by-year chronology of persons and events. Page 77 reproduces 1850 "Daguerreian Artists' Register" from the first issue of *The Daguerreian Journal*; page 85 reproduces 1851 list of officers and delegates attending the first convention of the New York State Daguerrean Association in Utica.

Willis-Thomas, Deborah. *An Illustrated Bio-Bibliography of Black Photographers 1940-1988* (New York: Garland Publishing, Inc.), 1988.

A 495-page volume giving full biographical and career entries for 177 photographers plus name, date, and geographical citations for 235 others.

_____. *Black Photographers, 1840-1940: An Illustrated Bio-Bibliography* (New York: Garland Publishing,Inc.), 1985.

A book of 159 pages covering approximately seventy Black American photographers. Quite limited text but gives brief biographies, lists of principal subjects, collection lists, bibliographies, and reproductions of pictures. Reviewed as being somewhat hard to use.

Witham, George F., compiler. *Catalogue of Civil War Photographers: A Listing of Civil War Photographers' Imprints* ([Portland, Oregon: Privately published]), 1988.

Listing of over 1700 "Civil-War Photographers" alphabetically arranged by state or territory. Available at US$5.85 postpaid from George F. Witham, 724 N.E. 68th, Portland, Oregon 97213, U.S.A.

Arizona:

Daniels, David. "Photography's Wet-Plate Interlude in Arizona Territory: 1864-1880," *The Journal of Arizona History* Vol IX, No 4 (Winter 1968), pp 171-194.

Hooper, Bruce. "Camera on the Mogollon Rim: Nineteenth Century Photography in Flagstaff, Arizona Territory, 1867-1916," *History of Photography* Vol 12, No 2 (April-June 1988), pp 93-100.

An article with extensively scattered details rather than a true directory.

_____. "Chronology of Commercial Photography and Stereography in Arizona Territory," in "Arizona Territorial Stereography—Part IV," *Stereo World* Vol 13, No 4 (September/October 1986), pp 29 and 48.

A very brief synoptic chronology derived by compressing

details from a series of articles on the topic. Helps establish date periods for a number of notable photographers.

_____. "Stoneman Lake: One of Arizona's Early Tourist Attractions Stereographed by D. F. Mitchell and W. H. Williscraft, 1875-1883," *Stereo World* Vol 12, No 4 (September/October 1985), pp 37-40 and 47.

Page 47 gives a column of "Photography in Prescott, 1874-1886," with names, working periods, and locations for several located or visiting photographers in one Arizona town.

McLaughlin, Herb and Dorothy. *Phoenix 1870-1970 in Photographs* ([n. p.] Arizona Photographic Association), 1970.

Page 28 offers a list of twenty-nine persons or firms active "in and around Phoenix prior to 1920."

Vaughn, Tom. *Bisbee [Arizona] 1880-1920: The Photographer's View* (Bisbee, Arizona: Cochise Fine Arts, Inc. and Bisbee Council on the Arts & Humanities, Inc.), 1980.

Exhibit catalogue rather than an actual directory but gives full listing of pictures in exhibit with photographers and image dates, making some extrapolation possible.

California:

Caddick, James L. *Directory of Photographers in the San Francisco Bay Area to 1900* ([San Francisco: Privately compiled]), 1985.

A computerized directory of photographers in towns surrounding San Francisco Bay. Apply directly to the compiler at 420 35th Avenue, San Francisco, California 94121.

Gates, R. B., compiler. *Early Santa Barbara Photographers* (1973).

Unpublished typescript listing held by the Santa Barbara Historical Society, Box 578, Santa Barbara, California 93102.

Hathaway, Pat. *Photographers of Monterey County, California 1870-1900* (Unpublished typescript listing held by the author, 568 Lighthouse Avenue, Pacific Grove, California 93950).

Hitchcock, Ruth, compiler. *Tehama County, California Photographers 1850-1900* (Unpublished typescript held by the Tehama County Historical Society, Red Bluff, California 96080).

Kobal, John. *The Art of the Great Hollywood Portrait Photographers* (New York: Alfred A. Knopf), 1980.

Includes somewhat informative listing of overlooked photographers in this specialized genre.

Palmquist, Peter. "California Nineteenth Century Women Photographers," *The Photographic Collector* Vol 1, No 3 (Fall 1980), pp 18-21.

Lists names, places, and dates for 112 women photographers and firms with women partners.

_____. "19th Century Photographers," *Yesterday and Tomorrow: California Women Artists* edited by Sylvia Moore (New York: Midmarch Arts Press), 1989, pp 282-191.

An essay generally addressing the research subject of early women photographers of California. Gives some biographical and career details on several individuals.

_____. "The Photographers of Humboldt Bay," *Journal of the West* Vol 20, No 3 (July 1981), pp 42-56.

Primarily a textual history but gives biographical information for four maritime photographers of the area.

_____. *Photographers of Siskiyou County, California 1850-1920.*

Available directly from the author at 1183 Union Street, Arcata, California 95521.

_____. "The Photographers of Trinity County [California] 1850-1900," *Trinity 1979* [Official Yearbook, Trinity County Historical Society, Weaverville, California], pp 4-33.

Includes directory listing of fifty-five photographers and gives biographical annotations.

_____. "Professional Photographers Working in Humboldt County, California 1840-1940," *Humboldt Researcher* [Newsletter of the Redwood Genealogical Society, Fortuna, California] Vol 6, No 4 (May 1974).

_____. *Shadowcatchers: A Directory of Women in California Photography Before 1901* (Arcata, California: Peter E. Palmquist), 1990.

Available directly from Peter Palmquist, 1183 Union Street, Arcata, California 95521. An absolute landmark of both basic research and presentation in useful form. Containing relatively expansive information about hundreds of women in various aspects of photography, this 272-page volume distills twenty years of research. Most details are documented and there are numerous interesting illustrations. A checklist by county is included to-

gether with a brief but valuable "Selected Readings" list. An even larger second volume, continuing similar coverage through 1920, is to appear within 1991.

_____. *Shasta County* [California] *Photographers 1850-1900.*

Available directly from the author at 1183 Union Street, Arcata, California 95521.

_____. "Yesterday's Photographs: Reflections of the Past—The Photographers of Shasta County California, 1850-1870," *The Covered Wagon* [Yearbook of the Shasta County Historical Society, Redding, California] (1977), pp 6-20.

Gives data on twelve early photographers and studios.

_____. "Yesterday's Photographs: Reflections of the Past—The Photographers of Shasta County, 1870-1900," *The Covered Wagon* (1978), pp 33-50.

Continuation in form and information of previous item.

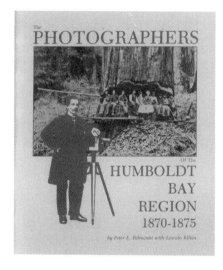

Palmquist, Peter E., and Lincoln Kilian. *Photographers of the Humboldt Bay Region* (Arcata, California: Peter E. Palmquist), 1985- , Vols 1- .

Available directly from Peter Palmquist, 1183 Union Street, Arcata, California 95521. One of the most ambitious research projects ever attempted in the field of photographic history, particulary on a regionally local basis. The series now having produced seven volumes (averaging around 125 pages) of a projected thirty or more, combines exhaustive photographic history and generous social history for a single county of the northern California coast. The two aspects of history are presented in textual form enhanced by numerous appendices, marginal cuts, sections of illustrations, chronological charts, and any other sort of added material that may enlighten the central topics. While occasional volumes

enlighten the central topics. While occasional volumes have been devoted in depth to single photographers, most cover the photographic activities of a period of years in astonishing detail. Each regular volume offers an extensive life and career outline for each photographer active in the period along with analysis of all recorded forms of logos or card mounts and an illustrated inventory of known specimens of work. Photographers of short duration are often traced through the rest of careers elsewhere, with the effect that the regional emphasis of the series is often exceeded to present valuable material for other areas of California, the United States, and abroad. Sometimes difficult to use quickly because coverage of individuals may reach into several volumes, but periodic indices to the series are being issued.

Patton, Mary Elizabeth, and Ronna H. Berezin. *Pasadena Photographs and Photographers 1880-1915: An Exhibit Presented by the Pasadena Historical Society* (Pasadena, California: The Pasadena Historical Society), 1982.

> An exhibit catalogue including an informative general text on the photographic history of the city and a biographical essay on the noted Elias A. Bonine. A group of illustrations and a list of the items shown offer further dates for some work.

Silva, Lester, compiler. *Sacramento, California— Daguerreotypist Checklist 1849-1860.*

> Unpublished typescript available from the compiler, P.O. Box 1015, Sacramento, California 95805.

Colorado:

Harber, Opal. *Photographers and the Colorado Scene 1901-1941* (Paonia, Colorado: Opal Harber), 1977.

> Available directly from the author at 3931 P 10 Lane, Paonia, Colorado 81428.

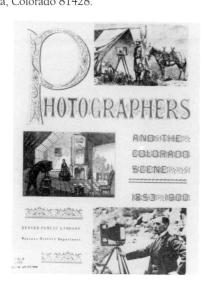

_____. *Photographers and the Colorado Scene 1853-1900* (Denver: Western History Department, Denver Public Library), 1961.

> One of the pioneering works in the field. A slightly expanded version has been republished as part of Colorado on Glass by Terry Wm. Mangan—see below.

_____. "A Few Early Photographers of Colorado," *Colorado Magazine* Vol XXXIII, No 4 (October 1956), pp 284-295.

Mangan, Terry Wm. *Colorado on Glass: Colorado's First Half Century as Seen by the Camera* (Denver: Sundance Limited), 1976.

> A full-scale photographic history of early Colorado; includes slightly expanded reprint of the Colorado directory by Opal Harber noted above.

Connecticut:

Fuller, Sue Elizabeth. "Checklist of Connecticut Photographers by Town: 1839-1889" and "Alphabetical Index of Connecticut Photographers: 1839-1889," *The Connecticut Historical Society Bulletin* Vol 47, No 4 (Winter 1982), pp 117-154 and 155-163.

> Taken together with William F. Robinson's essay, "The Connecticut Yankee and the Camera: 1839-1889," pages 97-116 of the same issue, these items make up a solid record of the first fifty years of photography in the state.

Robinson, William F. *The Connecticut Yankee & the Camera: 1839-1889* (Hartford, Connecticut: The Connecticut Historical Society), 1983.

> "A history of Connecticut photography including a checklist of photographers by town, 1839-1889;" 66 pp, 22 duotone plates, paperbound, US$3.50, postage and handling included. Order from The Connecticut Historical Society, 1 Elizabeth Street, Hartford, Connecticut 06105.

Delaware:

Williams, Jon M. "Daguerreotypists, Ambrotypists, and Photographers in Wilmington, Delaware, 1842-1859," *Delaware History* Vol 18, No 3 (Spring-Summer 1979), pp 180-193.

> Described as "discussion of history with census of twenty-four photographers."

District of Columbia:

Busey, Samuel C. "Early History of Daguerreotypy in the City of Washington," *Records of the* [District of] *Columbia Historical Society* Vol III (1900), pp 81-95.

Florida:

Rinhart, Floyd and Marion Rinhart. *Victorian Florida* (Atlanta, Georgia: Peachtree Publishers Ltd.), 1988.

> An illustrated social and photographic history of the state of Florida in the late 19th century and following. "Biographies of photographers" and a bibliography are included. Available at US$29.95 plus shipping from Peachtree Publishers Ltd., 494 Armour Circle, N.E., Atlanta, Georgia 30324, U.S.A. .

_____. *Victorian Florida: America's Last Frontier* (Atlanta, Georgia: Peachtree Publishers Limited), 1986.

> The section "Biographies of photographers" (pages 205-214) gives more or less detail on lives and careers of 196 photographers or firms issuing photographs of Florida between 1842 and 1900 as derived from a variety of sources.

Georgia:

Album—Original Photographs from the Atlanta Historical Society: Catalogue of an Exhibition at Handshake Center for the Arts, Atlanta, Georgia, June 4 - August 9, 1980.

> The "Appendix: Atlanta Photographers 1840-1930," pages 58-63, lists 420 photographers with approximate periods of activity only.

Hawaii (see Oceania: Hawaii)

Idaho:

Hart, Arthur A. *Camera Eye on Idaho: Pioneer Photography 1863-1913* (Caldwell, Idaho: The Caxton Printers, Ltd.), 1990.

> A full-volume survey of the history of the area with illustrations and regionalized commentary. Two tables give an alphabetical listing of photographers by name, location, and date periods (pages 156-176) as well as a listing with the same details arranged alphabetically by town (pages 177- 188.) The text opens some important new ground and illuminates previous gaps in otherwise known careers but is not exhaustively complete.

Illinois:

Czach, Marie. *A Directory of Early Illinois Photographers* (Macomb, Illinois: Western Illinois University), 1977.

> A full-scale directory and quite helpful although not total in coverage.

[Rhymer, Mary Frances, et al.] *Chicago Photographers 1847 through 1900 as Listed in Chicago City Directories* (Chicago: Print Department, Chicago Historical Society),

1958.

> One of the pioneer directories done anywhere in the field.

Kansas:

Taft, Robert. "A Photographic History of Early Kansas," *Kansas Historical Quarterly* Vol III, No 1 (February 1934), pp 3-14.

Louisiana:

Smith, Margaret Denton, and Mary Louise Tucker. *Photography in New Orleans: The Early Years, 1840-1865* (Baton Rouge, Louisiana: Louisiana State University Press), 1982.

> "Biographical Checklist of New Orleans Photographers," pages 151-171, gives details on the lives or careers of 211 photographers active between 1840 and 1870.

Maine:

Darrah, William C., compiler. *A Check List of Maine Photographers Who Issued Stereographs—A Special Supplement to the Maine Historical Society News-Letter* (May 1967).

> Lists about 130 photographers or publishers active between 1860 and 1900, both alphabetically and by town but does not give dates for particular names.

Maryland:

Kelbaugh, Ross J. "Dawn of the Daguerrean Era in Baltimore, 1839-1849," *Maryland Historical Magazine* Vol 84, No 2 (Summer 1989), pp 101-118.

> An article rather than a directory but gives useful information on several of the original photographers of the city.

_____. *Directory of Maryland Photographers 1839-1900* (Baltimore, Maryland: Historic Graphics), 1988.

> Available directly from the compiler at Historic Graphics, 7023 Deerfield Road, Baltimore, Maryland 21208. A full-scale directory giving alphabetical listings of the photographers in two sections, for Baltimore and for other counties of Maryland, with addresses or locations, date periods of work, and reference sources. Some entries offer period quotations on the subject and there is a section of biographies of several noted persons.

_____. *Supplemental Directory of Baltimore Daguerreotypists* (Baltimore, Maryland: Historic Graphics), 1989.

> A forty-eight-page booklet available for US$10 plus shipping directly from the compiler at Historic Graphics, 7023 Deerfield Road, Baltimore, Maryland 21208. Includes location and date information along with descrip-

tions of "every known means of signing an image used locally during this era."

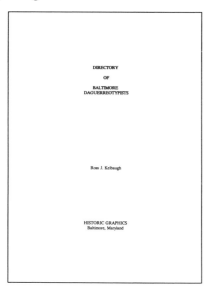

DIRECTORY
OF
BALTIMORE
DAGUERREOTYPISTS

Ross J. Kelbaugh

HISTORIC GRAPHICS
Baltimore, Maryland

Massachusetts:

Hoyle, Pamela. *The Boston Ambience: An Exhibition of Nineteenth-century Photographs* [February 9 through March 5, 1981] (Boston: The Boston Atheneaum), 1981.

> While not a directory, this catalogue offers career details for a number of leading Boston photographers and firms. Two essays, "The Daguerrean Artists" and "The Second Generation," cover generally the periods 1850-1875 and 1860-1890.

Polito, Ronald, compiler. *A Directory of Boston Photographers: 1840-1900*, 1983, revised 1985.

> A full-scale directory listing 890 studio photographers and 204 related professionals; some specialized information is stratified by topic, such as "Women Photographers," dealers, copyists, and album manufacturers, with one section devoted to "Photographic Activity by Year." Supersedes 1980 edition. Available directly from the compiler at Department of Art, University of Massachusetts— Boston, Harbor Campus, Boston, Massachusetts 02125.

Michigan:

Caterino, David R. "Union Views of Lansing?" *Stereo World* Vol 12, No 2 (May/June 1985), p 3.

> A research request that reports by names and years the activities of a team from the Union View Company to Lansing, Michigan. While limited, the information is definite and precise enough to be useful.

Welch, Richard W. *Sun Pictures in Kalamazoo: A History of Daguerreotype Photography in Kalamazoo County, Michigan 1839-1860* (Kalamazoo, Michigan: Kalamazoo Public Museum), 1974.

Missouri:

van Ravenswaay, Charles. "The Pioneer Photographers of St. Louis," *Bulletin of the Missouri Historical Society* Vol X, No 1 (October 1953), pp 49-71.

> One of the significant early directories done in the field.

Montana:

Gray, John S. "Itinerant Frontier Photographers and Images Lost, Strayed or Stolen," *Montana—The Magazine of History* Vol XXVIII, No 2 (April 1978), pp 2-15.

> Gives sketchy biographical details for a few noteworthy early photographers of the Montana-Dakota region.

Morrow, Delores J. "Female Photographers on the Frontier: Montana's Lady Photographic Artists, 1860-1900," *Montana, The Magazine of Western History* Vol 32, No 3 (Summer 1982), pp 76-84.

> An article of general historical narrative giving some dates and career details for several professional women and a few amateurs who have left bodies of work.

New Jersey:

Moss, George H., Jr. *Double Exposure: Early Stereographic Views of Historic Monmouth County, New Jersey and Their Relationship to Pioneer Photography* (Sea Bright, New Jersey: Ploughshare Press), 1971.

> Pages 174-175 give a "Checklist of New Jersey Stereographers and Publishers of New Jersey Stereographic Views, 1859-1971," including names and towns only. The text of the book gives sections on individuals with career details, view lists, and illustrations of work. A handsomely conceived book that could well be emulated for other localized regions. Unfortunately very rare because the bulk of the edition was destroyed by a fire in the warehouse before general distribution.

New Mexico:

Erdman, Barbara, editor. *New Mexico, U.S.A.: A Photographic Essay of New Mexico* (Santa Fe, New Mexico: The Santa Fe Center for Photography), 1985.

> An exhibit catalogue of work by contemporary photographers mainly resident in the state. The section "The Photographers," pages 106-111, gives biographical and career entries for fifty-nine individuals, including a number of nationally major photographers.

Rudisill, Richard. *Photographers of the New Mexico Territory 1854-1912* (Santa Fe, New Mexico: Museum of New Mexico), 1973.

> A full-scale directory covering about 500 persons or firms, compiled largely from newspapers. Several individuals from El Paso, Texas are included because of proximity or patterns of work.

New York:

Bannon, Anthony, et al. *The Photo-Pictorialists of Buffalo* (Buffalo, New York: Media Study), 1981.

> Pages 87-99, "The Photographers," give biographies of thirty-two photographers who were members of this Pictorialist group.

Christopher, A. J. "Early Village [of Baldwinsville, New York] Photographers," *Baldwinsville Messenger* (July 24, 1974).

> A local history newspaper article which touches on seven early photographers of Baldwinsville, New York.

Doherty, Amy S.

> Has compiled a listing of photographers in Syracuse, New York. For information contact The George Arentz Research Library, Syracuse University, Syracuse, New York 13210.

Fordyce, Robert Penn, compiler. *Stereo Photography in Rochester, New York up to 1900: A Record of the Photographers and Publishers of Stereographs....* (Rochester, New York: Privately published), 1975.

> Lists forty-five individuals and firms. Available directly from the compiler at 102 Vassar Street, Rochester, New York 14607.

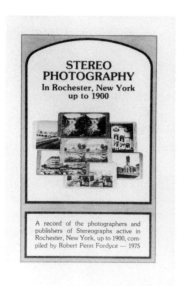

Gabriel, Cleota Reed. "Photographers Who Practiced in Syracuse, New York 1841 to 1900," *Photographica—A Resource Guide* (Syracuse, New York: Onondaga County Public Library and Light Work Organization), 1979.

> Lists thirty-five daguerreotypists, forty–six companies, and 173 photographers. May be ordered directly from Light Work, 316 Waverly Avenue, Syracuse, New York 13210.

_____. "A Bibliography [sic] of Early Syracuse [New York] Photographers," *Photographica: A Publication of the Photographic Historical Society of New York* Vol XIII, No 8 (October 1981), pp 12-13.

> Somewhat truncated and reduced reprinting of previous item; gives names, working dates, and occasional other notes for about 165 photographers.

Sampson, June.

> An unpublished Master's thesis on several stereo photographers in the area of Cooperstown, New York. Copies are held in the collections of New York University at Oneonta, New York, and the New York State Historical Association, Lake Road, Rt. 80, Cooperstown, New York 13326.

Vetter, Jacob C. "Early Photographers: Their Parlors and Galleries," *Chemung County* [New York] *Historical Journal* (June 1961), pp 853-860.

> A textual article surveying the early photographers of Elmira, New York. Gives some location and date particulars on about twenty-five people.

North Dakota:

Vyzralek, Frank E. "Dakota Images: Early Photographers and Photography in North Dakota, 1853-1925, *North Dakota History: Journal of the Northern Plains* Vol 57, No 3 (Summer 1990), pp 24-37.

> A survey article rather than a directory; gives an overview of several notable early photographers in the context of the historical development of the area. The author is also compiling a full directory for the Dakota region.

Ohio:

Fullerton, Richard D., compiler. *99 Years of Dayton* [Ohio] *Photographers* (Dayton, Ohio: Richard D. Fullerton), 1982.

> A full-scale directory covering 385 photographers or studios plus 106 "allied businesses."

Oregon:

Culp, Edwin D. "Oregon Postcards," *Oregon Historical Quarterly* Vol LXVI, No 4 (December 1965), pp 303-330.

Gives capsule biographies of several Oregon photographers.

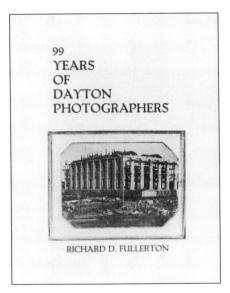

Goodman, Theodosia Teel. "Early Oregon Daguerreotypers and Portrait Photographers," *Oregon Historical Quarterly* Vol XLIX, No 1 (March 1948) pp 30-49.
 More a text article than a directory but gives numerous biographical details.

Miller, Alan Clark. "Other Photographers in Southern Oregon," *Peter Britt: Pioneer Photographer of the Siskiyous* (Unpublished Master's thesis done at Trinity College), 1972.

Pennsylvania:

Finkel, Kenneth. *Nineteenth-Century Photography in Philadelphia: 250 Historic Prints from the Library Company of Philadelphia* (New York: Dover Publications, Inc.), 1980.
 Pages 217-219 offer a "Selected List of Photographers Represented" and give biographical information on forty-three photographers or firms.

Heisey, M. Luther. "The Art of Photography in Lancaster [Pennsylvania]," *Papers of the Lancaster County Historical Society* Vol LI, No 4 (1947), pp 93-114.
 Gives historical accounts of several individuals and studios plus chronological list of several others.

Panzer, Mary. *Philadelphia Naturalistic Photography 1865-1906* (New Haven, Connecticut: Yale University Art Gallery), 1982.
 An exhibition catalogue which gives short biographies of sixteen significant regional photographers along with a general historical essay and plates.

Powell, Pamela C. *Reflected Light: A Century of Photography in Chester County* [Pennsylvania] (West Chester, Pennsylvania: Chester County Historical Society), 1988.
 A "Checklist of Photographers working in Chester County," pages 71-72, gives names, locations by town, and work decades for 104 professional photographers or partnerships active between 1840 and 1920 as defined from a variety of sources. Pages 17-58 give biographical articles for ten specific people.

Rhode Island:

Taylor, Maureen. "Nature Caught at the Twinkling of an Eye: The Daguerreotype in Providence," *Rhode Island History* Vol 42, No 4 (November 1983), pp 109-121.
 An article dealing with a city otherwise not covered in the literature.

Tennessee:

Reynolds, Ann, and John Compton. "Nashville [Tennessee] Photographers, 1853-1935," *Recorded in Nashville—A Visual Record by the City's Early Photographers* (Nashville, Tennessee: Metropolitan Historical Commission), 1980, pp 29-30.
 An exhibit catalogue listing names and date periods for about 170 individuals and studios.

Texas (also see New Mexico for partial listing of El Paso):

Galvani, Paul. "Early Houston Photographers, Part I [and] Part II," *The Photographic Collectors of Houston Newsletter* (October 1982), pp 1-2 and (November 1982), pp 1-2.
 A mixture of text and listing of over fifty-six photographers, apparently drawn from city directories and intended to demonstrate the thesis that there were "no famous photographers" and "no famous galleries" and only "average practitioners taking average likenesses for an undemanding populus [sic]." The thesis is argued by other Texas researchers. Some errors.

Utah:

Carter, Kate B., compiler. *Early Pioneer Photographers* (Salt Lake City: Daughters of Utah Pioneers), 1975.

_____. *The Story of an Old Album* (Salt Lake City: Daughters of Utah Pioneers), 1947.

Wadsworth, Nelson. *Through Camera Eyes* (Salt Lake City: Brigham Young University Press), 1975.

A full textual history which gives expansive biographical treatment to several major Utah photographers.

_____. "Zion's Cameramen: Early Photographers of Utah and the Mormons," *Utah Historical Quarterly* Vol XL, No 1 (Winter 1972), pp 24-54.
> A preliminary version of the previous item.

Virginia:

Ginsberg, Louis. *Photographers in Virginia 1839-1900: A Check List* (Petersburg, Virginia: Louis Ginsberg), 1986.
> A limited edition available directly from the compiler at Box 1502, Petersburg, Virginia. A true directory but far short of exhaustive.

Johnson, Brooks. "Virginia Daguerreotypists," *Mirror of an Era* [Catalogue folder for exhibition] ([Norfolk, Virginia]: The Chrysler Museum), 1989, [pp 5-6].
> Unpaginated folder gives brief biographical or career notes on eleven daguerreotypists once active in Virginia, including the area later to become West Virginia. The notes for the exhibit also offer fragments of location or date period information for a few others, including a few active elsewhere.

Washington:

Jones, Gordon. "Pioneer Northwest Marine Photographers," *The Sea Chest: Journal of the Puget Sound Maritime Historical Society* (June 1976).
> Mainly a reprint of the next item and subject to renewed criticism from local authorities.

_____. "Short Biographies of Photographers Who Helped Record the Maritime History of the Pacific Northwest," *Puget Sound Maritime Historical Association Newsletter Supplement* (November 1966).
> Gives very sketchy biographical notes on a few early photographers; has been criticized by local authorities for brevity and general lack of substance.

8. Oceania:

Australia:

Barrie, Sandy. *Professional Photographers in Australia, 1900 to 1920* 2 vols (), 1987.
> Vol 1, 66 pages, is an *Alphabetical Listing of Known Professional Photographers in Australia, 1900 to 1920*; Vol 2, 34 pages, is *Professional Photography in Australia—Additional Notes*. Available directly from Sandy Barrie, Early Australian Photographers Research Project, P. O. Box A 488, Sydney South, New South Wales 2000, Australia (research assistance inquiries should include reply postage).

_____. *Queenslanders Behind the Camera: Professional Photographers in Queensland, 1849-1920* 5 vols ().
> The total set is 186 pages; Vol 1 is an alphabetical listing with dates and addresses. Vols 2-5 give photographers' biographies. Available directly from Sandy Barrie, Early Australian Photographers Research Project, P. O. Box A 488, Sydney South, New South Wales 2000, Australia (research assistance inquiries should include reply postage.)

Davies, Alan, and Peter Stanbury. *The Mechanical Eye in Australia: Photography 1841-1900* (Melbourne, Australia: Oxford University Press), 1985.
> A full-scale textual history. Includes an alphabetical listing of over 3000 professional and amateur photographers. Gives known dates and addresses.

Hawaii:

Abramson, Joan. *Photographers of Old Hawaii* (Honolulu: Island Heritage), third edition 1981.
> An entire book giving biographies and selections of pictures by sixteen early photographers of Hawaii ranging from the 1850s to about 1920.

Davis, Lynn. *Na Pa'i Ki'i: The Photographers in the Hawaiian Islands 1845-1900* (Honolulu: Bishop Museum Press), 1980.
> An exhibit catalogue touching work by twenty–four early photographers. Quite limited in biographical detail, which is scattered through the text, but does offer an "Index to Photographers," to help location.

Schmitt, Robert C. "Notes on Hawaiian Photography before 1890," *Hawaii Historical Review* (October 1967), pp 409-416.

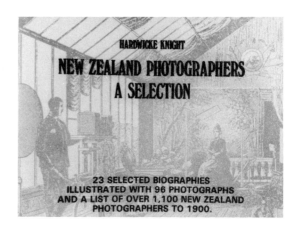

HARDWICKE KNIGHT

NEW ZEALAND PHOTOGRAPHERS A SELECTION

23 SELECTED BIOGRAPHIES ILLUSTRATED WITH 96 PHOTOGRAPHS AND A LIST OF OVER 1,100 NEW ZEALAND PHOTOGRAPHERS TO 1900.

New Zealand:

Knight, Hardwicke. *New Zealand Photographers: A Selection* (Dunedin, New Zealand: Allied Press Ltd.), 1981.

> Includes twenty-three one-page biographies, each with a selection of plates, and a listing of over 1100 photographers active before 1900 given only by name with some town or date period notes. Available from Allied Press Ltd., P.O. Box 517, Dunedin, New Zealand.

_____. *Photography in New Zealand: A Social and Technical History* (Dunedin, New Zealand: John McIndoe), 1971.

> The first effort at a general history of photography in the country. Pages 181-186 give a list of New Zealand photographers to 1900 and pages 187-189 give a cross reference "Geographical List of New Zealand Photographers." While later works give more full detail, this volume gives many pictures not otherwise seen.

Lester, John. *William Ferrier, 1855-1922: Photographer* ([n.p.]: [n.p.]), [n.d.].

> Described in Pajerski Catalogue 9 as "Catalogue of an exhibition of 152 items taken in New Zealand between 1880-1922; includes listing of other photographers active in Timaru."

Turner, John B., editor. *Nineteenth Century New Zealand Photographs* (New Plymouth, New Zealand: Govett-Brewster Art Gallery), 1970, pp 80-84.

> Section gives biographical notes on twenty-three early photographers or studios.

Woodward, Joan. *A Canterbury Album: Collodion Photography in Canterbury*, [New Zealand] *1857-1880* (Lincoln, New Zealand), 1987.

> Uncertain whether a true directory but presents information on over fifteen early photographers of the city.

Tahiti:

O'Reilly, Patrick. *Les Photographes à Tahiti et leurs Oeuvres 1842-1962* (Tahiti: Les Editions du Pacifique), second edition 1981.

> The entire book functions somewhat in the form of a chronologically-ordered directory by giving text sections on individuals or styles according to years. An index list of all references to photographers by name is also included and gives references to eighty-four individuals. A few early passages of the text throw light on photographers in South America and other parts of the world.

B. Works in Progress

1. General and International:

Lang, Robert J. *Panorama Documentation Project—List of Museums and Other Organizations with Panoramas—List of Panoramic Photographers* being compiled for the International Association of Panoramic Photographers.

> The listing thus far contains information on over 1100 photographers active during the last 150 years. It is backed by an on-going computerized data base of biographical information. Address: 100 Cooper Court, Port Jefferson, New York 11777.

Treadwell, T. K., and the late William Culp Darrah.

> Compilation of a listing of "basic information on all known stereographers, worldwide." The project is to correct and extend Prof. Darrah's work and format as far as possible beyond the present 7000 entries "to provide . . . a starting point for those interested in a particular region." Names, general locations, estimated decades of activity, and comments will be given in the final publication intended for later 1991 by the [American] National Stereoscopic Association. Address: 4201 Nagle Road, Bryan, Texas 77801.

Walters, Judith Allison.

> Continuous collection of location data on early photographers, photographs, and other genealogy-related materials. Has already published *Photographers of North America, Great Britain and Europe* (1980; available for US $6.50 plus .65) Research being continued for additional information. Address: P. O. Box 129, Bothell, Washington 98041.

2. Europe:

Austria:

Kralik, Bodo.

> Compilation of a directory of Viennese photographers to 1880, to include biographies and trade emblems. Address: Alszeile 11/2, A-1170 Wien, Austria.

Belgium:

Schwilden, Tristan, and Steven Joseph.

A directory of 19th–century photographers in Belgium plus collecting information on all aspects of early photography in the country, especially photographically-illustrated books. Address (Schwilden): Librairie Schwilden, Galerie Bortier 5, 1000 Brussels, Belgium; (Joseph): Rue Bordiau 5, 1040 Brussels, Belgium.

Greece:

Xanthakis, Alkis X.

Compiling a "Lexikon" or directory of Greek photographers, both in and outside Greece, and foreign photographers active in Greece, 1839-1945. Address: Head of Photography, Athens Cultural and Technological Institute, P. O. Box 4198, Athens, Greece.

Netherlands:

Wachlin, Steven.

Compiling an inventory of all commercial photographers in the country born before or in 1880, derived from population registers supplemented by commercial directories. About two-thirds of the country has been surveyed in detail and completion is intended in 1992. Also working on the former Dutch colonies of Surinam and Curadao (see Latin America). Address: P. O. Box 11097, 1001 GB Amsterdam, Netherlands.

Sweden:

Jacobson, Claes.

Collecting comprehensive information on all 19th–century photographers from Sweden who emigrated elsewhere in the world. Address: Swedish Pioneer Historical Society, Fridhemsgatan 13, 8tr, S112, 40 Stockholm, Sweden.

United Kingdom:

Budge, Adrian.

Collecting information for a directory of photographers in Bradford, England, through 1939. Address: Head of Education & Interpretation, National Museum of Photography, Prince's View, Bradford, West Yorkshire BD5 OTR, England.

Fenner, Robin.

Compiling full information on the early photographers of the county of Devon, England. While complete details and address are not given, this project is noted on page 11 of *Views and Likenesses: Photographers and Their Work in Cornwall and Scilly 1839-1870* by Charles Thomas (Truro, Cornwall: Royal Institution of Cornwall), 1988, previously cited under published works.

Heathcote, Bernard V., and Pauline F.

Compilation of a "gazetteer of early portrait studios of the British Isles." Address: "Rudlow," Plough Lane, Lowdham, Nottinghamshire Ng14 7AT, England.

Pritchard, Michael.

Revision and expansion of previously published *Directory of London Photographers 1841-1908* (See entry under Section I - "Published Works.") Address: 38 Sutton Road, Watford, Hertfordshire WD1 2QF, England.

Royal Photographic Society Historical Group.

A continuing series of supplements to the *PhotoHistorian* quarterly, each giving a full-scale directory for one town (or more if small) in Britain. The twenty-six already issued are being revised for publication in a single volume (including the several noted elsewhere in this Bibliography.) Address: Michael Pritchard, Secretary, Royal Photographic Society Historical Group, 38 Sutton Road, Watford, Hertfordshire WD1 2QF, England.

Smith, Bill.

Compiling information on "photographers in [the town of] Hitchin and the north of the country" [of Hertfordshire.] Noted without other specifics or address in *Hertfordshire Photographers 1839-1939* compiled by Bill Smith and Michael Pritchard (Stevenage, England: [n. p.]), 1985, cited above under published works.

3. Latin America:

Curacao:

Wachlin, Steven.

A survey of the photographers and studios in the area to 1910, compiled from newspaper sources. Address: P. O. Box 11097, 1001 GB Amsterdam, Netherlands.

Mexico:

Casanova, Rosa, and Olivier Debroise.

A directory of 19th-century photographers in Mexico, as well as personalities and commercial houses involved in some way with the photographic process. Address (Casanova): Lungo Dora Firenze 61, 10152 Torino, Italy; (Debroise): Apdo. Postal 11586, 06100 Mexico, D F., Republic of Mexico.

Rochlin, Fred.

A directory of early photographers active in the state of Sonora. Address: Arizona-Sonora Historical Society, 10790 Wilshire Boulevard #305, Los Angeles, California 90024.

4. North America:

Canada:

Schwartz, Joan M.

Supervising staff research of database project "Checklist of Canadian Photographers, 1839-1885" also to be published in inexpensive book form. Address: Chief, Photography Acquisition & Research, Historical Resources Branch, National Archives of Canada, 395 Wellington Street, Ottawa, Ontario K1A ON3, Canada.

United States:

General and Regional:

Baryla, Bruce.

Compiling a listing of photographers derived by research into federal occupational tax registers, particularly during the period of the Civil War. Address: c/o Ciociola & Company, 888 Seventh Avenue, New York, New York 10106.

Craig, John S.

Compiling *Craig's Daguerreian Registry*, a comprehensive directory of American photographers 1839-1860, from all available sources; currently over 9,000 entries; some information available upon inquiry. Address: P. O. Box 1637, Torrington, Connecticut 06790.

Drake, Greg.

Compiling listings for Connecticut, Maine, New Hampshire, Rhode Island, and Vermont, currently holding information on around 5000 photographers. Address: 47 Wiltshire Road, Brighton, Massachusetts 02135.

Fleming, Paula.

Compiling biographical and career data on photographers of American Indians before 1920. Substantial emphasis to date on Washington, D.C.; Philadelphia, Pennsylvania; and the Territories (Montana, Wyoming, Dakota, Utah, Nebraska, and the Indian Territory.) Address: National Anthropological Archives, Smithsonian Institution, Room 60-A, Natural History Building, Washington, D. C. 20560.

Kelbaugh, Ross J.

Continuing work to complete a six- volume *Directory of Civil War Photographers*; Volume I already published. Address: Historic Graphics, 7023 Deerfield Road, Baltimore, Maryland 21208.

Mautz, Carl.

Continuing accumulation of details for expand biographical checklist of early photographers of the American

West. Address: P. O. Box 9, Brownsville, California 95919.

Arizona:

Hooper, Bruce.

A directory of Arizona photographers from 1864 to 1920; includes some amateurs and data from parts of careers pursued in other states. Address: Center for Colorado Plateau Studies, Northern Arizona University, Box 5613, Flagstaff, Arizona 86011.

California:

Callarman, Barbara Dye.

Completed manuscript of *Nineteenth Century Photographers of Los Angeles County, California* covering 250 photographers with some biographical data and locations of work in state collections and including an extensive bibliography. Also working on a "Checklist of 19th & Early 20th Century Southern California Photographers" and seeking publishers for both works. Address: Director, Downey History Center, Downey Historical Society, P. O. Box 554, Downey, California 90241.

Miller, Mrs. Kathleen L.

Collecting information toward a regional directory of early photographers in southern California, particularly emphasizing Los Angeles. Address: 23130 Hatteras Street, Woodland Hills, California 91367

Palmquist, Peter.

A directory of photographers of California to 1900. Address: 1183 Union Street, Arcata, California 95521.

Spencer, Horace.

Working toward an illustrated directory of early photographers of the area of Stockton. Address: 1964 Rosecrans Way, Stockton, California 95207.

Dakota Territory (also see North Dakota)

Kolbe, Robert, and Brian Bade.

Collecting details for a directory of photographers of the Dakota Territory and the states of North and South Dakota 1860- 1920. Address: The Dakota Image, 636 West 21st Street, Sioux Falls, South Dakota 57105.

District of Columbia:

Fleming, Paula, and Laurie A. Baty.

A directory of 19th–century photographers of Washington D. C. Address (Fleming): National Anthropological Archives, Smithsonian Institution, Room 60-A

Natural History Building, Washington, D. C. 20560; (Baty): 302 Dunkirk Road, Baltimore, Maryland 21212.

Florida:

Punnett, Richard.
Compiling a biographical directory of Florida photographers to 1929; to include sub-lists of women and black photographers plus other bibliographic or research aids. Address: 111 Coquina Avenue, Ormond Beach, Florida 32174-3303.

Hawaii: (see Oceania: Hawaii)

Georgia:

Elzroth, Lee.
Compiling a directory of Georgia photographers. Address: Georgia Department of Archives & History, 330 Capitol Avenue, Atlanta, Georgia 30334-1801.

Illinois:

Foster, Jim.
Has "near completion" a "comprehensive annotated list of Illinois photographers from 1839 to 1930" based on commercial listings and picture mounts. To be available on disk for Macintosh (Microsoft Works 2.00a data base.) Further data and logos are desired and will be credited. Copies of the disk with explanatory notes and bibliography (Special Publication #16) or "Modified Hard Copy" [Printed] version without full annotations are available at US$5. Also collecting for publication American card photograph backmarks and information on tintypes and tintypists. Address: P. O. Box 3008, Urbana, Illinois 61801.

Iowa:

Zeller, John, and Lorin Horton.
A directory of photographers in Des Moines, Iowa, before 1900; also collecting data on photographers in Iowa to 1860. Address (Zeller): 7118 El Rancho, Des Moines, Iowa 50322; (Horton): Iowa State Historical Department, State Historical Society of Iowa, 402 Iowa Avenue, Iowa City, Iowa 52240.

Massachusetts:

Polito, Ronald, and Chris Steele.
A directory of Massachusetts photographers in the 19th century. Address (Polito): Department of Art, University of Massachusetts, Boston, Massachusetts 02125; (Steele): 47 Wilshire Road, Brighton, Massachusetts 02134.

Michigan:

Ross, Thomas.
Work on a checklist and later full directory of Michigan photographers to 1910. Address: 35892 Parkdale, Livonia, Michigan 48150.

Tinder, David.
Collecting comprehensive information on photographers of Michigan before 1920; has identified over 10,000 to date. Address: 6404 Coleman, Dearborn, Michigan 48126.

Minnesota:

Woolworth, Alan.
A directory of Minnesota photographers to 1930. Address: Publications and Research Division, Minnesota Historical Society, 690 Cedar Street, St. Paul, Minnesota 55101.

Montana:

Morrow, Lory.
Compiling a directory of early Montana photographers. Address: Montana Historical Society, 225 North Roberts Street, Helena, Montana 59601.

New Jersey:

O'Connor, John E.
A directory of New Jersey photographers to 1900. Address: New Jersey Institute of Technology, Newark, New Jersey 07102.

North Carolina:

Cotten, Jerry.
Compiling a database of photographers active in North Carolina through 1910. Address: Photographic Services Section, CB #3934, Wilson Library, The University of North Carolina, Chapel Hill, North Carolina 27599-3934.

North Dakota (also see Dakota Territory):

Vyzralek, Frank E.
Working toward a directory of early photographers in North Dakota. Address: Great Plains Research, 702 Capitol Avenue, Bismarck, North Dakota 58501.

Ohio:

Waldsmith, John.
Completed manuscript for *A Directory of Ohio Photographers, 1839-1900*; includes professional photographers, itinerants, employed studio operators, and "accomplished amateurs," with verified dates and locations. Address: Antique Graphics, P. O. Box 191, Sycamore, Ohio 44882.

Oklahoma:

Cowen, Chester R.

Continuing work on comprehensive database for photographers of Oklahoma and the Indian Territory. Address: Photo Archivist, Oklahoma Historical Society, Wiley Post Historical Building, Oklahoma City, Oklahoma 73102.

Oregon:

Oregon Historical Society Photographs Library.

A continuing compilation of data sheets on early Oregon photographers, mainly from city directories. Current form (over ninety pages) is available on order at any time in photocopies at cost. Address: Susan Seyl, Photographs Librarian, Oregon Historical Society, 1230 S.W. Park Avenue, Portland, Oregon 97205.

Robinson, Tom.

Compiling biographies of Oregon 19–century photographers. Address: Tom Robinson, Concert Sound, 140 SE 28th, Portland, OR 97214.

Pennsylvania:

Brey, William A., and Marie.

Compiling information for a directory of photographers to 1900 in the city of Philadelphia. Address: 1916 Cardinal Lake Drive, Cherry Hill, New Jersey 08003.

Pennsylvania Historical Photography Group.

To undertake "an inventory of historical photo collections and of photographers who practiced in the state." Address: Jay Ruby, President, The Center for Visual Communication, P. O. Box 128, Mifflintown, Pennsylvania 17059.

Powell, Pamela C.

Compiling separate listings of photographers and daguerreotypists active in Chester County. Current working versions available for US$2.50. Address: Photo Archivist, Chester County Historical Society, 225 North High Street, West Chester, Pennsylvania 19380-2691.

Ries, Linda A.

A listing of photographers in the city of Harrisburg to 1930. Address: Head, Reference Section, Division of Archives and Manuscripts, Pennsylvania Historical and Museum Commission, Box 1026, Harrisburg, Pennsylvania 17108.

Rifkind, Eugene.

A computer listing of Philadelphia photographers, currently about 400 entries. Address: 1217 Deveraux Avenue, Philadelphia, Pennsylvania 19111.

Ruby, Jay.

A list of photographers who practiced in Juniata County. Address: Department of Anthropology, Temple University, Philadelphia, Pennsylvania 19122.

South Dakota (see Dakota Territory)

Texas:

Haynes, David.

A directory of photographers in Texas to 1900. Address: Institute of Texan Cultures, University of Texas, P. O. Box 1220, San Antonio, Texas 78294.

Sarber, Mary A.

Collecting comprehensive information on the photographers of El Paso, Texas. Address: El Paso Public Library, 501 North Oregon Street, El Paso, Texas 79901.

Wyoming:

Jost, Loren.

Collecting information on early photographers of Wyoming, particularly the Wind River Valley region. Address: 308 Moose Drive, Riverton, Wyoming 82501.

5. Oceania:

Australia:

Barrie, Sandy.

Researching for a directory and biographical history of professional and amateur photographers active in Queensland, Australia, between 1849 and 1920; also acquiring data on professional photographers elsewhere in Australia after 1900. Address: Early Australian Photographers Research Project, P. O. Box A488, Sydney South, New South Wales 2000, Australia. (Research assistance inquiries should include reply postage.)

Hawaii:

Davis, Lynn.

Compiling career data on early photographers in Hawaii. Address: Chairperson, Visual Collection, Bernice P. Bishop Museum, P. O. Box 19000A, Honolulu, Hawaii 96817.

Index of Authors